Early Art and
Architecture o

Oxford Histc

D0880337

P mic
M Coast
Se), Great
If on, 1973),
ar g (Elsevier/Phaidon,
Nigeria, Mozambique, Tanzania, the 1978), *The Hunter's Vision* (British
Kenya and Somali coasts, and Qatar. He Museum Press, 1995), and many papers
has spent the last ten years researching in specialist journals, encyclopaedia
the rock art of Zimbabwe. His entries, and school and guide books.

Oxford History of Art

Titles in the Oxford History of Art series are up-to-date, fully illustrated introductions to a wide variety of subjects written by leading experts in their field. They will appear regularly, building into an interlocking and comprehensive series. In the list below, published titles appear in bold.

WESTERN ART

Archaic and Classical Greek Art
Robin Osborne

Classical Art From Greece to Rome
Mary Beard & John Henderson

Imperial Rome and Christian Triumph
Jas Elsner

Early Medieval Art
Lawrence Nees

Medieval Art
Veronica Sekules

Art in Renaissance Italy
Evelyn Welch

Northern European Art
Susie Nash

Early Modern Art
Nigel Llewellyn

Art in Europe 1700–1830
Matthew Craske

Modern Art 1851–1929
Richard Brettell

After Modern Art 1945–2000
David Hopkins

Contemporary Art

WESTERN ARCHITECTURE

Greek Architecture
David Small

Roman Architecture
Janet Delaine

Early Medieval Architecture
Roger Stalley

Medieval Architecture
Nicola Coldstream

Renaissance Architecture
Christy Anderson

Baroque and Rococo Architecture
Hilary Ballon

European Architecture 1750–1890
Barry Bergdoll

Modern Architecture
Alan Colquhoun

Contemporary Architecture
Anthony Vidler

Architecture in the United States
Dell Upton

WORLD ART

Aegean Art and Architecture
Donald Preziosi & Louise Hitchcock

Early Art and Architecture of Africa
Peter Garlake

African Art
John Picton

Contemporary African Art
Olu Oguibe

African-American Art
Sharon F. Patton

Nineteenth-Century American Art
Barbara Groseclose

Twentieth-Century American Art
Erika Doss

Australian Art
Andrew Sayers

Byzantine Art
Robin Cormack

Art in China
Craig Clunas

East European Art
Jeremy Howard

Ancient Egyptian Art
Marianne Eaton-Krauss

Indian Art
Partha Mitter

Islamic Art
Irene Bierman

Japanese Art
Karen Brock

Melanesian Art
Michael O'Hanlon

Mesoamerican Art
Cecelia Klein

Native North American Art
Janet Berlo & Ruth Phillips

Polynesian and Micronesian Art
Adrienne Kaeppler

South-East Asian Art
John Guy

Latin American Art

WESTERN DESIGN

Twentieth-Century Design
Jonathan Woodham

American Design
Jeffrey Meikle

Nineteenth-Century Design
Gillian Naylor

Fashion
Christopher Breward

PHOTOGRAPHY

The Photograph
Graham Clarke

American Photography
Miles Orvell

Contemporary Photography

WESTERN SCULPTURE

Sculpture 1900–1945
Penelope Curtis

Sculpture Since 1945
Andrew Causey

THEMES AND GENRES

Landscape and Western Art
Malcolm Andrews

Portraiture
Shearer West

Eroticism and Art
Alyce Mahon

Beauty and Art
Elizabeth Prettejohn

Women in Art

REFERENCE BOOKS

The Art of Art History: A Critical Anthology
Donald Preziosi (ed.)

Oxford History of Art

Early Art and Architecture of Africa

Peter Garlake

OXFORD

UNIVERSITY PRESS

OXFORD

UNIVERSITY PRESS

Great Clarendon Street, Oxford OX2 6DP

Oxford New York

Athens Auckland Bangkok Bogotá Buenos Aires Cape Town
Chennai Dar es Salaam Delhi Florence Hong Kong Istanbul Karachi
Kolkata Kuala Lumpur Madrid Melbourne Mexico City Mumbai
Nairobi Paris São Paulo Shanghai Singapore Taipei Tokyo Toronto Warsaw
and associated companies in Berlin Ibadan

Oxford is a registered trade mark of Oxford University Press
in the UK and in certain other countries

0–19–284261–7

10 9 8 7 6 5 4 3 2 1

British Library Cataloguing in Publication Data
Data available

Library of Congress Cataloguing in Publication Data
Data available

ISBN 0–19–284261–7

Picture research by Charlotte Morris
Copy-editing, typesetting, and production management by
The Running Head Limited, Cambridge, www.therunninghead.com
Printed in Hong Kong on acid-free paper by C&C Offset Printing Co. Ltd

Contents

	Acknowledgements	7
Chapter 1	Introduction	9
Chapter 2	Rock Art of Southern Africa	29
Chapter 3	Nubia	51
Chapter 4	Aksum	73
Chapter 5	The Niger River	97
Chapter 6	West African Forests	117
Chapter 7	Great Zimbabwe and the Southern African Interior	141
Chapter 8	The East African Coast	167
	Notes	189
	Further Reading	197
	Timeline	200
	List of Illustrations	207
	Index	211

Acknowledgements

Hank Drewel read a draft of Chapter 6 and John Picton read early drafts of most chapters. Both contributed important corrections and additional information. Peter Jackson and the Architects Partnership, Harare, lent me their computers and e-mail facilities with an extraordinary generosity of time and effort. Carolyn Thorp was a great help in obtaining access to the collections of the Museum of Human Sciences, Zimbabwe.

I hope James Kirkman and Cran Cooke imparted some of their zest, enthusiasm, energy, and dedication to me in my first years of archaeological research. Frank Speed and Roy Sieber eased my passage into research in Nigeria. Years of friendship and exposure to the keen analytical mind of John Conradie were a constant pleasure and stimulus.

Barbara Murray watched over, encouraged, and criticized the book—and me—as we grew. As always, my mainstay has been my wife, Margaret. From bringing up our family and creating homes in various almost impossible circumstances, through patient work on the most delicate tasks of recovery and conservation in the field, to bringing the critical skills of an art historian and editor to bear on the text, her support has been beyond the reach of conventional public expressions of gratitude.

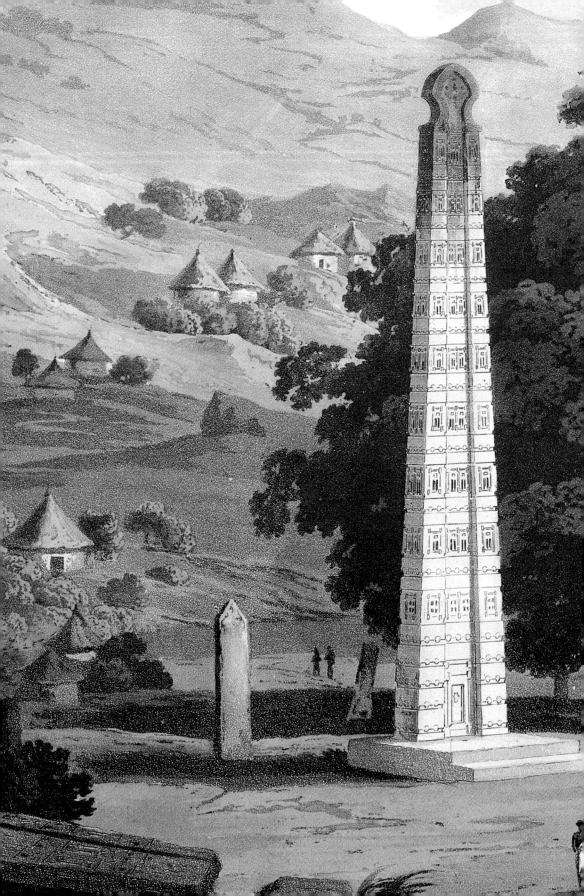

Introduction

1

The problem of selection

This volume deals with the art of an entire continent, nearly a quarter of the world's land mass, and its development over more than five millennia. It starts with the oldest surviving rock paintings and ends with the first European sea-borne contacts with sub-Saharan Africa—by the Portuguese in the late fifteenth and sixteenth centuries. With them all Africa began to be incorporated into an exploitative world economy.

One can only hope at most to give some tastes of a few of the many contrasting flavours of early African culture. One has to practise rigorous selection. How then were the seven themes in this volume selected? The primary criterion was that a reasonable corpus of relevant material survived. This inevitably meant that all works considered were made of materials that were capable of surviving the African climates for centuries. In practice this means inorganic paints on rock surfaces, stone, some metals, pottery, bricks and mortar. Except in Nubia, virtually no work in wood, ivory, or animal or plant materials has been preserved for this length of time. Hence there can be little discussion of textiles, clothing, basketry, leather-work, ivory- or wood-carving, or buildings in timber or thatch. This in turn means that almost all the crafts of the mass of every population receive no mention, for virtually nothing is known of them. Except with the rock art, one is discussing 'royal materials' and the art of the ruling classes—the temples, shrines, shrine furniture, palaces, tombs, and grave goods of minorities—the official art of cities and states. But states and cities, monarchies and monuments, were scarcely natural or inevitable developments for Africa. 'Africa's great achievement in law and politics was probably the stateless society, based on cooperation rather than coercion, not to mention the fact that the African states had been so organized as to preserve local autonomy.'[1]

One part of Africa—Egypt and the Mediterranean littoral—has been denied inclusion. It is so well studied and there are such rich bodies of material at the disposal of researchers that they must be dealt with by specialists in Egyptian, Roman, and Islamic art. I could not do them justice.

Map 1 Africa

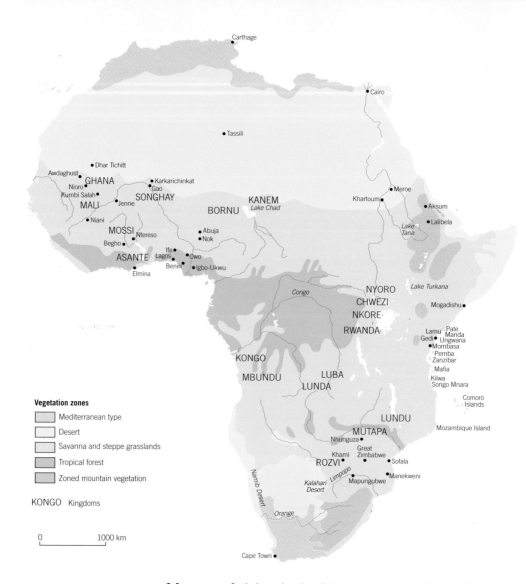

Vegetation zones

Mediterranean type

Desert

Savanna and steppe grasslands

Tropical forest

Zoned mountain vegetation

KONGO Kingdoms

0 1000 km

Many may feel that this book is incomplete without a discussion of the prehistoric rock engravings and paintings of north Africa and the Sahara. While it is true that considerations of space impose this omission, it is not the whole story. This art is the product of many different social and ethnic groups over long periods of time and is much more varied, very different from and lacking the fundamental cognitive unity of its southern African counterpart. It is not possible to get a grip on it and penetrate its different significances and meanings through ethnographic connections with recently extinct or living human societies. Attempts to interpret it through southern African models are

dangerous and at present unconvincing. Research on it has followed very different paths and traditions to those of southern Africa. To enter this field is too complex a task to have justice done to it here.

Diversity

Three aspects of all the arts and societies discussed here stand out: their diversity, their continuity, and their wide contacts. The societies are indeed so diverse that it would be an artificial imposition to try to link each topic together to form some sort of single unified narrative.

Each centre of early art discussed here is very different in its environment, topography, ecology, resources, peoples, and history. We consider the art of hunter-gatherers in southern Africa, who belied their so-called 'primitive' technologies and social organization to develop an art expressing perceptions, concepts, and beliefs of extraordinary richness and complexity; the edges of the Middle Nile, a lifeline in a desert land, where Egypt and sub-Saharan Africa developed new artistic syntheses; Aksum in the mountain fastnesses of Eritrea and Ethiopia, with its own highly idiosyncratic monuments; the desert fringes of west Africa, watered and made fertile and productive by another great river, the Niger; the tropical forests of southern Nigeria, seemingly cut off from the outside world yet nourishing the innovative centres of sophisticated copper-alloy technologies; the high inland plateau of southern Africa, where communities of Bantu-speaking farmers, who developed and populated so much of eastern and southern Africa, reached a high degree of social and political complexity; the low-lying coral coastline of east Africa with its reefs, islands, and harbours, which saw the growth of a string of towns and cities stretching along 2,000 km of tropical coastline.

The states differed from each other fundamentally. The religious institutions of Nubia—most notably the Amun priesthood of Jebel Barkal—were intimately involved in the growth and character of the Nubian state and exerted great influence on the rulers and state of Kush. Jebel Barkal, Napata, and Aksum as well were probably religious and ceremonial centres rather than cities. The religious pre-eminence of Ife seems always to have outweighed its economic, political, or military importance.

The Aksumite state is little understood but there are indications that it resembled a feudal federation of military leaders, vassals giving varying degrees of loyalty to the monarch. Originally no more than a military leader himself, he sought every support from symbolism and art, historical precedent and pedigree, ceremony and belief, to assert and enhance his credibility. In a broadly similar way, Great Zimbabwe created a cultural hegemony, spreading a court culture with its own distinctive symbols, architecture, and crafts and economic strategies

over the inland plateau to a network of lesser states. These probably had only very loose and changing political or tributary relationships with the centre. It may be comforting but it is misleading and anachronistic to promote either of these polities to the status of empires. None had the means, the economic controls, or the military strength to sustain an empire, or the manpower to plant and govern colonies. Conquests were always transient; territories were never occupied permanently nor were conquered peoples reduced to lasting subjection.

The towns along the Inland Niger Delta are best understood in terms of their internal networks of riverine trade rather than simply as the termini of desert caravan routes or as entrepots. The east African towns and cities all grew prosperous through international maritime commerce. For almost all their history, they each remained fiercely independent and resisted all attempts at centralization or incorporation into large unified states.

Historical research must change its focus from state systems as uniform entities and start to examine their inner dynamics. To begin to understand the essential natures of these very diverse societies, we will have to pay more attention to their institutions. It is these that give a society its structure, character, and identity. It is these that evolve to absorb disruptions and adapt to contradictions successfully. It is failures in these areas that can lead to decline. The variety of social, political, and economic institutions found in Africa is as diverse as the states themselves: age-grades, craft guilds, 'secret societies' or sodalities, brotherhoods, sects, councils of elders, initiation schools, shrines, and their servants, mediums, rainmakers, and shamans. One seeks to understand the nature of rule and the ruler, the beliefs that surround him and support or compete with his power. All the art we are concerned with was created within such institutions to express and serve them.

Continuity

There was once a propensity for archaeologists—and some historians—to divide their material into definable and distinct periods and cultures. This has helped to mask the extraordinary and much more important underlying longevity and continuity of many African cultures. The origins of the rock art of southern Africa are lost in the beginnings of the Later Stone Age or even earlier. The tradition survived to record patrols of British Army 'red-coats' into the artists' last retreats in the mid-nineteenth century: a span for a single artistic tradition of at least 20,000 years [8]. The Nubian state is often divided into two distinct entities: the states of Napata and Meroe. It was in fact a social, political, and cultural unity. It can with good reason also be extended back in time to include the Kerma state, and forward in time

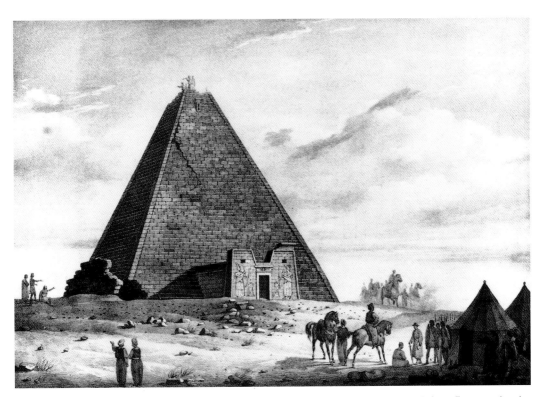

1
An engraving of 1821 showing the pyramid of Candace (Queen) Amenishakheto of Meroe in 10–1 BCE. This was the only pyramid with a tomb chamber within the pyramid itself. It was destroyed by the rapacious vandal Giuseppe Ferlini in 1834. The grave goods he looted included a great deal of jewellery wrought by Meroitic craftsmen and showing the waning of Egyptian fashion. Much use was made of hammered, cast, and intricately braided gold wire, gold droplets, and beads.

to take in the Ballana tumuli tombs of Lower Nubia. It can also be extended further in space to notice the influences on the culture of the pastoral peoples of the hinterland of the Upper Nile. This gives a continuity to early Nubian culture that lasted 3,000 years, ending only with the establishment of Christianity in the sixth century. In the same way, Aksumite culture can be seen evolving from sixth-century BCE Yeha [2] through to thirteenth-century CE Lalibela: giving a recognizable individuality to its artistic life for 2,000 years. Early African history saw much change, innovation, and adaptation, as well as many disruptions and disjunctions. But basic attitudes and values persisted. These gave each culture its identity and motivated and gave direction to development and change.

Connections

Each of the cultures dealt with in this book was highly individual, assured, and confident. Yet most also had connections with much wider worlds. The artists of the Stone Age rock paintings observed and interacted with incoming farmers, pastoralists, and white settlers. They portrayed aspects of them in their paintings but this did not affect the complex belief system that their art continued to explore. The connections linking Nubia to Egypt influenced every level of life in Nubia. By the time Meroe was at its most prosperous, it was part of

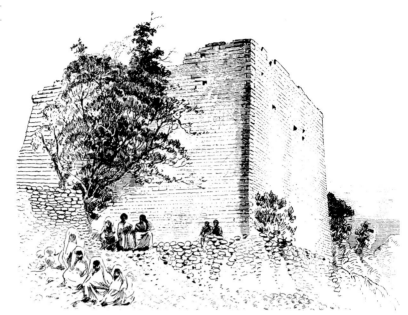

The temple at Yeha, not far north of Aksum. It was described in 1520 by the Portuguese priest Alvares as a 'tower built very strongly of hewn stone . . . exquisite masonry . . . royal grandeur such as I have never seen'. In interpreting it, J. Theodore Bent, author of this engraving, considered Yeha as 'the principal city of Sabaean colonisation', which, like Aksum, 'bear[s] obvious traces of a Graeco-Egyptian civilization, influencing a people given to sun worship' (Bent, 144–5).

Mediterranean culture. Meroe faded as the trade down the Nile declined and Mediterranean countries developed their trade with Asia through the Red Sea. Aksum, on the other hand, flourished when it took advantage of this trade and became another node in the network and another limb of Mediterranean culture. The Nubian successor states to Kush and also Aksum converted early to Christianity, played roles in the first Christian Councils, and helped to develop Christian theology. Aksum's presence in the holy sites of Jerusalem was never severed. Both cultures borrowed elements from the early architecture of the Eastern Churches and made them their own.

The oldest precise pictorial representation of stelae at Aksum, depicted in a lithograph by Henry Salt, who visited Ethiopia in 1805 and 1809 and was the first person to attempt an archaeological excavation in the country.

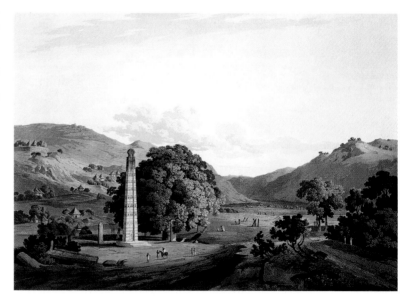

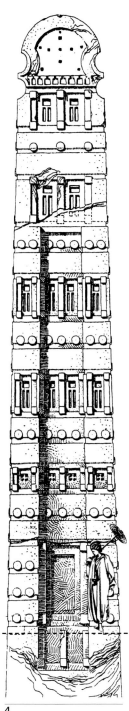

4

A carved granite 'multistorey' stele of Aksum, in a measured drawing made by the Deutsche Aksum-Expedition of 1906.

Aksum's economy was strangled by the first Muslim expansions. In contrast, Muslim trade integrated east Africa into the world community of Islam, exposing its architecture to influences from far afield. The court arts of Egypt and Europe received new stimuli as they gained access, through east Africa, to the ivory and rock crystal of the interior. The most important export from east Africa was the gold of Zimbabwe. Kilwa and Great Zimbabwe shared two centuries of prosperity. Despite these ties and a permanent presence of Swahili traders at the royal courts of the interior, virtually no cultural or artistic influences percolated between the two proud, equal, and very different societies.

There were areas of isolation as well as areas of widespread interaction. In the west African forests one can see the most sophisticated arts developing from the eighth century CE, in the hands of skilled craftsmen who were masters of their materials and using techniques at least as complex as any in the rest of the world at the time. Many have speculated on the sources of both their raw materials and expertise. It becomes increasingly apparent that these skills were entirely independent local indigenous flowerings. In ironworking Africa not only invented smelting techniques independent of the outside world but may also have developed major centres of production, trade, and exports: in the Great Lakes region of eastern Africa and in the west African Sudan. Mentions of exports of African iron occur repeatedly in the earliest documents. Once more, one can justifiably assert the powers of African creativity and invention.

In many of the early societies of Africa one is conscious of two facets: the strong indigenous creativity of the societies and their place in a wider world. But contained in this were the seeds of decay. The African states were suppliers of raw materials of considerable value or rarity to the wider world—slaves, gold, and ivory of the highest quality, as well as aromatics, semi-precious jewels, and wild animals or their skins. These states seldom realized the full value of their products and could not control their prices. In return, they were recipients of manufactured luxury goods—textiles, beads, glass, wines, and oils and, later, quantities of Chinese trade ceramics. Many were worthless trinkets. It was the start of a system of unequal exchange that still drains Africa of resources and stultifies the development of her manufactures.

The written evidence

Many parts of Africa have been literate for centuries. Nubia carved its inscriptions in the hieroglyphs and language of Egypt. Later, the local language is preserved in many inscriptions and documents using Nubia's own Meroitic script. This has yet to be fully deciphered. Nevertheless it has given us a full list of the Meroitic rulers and is a potentially rich source of information on other details of Meroitic

society. Royal commemorative standing stones or stelae in Aksum preserve in their inscriptions details of royal achievements. Locally minted coins of Aksum and various mints in east Africa record the names of successive rulers, providing a firm chronological framework for their histories. Several chronicles survive which detail the histories of east African coastal towns and dynasties. The earliest, the *Kilwa Chronicle*, was written at least as far back as the sixteenth century, when it was incorporated in a Portuguese history.[2]

Many outsiders gave their descriptions and opinions on many different African societies. In the fifth century BCE Herodotus reached as far south as Aswan and there heard about 'the Ethiopians'—under which name he included Nubians. He wrote both of the Kushite kingdom and its mother city of Meroe. Compiled in Alexandria in the first century CE, the *Periplus of the Erythraean Sea* is a guide to the ports and markets along the Red Sea and Indian Ocean coasts of Africa. Pliny the Elder described Adulis, the port of Aksum, at about the same time. He was followed with further detail by the *Geography* of Claudius Ptolemy, also written in Alexandria, the later versions of which include fourth-century CE material, and by Cosmas Indicopleustes writing in the sixth century.

Many Muslim geographers were tireless travellers and writers. From them we have useful descriptions of the caravan routes across the Sahara Desert and of the trading cities and states of the region. Some go back to the tenth century and there are even brief mentions of the region up to two centuries earlier than this. One of the most famous travellers, Muhammed ibn Abdulla ibn Battuta, was born in Tangier but travelled as far as China. His travels included lengthy stays in west Africa, Mogadishu, and Kilwa.

The Portuguese navigator Vasco da Gama described Kilwa and other east African towns during the voyage that opened the Indian Ocean to the Portuguese in 1498. There are many volumes of published records of Portuguese activities in the interior from then on. Many focus on the Mutapa state, the most powerful successor state to Great Zimbabwe and its tributaries. Historians included Joao de Barros, writing in 1552—who reproduced a description of the ruins of Great Zimbabwe—and Joao dos Santos who spent some years at the Mutapa court in the 1590s and left a particularly detailed account of it.[3] There were many others. The priest Francisco Alvares stayed some years in the court of Ethiopia and gave detailed and accurate descriptions of Aksum and Lalibela as they were in the 1520s.[4]

All these written works have to be approached circumspectly. They contain vivid nuggets of convincing information mixed with fantasies. None of the writers were modern historians or anthropologists aiming at dispassionate accuracy with evidence to back it. All had their own interests and prejudices and often a strong desire to astonish their

readers. Hence a focus on the curious and irrational and many lapses into myth. Many early histories are collages of other people's work, including some that was decades out of date or derived from other regions. The same stories can be used and re-used unacknowledged down the years so that repetition gains for them a spurious authenticity. Many descriptions were written years after the author experienced his adventures and when his memory was dim and muddled. Distances, sizes, and numbers—be they of populations or missionary converts—can be particularly inaccurate.

Examples of the dangers of the documents are abundant. An Aksumite stele recording victories of Negus Ezana is usually taken to commemorate an invasion of Meroe and is indeed the only evidence for this event, one that is generally credited with ending the Kushite state. It now looks as if the stele may only preserve details of a much more local Ethiopian campaign. The lost metropolis of Rhapta, described in the *Periplus of the Erythraean Sea*, has long been sought in southern Tanzania; it now seems it most probably lay in northern Kenya. Later insertions into the *Periplus* have garbled distances and the sequence of ports. Parts of both ibn Battuta's and da Gama's descriptions of Kilwa simply do not fit with unarguable archaeological evidence.

Foreign attitudes to the African past

Foreign interest in the remote African past took on a new and different impetus in the late eighteenth and nineteenth centuries. It was the product of increasing European exploration, penetration, and eventually colonization. It was this Europe that presented the African past to the world. The authors all believed that Europe represented the peak of the evolutionary ladder, of human ingenuity, of intellectual and moral refinement, of culture and civilization. In comparison, Africa was and always had been barbarous and inferior. Such prejudice coloured, both obviously and subtly, all European interpretations of the African past. Its distortions are still so pervasive that they have yet to be fully recognized in all their ramifications. They stand as a warning of how all interpretations of culture, aesthetics, and history are subjective and contingent. Every claim to present 'facts' 'objectively' and with 'scientific accuracy' must be viewed with considerable scepticism.

Africa was perhaps the main arena where debates on human evolution were fought out in the late nineteenth and twentieth centuries. The widely admired South African statesman and polymath Jan Christiaan Smuts characterized the San hunter-gatherers of his homeland, heirs of the artists whose paintings are so much admired, as occupying 'the lowest scale in human existence . . . dwarfed and

shrivelled and mentally stunted . . . a mere human fossil . . . there is nothing left for him but to disappear'.[5] This stereotype could on occasion be turned to advantage. The influential critic and art historian Roger Fry first presented southern African rock art to a European audience in 1910 by predicating its artistic value on the 'innocent eye'. The San artists were the 'lowest of savages'. This endowed them with a preternatural perfection of vision because the 'retinal image passed into . . . a picture with scarcely any intervening mental process'.[6]

Racial stereotyping often meant that an alien origin was sought for any art that seemed worthy of admiration. Africa has been denied any credit for the monuments on its soil so often that it can only be the product of racial prejudice. Leo Frobenius, the ethnologist and archaeologist who explored many different parts of Africa between 1900 and 1935, divided southern African rock paintings into two classes: shamanic San or Bushman paintings, and intellectual, 'classic' paintings. He derived the latter from the ancient civilizations of south-western Asia, Egypt, and Crete.[7] Abbé Henri Breuil, the most respected prehistorian in Europe for the first half of the twentieth century, followed Frobenius closely, though he never acknowledged this in print. He too proposed that the finest paintings—distinct from 'the hideous little Bushman figures'— were the work of foreigners of the remote past. They were perhaps even the seeds from which Egyptian and Minoan art grew.[8]

The denigration of African artists and craftsmen and the invention of foreign origins for its greatest achievements is certainly not limited to San art. Nubian art is still widely seen as a provincial Egyptian product. Much of the early Aksumite artistic achievement is credited to south Arabian states. Frobenius, who revealed the work to the world, saw the sculpture of Ife as evidence of ancient Greek colonists in Africa, even of the existence of Atlantis [5, 67]. East African coastal history is still dominated by disputes about the Swahili builders: whether they are an essentially indigenous Bantu-speaking people or the mixed-blood descendants of Islamic colonizers.

Colonial archaeology

Archaeology has to be our main source of information on the societies of which every early artistic tradition is an expression. We therefore have to pay very close attention to its theory, methods, and practitioners. We must make close and critical assessments of all the material we use. Until the 1960s and beyond, almost all the archaeologists of Africa were part of the colonial settler world. Brought up and trained overseas, thereafter they worked in isolation. They were frequently obsessive and assertive. They were 'prima donnas' not 'team players'. Their funding was universally sparse and

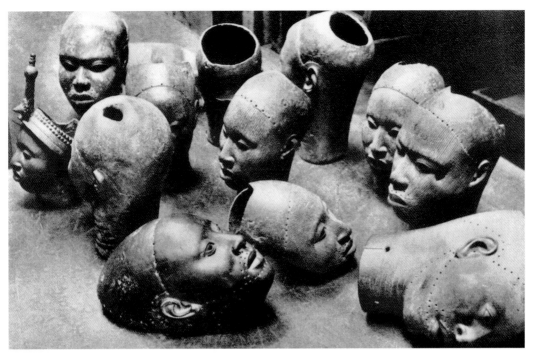

5

The cast brass heads discovered in the Wunmonijie Compound near the royal palace of Ife in 1938 and photographed soon after their discovery.

problematic. It was compensated by their extraordinary enthusiasm, energy, and determination. Their field was virgin. Much of their most valuable work was a response to chance finds of unexpected richness. Hitherto unknown periods and 'cultures' were defined by detailed stratigraphic and typological analyses of stone tools and pottery. Much work was devoted to establishing some sort of secure basic chronology, later aided by the introduction of radiocarbon dating.[9]

Much excavation up to this time was rescue work. Though the technical standards could be exemplary, as at Igbo-Ukwu, rescue work is not part of a planned research project; rescued sites often stand in isolation, and we know little of their wider context. The same can be said of work done at other southern Nigerian sites in Ife and at Owo in the 1970s. It even applies to the huge international projects on Nile lands in the Sudan prior to their flooding by Lake Nasser.

Much of the work at Kilwa and Husuni Kubwa on the Tanzanian coast was aimed at clearance and conservation—to make them presentable and comprehensible to visitors [6]. The value of the research at Manda off the Kenya coast and at Aksum in the 1970s was dissipated by a lack of clarity over the aims of excavation. Much seems to have been unplanned and opportunistic. A lot of important research work in Africa has never been published. This can perhaps be partly excused for sites where the material was in disturbed and secondary deposits and the main object of the excavations was to recover and conserve this material in museums: this is true of excavations at Ife and in the Nok area of Nigeria up to the first half of the 1950s. There can be

no excuse for the failure to publish fully excavations at Aksum or Ife in the late 1950s or Great Zimbabwe in the 1970s. Information withheld is information lost.

Advances in archaeology

In the northern world, the nature of archaeology changed almost totally in the later 1960s. The profession reached maturity. Archaeologists outside Africa became self-conscious and questioning, much more aware of the theoretical and methodological underpinnings of their discipline. Research programmes were now developed with considerable care and precision, designed to investigate and test equally well-formulated hypotheses. Research became 'problem-oriented'. Fieldwork, excavation, and analysis became much more extensive and thorough, undertaken by teams of specialists. There was a demand for survey work on a large scale. High-technology sensing equipment and field computers for recording and analysis became common. Very little—if any—of this impinged on African archaeology.

There were exceptions. The carefully planned work of Mark Horton at Shanga in northern Kenya in the 1980s demonstrated the rewards of clearly defined aims. The work of Roderick and Susan McIntosh at Jenne-Jeno on the inland delta of the Niger River is a further example of a well-planned and rigorously pursued research programme that has transformed our knowledge of this area.

Archaeology in independent Africa

It seems strange how in the last forty years so few significant contributions to African archaeology have come from African archaeologists. Their promise of fresh perceptions, insights, and understanding is largely unrealized. We must ask why. One response might be that archaeology is discredited in Africa because colonial studies of the past were manipulated in the service of political ends. There is perhaps just sufficient evidence for such accusations to stick. Towards the end of a career covering nearly thirty years in the Sudan, the Commissioner for Archaeology and Anthropology advised that 'the main justification for archaeological research in Africa in these difficult days' was to give 'a sense of proportion and balance' to 'the politically minded African with the mental instability of adolescence'.[10]

There are other more pressing reasons for the neglect of studies of the remote past. Almost every African economy has been under severe strain for many years. In every country there are also stresses from population increases, environmental degradation, infrastructural decay, unemployment, and poverty. Few countries have adequate budgets for health or education. In these circumstances, funds for historical

research, museums, or galleries are inevitably and rightly severely restricted and in many cases virtually non-existent.

This does not mean that there has been a lack of archaeologists. Everywhere their numbers have probably increased tenfold or more since African countries achieved their independence. Many are highly trained with postgraduate qualifications from universities in Europe and the United States of America. Despite their increased numbers, African archaeologists are still scattered. An essential element needed for real advancement of the subject, a 'critical mass' of peers able to explore and review, comment on each others' progress, and suggest further lines of enquiry, is everywhere lacking. Many are thrust into senior administrative posts straight from university. Many others have impossible and unaccustomed teaching and curatorial burdens. Many of the best abandon their profession with its low public-service salaries for greater opportunities and rewards in private enterprises.[11]

Anthropology and art history

There is a tendency in archaeology to privilege the 'material fact' and to emphasize 'objectivity' and 'scientific proof'. Archaeologists tend to decry art-historical analyses as subjective, unprovable, and therefore irrelevant: doomed attempts to penetrate the uncharted territory of the human mind. Certainly they are also unwilling to accept that formal or iconographic analysis can be as rigorous, firm, and revealing as results drawn from their own modes of investigation. Only in Nubia have art historians taken their rightful place as important contributors to the understanding of a remote past.

The understanding and appreciation of the later arts of west and central Africa have been transformed in recent years by combining anthropological and art-historical approaches. This is particularly true of work done by researchers from the United States of America. Objects have been figuratively removed from their museum showcases. They are no longer no more than objects of formal aesthetic analyses that are the invented and imposed constructs of foreign connoisseurs. They have been resurrected and restored—figuratively again—to the societies that created them. Now they are appreciated as essential elements of shrines, as insignia of royalty, as the foci of ceremonies, celebrations, and dances, as agents and channels of power, as symbols of identity, as expressions of values and beliefs. The essential roles that anthropologists must play in such studies is obvious.

It is less apparent how all this can be applied to the early art of Africa. The length of time separating early cultures from contemporary society seems too great. Culture is not static. On the other hand, we have already emphasized the continuity of the culture of so many African societies over such long periods. David Lewis-Williams has

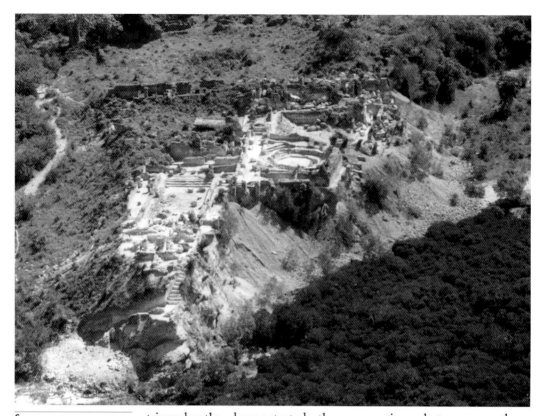

6

An aerial view taken in 1961 of the partially excavated fourteenth-century Swahili palace of Husuni Kubwa, on a sandstone promontory outside the great trading city of Kilwa, on the southern coast of Tanzania.

triumphantly demonstrated the connections between southern African rock paintings and a universal San belief system. He showed how San beliefs were the keys to understanding the art. Now not just the late nineteenth-century collections of southern San folklore but many fine more recent studies of northern San groups by anthropologists and others, such as Richard Lee and Richard Katz, have provided a wealth of new insights into the art. With such encouragement, one can now see, for example, how David Lan's study of the Shona reveals deep-rooted readings of landscape. These may be seen as the source of the architectural forms of the historic zimbabwes. John Middleton, more than other anthropologists, has emphasized how culture and history formed the Swahili. James de Vere Allen's research interprets the historic architecture of the east African coast through Swahili culture. Further, this architecture can now be seen as a formative and defining influence on the culture. Rowland Abiodun's insights into Yoruba values and aesthetics can be used to reveal much about the art of ancient Ife. His work is particularly important because he is himself a Yoruba. The potential African contribution to the art history of Africa has been ignored for far too long. Indigenous African views of the African past have yet to be fully developed and utilized. Until they are, the full contexts, significance, or meaning of its ancient art and monuments will not be comprehended. These approaches are still in

their infancy. This volume can only make tentative explorations of what is a new field.

A case study: interpreting Great Zimbabwe

The ways that interpretations of the African past have been determined by the ideological views that are currently dominant cannot be illustrated better than by examining successive explanations of Great Zimbabwe.[12]

1. For the first European colonists, and especially for their sponsor, financier, and propagandist Cecil John Rhodes, Great Zimbabwe epitomized the promise of the golden riches of an ancient land and the success awaiting its new exploiters. Rhodes himself drew the parallels between Phoenicia, from where he believed its first colonizers had come, and Britain: both were tiny countries on the edge of continents and hence both nurtured the most intrepid seafarers and determined traders the world had seen. He paid for and found support from the first archaeologist to investigate the site. Pictures of Great Zimbabwe soon embellished the share certificates of mining companies.
2. The archaeologist who in 1929 proved conclusively that Great Zimbabwe was an entirely indigenous African creation was also content to dismiss its architecture as the 'product of an infantile mind' and of a divided society where the builders were the slaves of the occupiers.[13]
3. Her successors in the 1950s periodized Great Zimbabwe's history but were not able to accept that the developments that defined their periods could have been generated internally. All change could only

7
An engraving of the conical tower at Great Zimbabwe published by J. Theodore Bent. He was the first person to attempt to establish the origins of the ruins through archaeological work, sponsored by the Royal Geographical Society, The British Association for the Advancement of Science, and the British South Africa Co. in 1891, only nine months after the British occupation of the country. He concluded it was Semitic, 'built by a Northern race'.

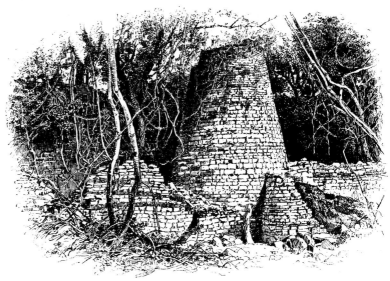

be the result of external forces, usually invasions by different tribes, each generally accompanied by violence and destruction.[14] This was only a reflection of the then common view of African history, notoriously described as 'the unrewarding gyrations of barbarous tribes'.[15]

4. The racist rebellion in Rhodesia in 1965 stimulated a considerable literature—none of it by archaeologists—based on racist assumptions about irredeemable black incompetence on a scale that ensured Rhodesia would always have to be subject to rule by some master race.[16] The rebels not only denied that Great Zimbabwe was African, they promoted the ruins as concrete proof of the ancient presence of previous exotic overlords and threatened and censored professional archaeologists who opposed this.

5. As limited African competence was grudgingly accepted by Rhodesians, it was held that African states could only survive with foreign capital and trade, as neo-colonial states. At the same time Great Zimbabwe was presented as the product of long-distance international trade.[17]

6. A contrary view emphasized the control and management of cattle as the primary means of generating wealth and controlling people.[18] It implied a critical view of the benefits of globalization.

7. When the South African government created Bantustans to further its policy of apartheid, propagandists for the policy presented the traditional African ways of life as admirable and worth protecting but so exotic and irrational that they were incomprehensible to and unassimilable by outsiders. A flavour of this can be sensed in a concurrent interpretation of Great Zimbabwe. Against all common sense, the vast labour and skills used in the construction of the main building were said to have served solely to provide a rarely used initiation centre. Design, layout, and decoration were seen as coded messages about such things as fertility, procreation, and respect for the elderly.[19] It has been rejected with considerable force by all knowledgeable anthropologists, archaeologists, and indigenous Zimbabweans familiar with their traditions and history.

8. Zimbabwe's independence in 1980 ushered in a short period of general euphoria. The first black Director of Museums rapidly published a book denouncing all archaeological studies as imperialist. He presented Great Zimbabwe as the epitome of 'Merrie Africa', the entire populace in a continuous state of revelry and the prosperity of the state determined by the size of the ruler's genitals.[20]

9. The new government paid lip-service to 'Marxism-Leninism' for a brief period and there were a few tentative attempts to portray Great Zimbabwe as the product of the cooperative enterprise of an 'African socialism'.

10. Finally, now that the country is characterized by the accumulation of great wealth in the hands of a small elite, the country's senior

archaeologist proposes that the period to which Great Zimbabwe belongs can only be understood as the consequence of 'a decisive . . . ideological change . . . a shift in the system . . . in which the material accumulation of goods by individuals is encouraged.'[21]

11. In this book, I suggest that the architecture of Great Zimbabwe has a symbolic content expressing and validating the nature of the ruler's relationship to the land he rules. This can be seen as a reflection of current concerns in Zimbabwe over the ownership of land.

This is a salutary warning to every reader to approach all interpretations of the African past with extreme caution and every critical faculty at the ready.

Destruction of monuments

Many monuments in Africa are at risk. An appalling number have been destroyed in recent years. Throughout Africa caves and rock shelters containing rock paintings are particularly fragile and susceptible to damage. The more widely they are known the more they are at risk. Publicity may encourage tourists and they may generate incomes for the locality. Tourist development imposed on an area without adequate consultation or support from the local population is particularly unpopular.[22] Many people living near paintings resent strangers who intrude into their privacy. They may deface paintings in protest or destroy them as the cause of intrusion. Picnickers light fires near paintings, causing devastating exfoliation of the rock surfaces. Photographers spray paintings with every sort of liquid to enhance momentarily their clarity at the expense of helping to form a permanently opaque film over them. Vandals are ever eager to perpetuate their names by scrawling them over any admired object. Some missionaries encourage the defacement of paintings as pagan images. Some traditional healers remove painting pigment for use as medicine. Physical or custodial protection are seldom adequate solutions to these threats if only because of the sheer number of sites.

The best known example of the pillage of important monuments is the removal to Rome in 1938 of one of the largest carved stelae of Aksum by Italian troops after their occupation of Ethiopia. For over sixty years it has stood in the centre of the city as an unintended monument to the barbarity of Fascism.

The damage to ancient Swahili towns, mosques, and monuments along the Kenya coast has been particularly extensive.[23] This is in part the unintended consequence of those who misinterpret them as an alien introduction of colonists from outside Africa. This myth is included in textbooks and taught in schools. It led to the conclusion that these monuments were irrelevant to Kenya and its history and hence did not

merit preservation. National land containing monuments has been sold off to private developers. Tourist hotels and restaurants are set in historic sites. Ancient stone buildings are demolished and their foundations robbed for building materials. Local inhabitants claim with some legitimacy that ancient sites are theirs but then go on to insist that they may do with them what they will. Ten to fifteen per cent of an entire historic island town, Takwa, has been destroyed in the process of oil exploration and the accompanying road building. The poverty of the institutions responsible for protecting Swahili monuments can often have unintended but disastrous effects. Important stone ruins at Songo Mnara, an island off southern Tanzania, have been reduced by deliberate burning to mounds of lime.[24] Their custodians claim they cannot afford to keep them clear of undergrowth any other way. The problems are universal. A favourite building material, especially for cattle-dipping tanks, are the dressed granite blocks used originally in constructing the ancient royal residences of Zimbabwe. Several have been damaged or nearly entirely destroyed through this.

Looting

Portable art works in Africa are at even greater risk than monuments. There is an insatiable demand for them from apparently reputable collectors outside Africa and even from prestigious museums. They can be easily stolen or looted, smuggled out of the countries, and sold for enormous profits on the international art market.[25] The trade in the centuries-old pottery sculpture of Mali provides the best example.[26] Many villagers, even entire villages, depend on illicit digging for antique sculptures for their livelihoods. Innumerable ancillary objects are broken or thrown away as unsaleable. Villagers sell pottery sculptures for a pound or two to the agents of European and American dealers who can find sales at prices in excess of £100,000 for each piece. The most controversial of all collections of Malian pottery sculptures, that of Count Baudoin de Grunne, is said to have been sold to the Fondation Dapper in Paris for a price in excess of £6,000,000. It is never displayed and is almost inaccessible to scholars.[27]

As the Malian trade became more difficult, there was a vast increase in the looting and export of sculptures from the Nok area of central Nigeria [61].[28] These include otherwise unknown examples of complete figures up to 1.5 m high, and beautifully preserved sculptures of the highest aesthetic quality whose freshness suggests that they were more probably removed from their original, primary contexts than recovered from alluvial gravel like almost all other examples. Several have appeared proudly in major exhibition catalogues and museums. The most elaborate of the ritual pots from the tenth-century grave goods of Igbo-Ukwu was recognized by chance in the gallery of a

Belgian dealer [**81**].[29] It had not even been reported stolen from its Nigerian repository. In 1995 cemeteries with rich and intact grave goods of a hitherto unknown culture (subsequently dated to the eighth and ninth centuries CE) were recognized in a road cutting by Nigeria's leading archaeologist, Ekpo Eyo.[30] He managed only two days' rescue work on the sites. When he returned a year later they were almost entirely destroyed by looters. Pottery sculptures from the Calabar sites have already been recognized in leading New York galleries [**62**].

Many Ife brass and pottery sculptures, including some of the life-size brass heads that are of such rarity and importance, have been stolen from three different Nigerian museums. In many of these cases it has been alleged that senior museum officials responsible for objects in their care have been deeply implicated in their thefts.[31] The majority of sculptures from Obalara's Land in Ife have also been stolen [**72–77**]. Richly sculpted brass rings, earth still adhering to them and clearly related to Ife work, suddenly appeared in auction rooms and subsequently in leading museums in Europe and the United States in the 1970s [**79**]. These rings are our only indication that another very rich and unknown site or sites had clearly been pillaged and all information about them lost.

Art works inexpertly removed from their original contexts without any observations or records of what these may have been are reduced to objects without a past. The object loses its social context, associations, and significance. It no longer has a history.

Is there anything to alleviate this gloom? Not much. Many ancient monuments in Africa have been declared World Heritage Sites by Unesco. This gives them a high profile and enhances their tourist potential. It does not ensure their protection or conservation, nor does it assist in funding further research on them. These remain the responsibilities of national authorities. In 1970 Unesco approved a convention that outlawed illicit export and trafficking in cultural property. It has not been ratified by many countries in Africa or by those countries most involved in such trafficking. It has not curtailed illegal markets. Recognizing that trade in ancient Malian art works had reached crisis point, in 1993 the United States of America passed emergency restrictions prohibiting the import of all such works into the country. This was an unusual victory even if the ban applied only to Malian work and had a life of only five years.[32] It left bigger markets, more dishonest dealers, and more amoral collectors unaffected. Equally distressing is the fact that some of the most famous museums in the United States and Europe continue to accept donations of, buy, and display ancient African art that cannot possibly have left its country of origin legally. They claim there is no documentary proof of any wrongdoing and that no law of their countries has been broken. Museums around the world have proved willing to follow their example.[33]

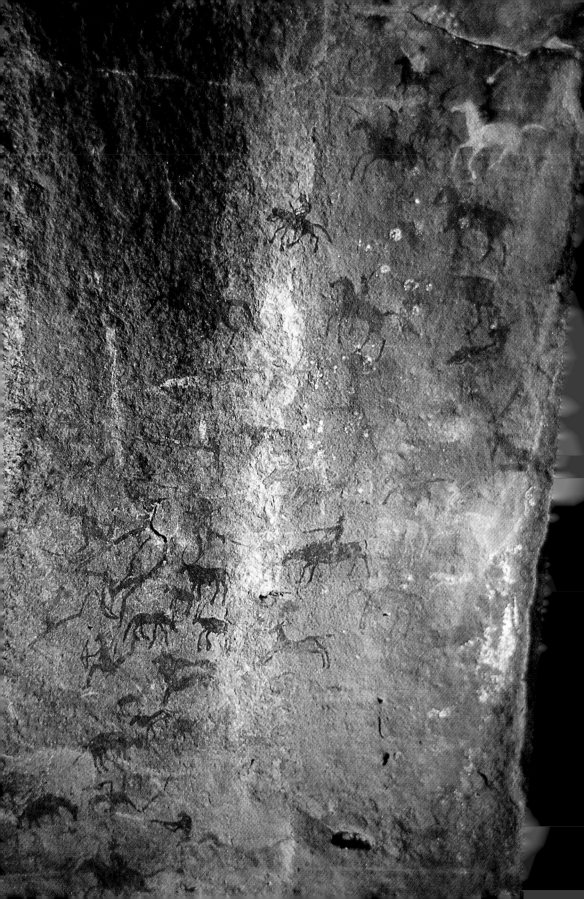

Rock Art of Southern Africa

2

The environment

The topography of southern Africa consists in essence of a high interior plateau bounded by a steep scarp that falls to a coastal plain [**Map 2**]. The high gently rolling and once well-wooded and well-watered plains of the Zimbabwean plateau are broken by numerous granite hills: some of them huge smooth whale-backs hollowed by large smooth-faced domed caves, others tumbled masses of boulders. A great many of both these forms bear paintings. Further south the sandstone Maluti mountains of Lesotho are also extremely rich in paintings.[1] The high mountains and painted shelters spread into the eastern Cape Province and eastern Free State and reach their climax in the Drakensberg [**10**].[2] The coastal belt of the Western Cape Province of South Africa is bounded by a series of low mountain ranges of a hard coarse quartzite, the location of many small panels of paintings.

Inland from the Atlantic coast, the scarp separating the coastal Namib Desert, one of the most arid regions of Africa, from the dry steppe-lands of the interior is punctuated by the great granite massif of the Brandberg, rising 2,000 m above the plain. It has its own micro-climate with good shelter and enough rain to provide near-permanent

8

What must be one of the last paintings of a long artistic tradition shows uniformed and mounted British soldiers, who can be dated to about 1830, attacking a San band. The genocide of the San was already under way.

9

The rock engravings of southern Africa are perhaps less appealing to us than the paintings. Their distributions, materials, and methods are also distinct. These differences are largely a measure of geology and topography. The preoccupations, metaphors, and symbols of the artists of both seem to have been much the same.

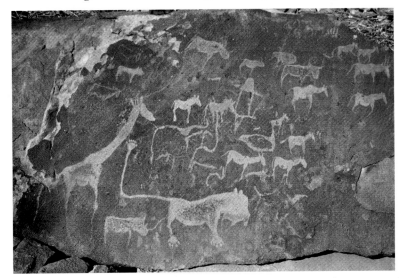

water and support a varied population of small game. Here and in smaller massifs nearby there are great numbers of painted sites, which are also among the best recorded and published.[3]

Throughout the drier and much less mountainous interior—in the Northern Cape Karroo, in the south-west of the Northern Province, in the valleys of the middle Vaal and Orange Rivers, and in the western Free State—there are rock engravings on ancient glaciated and striated rock pavements. There are also isolated examples in Botswana and Zimbabwe and a notable concentration at Twyfelfontein not far from the Brandberg in Namibia [9].[4] The scrub of the Karroo merges into the dry sand country of the Kalahari Desert of Botswana, eastern Namibia, and southern Angola. These are the last refuges of the remnants of San or Bushmen hunter-gatherer communities.

Until the mass slaughters of the nineteenth century, the savanna, woodland, and even the semi-desert areas of southern Africa supported one of the largest, densest, and most varied animal populations from the start of human history. It is now almost impossible to envisage their descriptions of herds of elephant and buffalo in dense masses stretching for mile upon mile of river bank, of herds of springbok

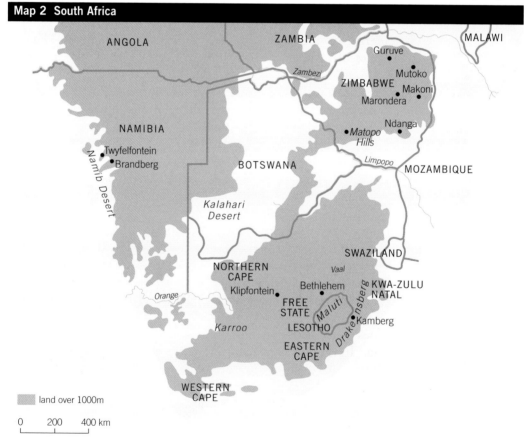

Map 2 South Africa

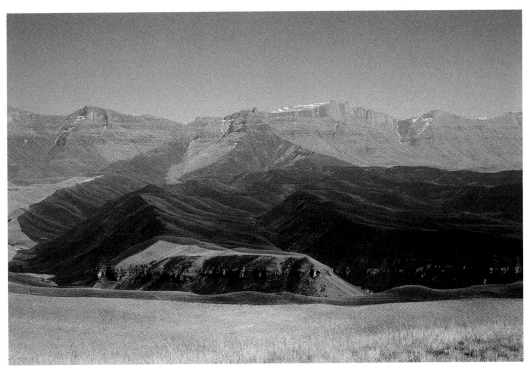

10

The mountains demarcating the inland plateau of southern Africa reach their climax in the Drakensberg of Kwa-Zulu Natal. Numerous shelters have been weathered out of the narrow horizontal band of 'Cave Sandstone' at the foot of the high scarp (foreground). They contain some of the most beautiful and most intensively and rewardingly studied paintings of Africa.

covering open plains to the far horizons, or of the many different species of large game—antelope of many different species, zebra, giraffe, wildebeest, and ostrich—that could be recognized with a single sweep of an eye. These were, in their turn, the food of many species of predators and scavengers. All were the subjects of prehistoric artists.

Dating

There has been no direct dating of any pigment or painting of the sub-continent. Dating evidence derives from dated archaeological deposits that contain rock spalls bearing fragments of paintings. The earliest painted fragments so far found are seven painted slabs, some with recognizable images, from a cave in southern Namibia. They were in the topmost levels of a Middle Stone Age deposit dated to between 26500 ± 450 BCE and 24300 ± 450 BCE. There has been much discussion about whether the spalls should rather be associated with the overlying Later Stone Age deposit, dated to approximately 16500–17750 BCE. The consensus now appears to be that the association with the earlier deposit is valid.[5] In the largest painted cave in the Brandberg, a fragment of a painting, that could be fitted back into its exfoliation scar, came from a Later Stone Age deposit, dated to 810 ± 50 BCE. Other spalls and three further dates supported this dating.[6] Large numbers of tiny painted spalls have been found in several Later Stone Age cave deposits in the Matopo Hills, dating from 11000 BCE onwards.[7]

Dating by subject

The subjects of some paintings are valuable indicators of date. Paintings in Zimbabwe and the Cape depict sheep being herded. The earliest firm archaeological evidence for such pastoralism goes back a little over 2,000 years. No paintings in Zimbabwe show cattle, which were introduced a little less than 2,000 years ago, with large herds accumulated almost everywhere by 1,000 years ago. Paintings in the Western Cape, whose coarse brush-strokes and bright colours place them at the end of the artistic tradition there, show figures in European dress, wagons, and at least one full-rigged sailing ship. In the Drakensberg there are not only paintings of fights over herds of cattle but some showing uniformed soldiers with powder horns and firearms, who can only have been observed in the mid-nineteenth century [8].

11

The British Association for the Advancement of Science met in Johannesburg in 1929 and stimulated an upsurge in archaeological research with Abbé Breuil, Miles Burkitt, Leo Frobenius, and Gertrude Caton-Thompson all separately investigating the rock paintings and stone buildings of southern Africa. Here Maria Weyersburg of the Frobenius Expedition copies paintings in the cave of Silozwane in the Matopo Hills, Zimbabwe.

Concentrations of painted spalls and fragments of ochre are interpreted as marking two periods of intensive painting activity, between 7800 and 5600 BCE and between 200 BCE and 500 CE. In the Collingham Shelter in the Drakensberg area, the exfoliation of a slab bearing a painting of a human stick figure is dated to about 150 CE.[8] The shelter roof, bearing paintings characteristic of the most technically complex and sophisticated of all the Drakensberg art, collapsed about 1300 CE. All these dates from archaeological deposits only indicate when painted spalls were incorporated into the deposits. They therefore provide only uppermost limits for the dates of the paintings themselves.

Dating evidence for the rock engravings shows them to be contemporary with the paintings. A slab bearing a fine line engraving of part of an animal was found in deposits in the Wonderwerk Cave in the Northern Cape Province, dated to 8200 BCE. Later deposits in the same cave, dated to between 3200 and 2000 BCE, contained slabs engraved with geometric patterns by the same technique. Cation-ratio dates, calibrated from measuring the leaching of trace elements in the patina formed over engravings, from Klipfontein in the Northern Cape, fall into the same dating spectrum.[9] Engravings in different techniques and 'styles' are shown to be contemporary with each other and to date from 6400 BCE to 800 CE, with the earliest representational engravings going back a further 1,600 years and geometric designs continuing into very recent times.

Celebrating the art

Roger Fry established an approach to the southern African rock paintings that was to be dominant for over 60 years.[10] The disciples of Fry, of whom there are still many, have emphasized the apparent naturalism of almost every painting. This enabled anyone to identify the creatures depicted in each image and to join the artists in a celebration of the beauty and variety of African wildlife. Here was art without the

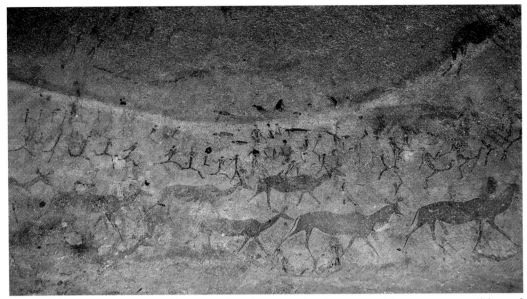

12

At one side of a large granite cave, a quartz vein has been partly weathered away to create a deep crack. The vein had been extended across much of the face of the cave by a long line of predominantly white paint. This has become the field for long lines of antelope, people, and mythical creatures. In form, the white line resembles some human emanations or some semi-reptilian 'snakes'. Lines of elongated running kudus and hunters follow the line.

impediments of style or stylization, art at its most accessible and universal. Appreciation of it demanded no prior knowledge or expert intervention. It could be shared and understood by anyone of any period and any culture. If interpretation was possible or needed—and it probably was not—it rested on highly romanticized and Eurocentric notions of 'art for art's sake' and of artists as people with such highly developed creative talents that they could break all social bonds and conventions with impunity and become 'free beings'. With the artists standing outside their societies, there was no need to study a society to understand its art.

Analysing the art

The rock surface

The rock surfaces exposed in the different regions differ considerably in texture, areas suitable for painting, and the spaces that their weathering creates. Examples of artists' responses to particular surface features exist. A particularly persuasive example is shown in **12**. I suspect that examples of such regard for natural form are exceptions rather than widespread. More common are images that completely ignore the natural background and, for instance, extend from dark original surfaces across fresh-looking exfoliation scars, with no regard for the contrast.

Earlier paintings provide the main field for later paintings. Many painted sites are a dense palimpsest of superimposed images: this was a puzzle to scholars because later artists all appeared deliberately to ignore, deface, or destroy the work of their predecessors. Now, the later

paintings can be interpreted as commentaries on the earlier work, seeking to expand and amend the ideas it represents, to give them further definition and precision, to enlarge and enhance the impact of the first work. Thus every panel of paintings had different conceptual concerns. Each was a debate between artists on different aspects of perception and belief in a society where characteristically discussion replaced dogma. Certainly every large cave was given its own visual character, very different to that of any other cave.

The fundamental principles

The prime aim of the art was to construct images that were immediately and readily legible and identifiable to any observer. A range of conventions were developed to achieve this. Multiple viewpoints were used to create a single image. An animal's body, head, and legs were viewed from the side; cleft hooves, ears, and some horns were shown from the front. A warthog's tusks were depicted from the top, a crocodile's belly from the bottom. In a human figure, the body seen from the side allowed expressive force to be given to the curves of spine, buttocks, thighs, and calves. A person's shoulders were shown from the front to separate the two arms. Heads were always shown in profile and without features save to separate the curved dome of the head from the highly simplified protruding face. Details normally concealed within the outline of the body were transposed to break the body outline.

The paintings are aggregates of readily identifiable elements put together using a system of conventions both rigid and easily manipulated. Consequently it took a minimum of skill to reproduce the standardized imagery. It was probably harder to master the preparation of pigments and paint and the application of paint to the rock surfaces.

The numbers of sites

It is difficult to estimate how abundant paintings are. Statistics drawn from most surveys are misleading. Outside South Africa and the Brandberg, surveys list only a small fraction of the extant sites. A few hours of systematic exploratory work in many regions will still reveal numbers of hitherto unrecorded sites. Certainly each region has many hundreds and, in some instances like Zimbabwe, many thousands of sites. Sites vary considerably in size and significance. The largest sites, all well sheltered but open to daylight, frequently have evidence of human occupation stretching back many tens of thousands of years. Some, however, have steeply sloping rock floors strewn with fallen boulders and show no sign of any sustained occupation. The smaller sites, on exposed boulders or under shallow overhangs, offer little shelter or evidence of occupation. Nothing has been recognized within any deposits to suggest any specialized usage of any sites with paintings. It is therefore at present inappropriate to isolate particular sites as ceremonial or ritual sites. Painting is better seen as an integral part of ordinary daily life.

Small, simple, even rudimentary images with uneven outlines and brush-strokes, yet following all the conventions of the art and generally located round the lower edges of painted panels, show that artists with very different degrees of skill, including perhaps children, contributed to even the largest and most complex panels and that painting was not the prerogative of the skilled.

The selection of subjects

The rock paintings are the work of Later Stone Age San hunter-gatherer societies. Their life provided the vocabulary of all the imagery. Paintings, used circumspectly, are thus valuable records of prehistoric clothing, equipment, weaponry, hunting and gathering techniques, food and its preparation, the different dances of men and women, family and group sizes, and much more. They are not always in full agreement with ethnographic or archaeological evidence: paintings in Zimbabwe illustrate single large stone arrowheads being bound to the shaft with twine or sinew—considered characteristic of the Middle Stone Age—rather than the multiple little stone barbs set in mastic, usually associated with the Later Stone Age. Such discrepancies have yet to be addressed.

With few exceptions, the human subject matter and its treatment were carefully selected. Almost all figures are without blemish or

13

The conventions of representation were broken only in a few exceptional Drakensberg paintings. Here eland are shown in different postures, in foreshortened perspective and partly obscured by the partial overlapping of images: all developments in representation not found anywhere else.

individuality and timeless, always in the prime of life. I have never seen paintings of disease and disfigurement; death or burial are never illustrated—nor is childbirth, and few show suckling and caring for babies. The poses, equipment, and weapons are those that were perceived to define the most significant social roles: as hunter, father, mother, provider, or protector. Bands of hunters are painted in great numbers, yet only in special circumstances (which will be discussed later) is an animal actually encountered and killed. Seldom if ever is one shown tracked, defending itself, escaping, trapped, butchered, cooked, or eaten. Although they provided most of the food for everyone, parties of female foragers are shown far less often than hunters, and again they are never to my knowledge shown actually engaged in digging and collecting.

Paintings of animals were equally selective in their subjects. In different regions artists concentrated on different animals. In northeastern Zimbabwe the focus was the kudu antelope; in south-western Zimbabwe it was the giraffe. In the Brandberg the giraffe and oryx were painted most often; in the Drakensberg eland were painted to the almost complete exclusion of any other animals except rhebok. Not only are there far more paintings of the eland but they are larger and painted with great care and love, with softly graded colours to their coats, from many different perspectives and in compositions that suggest large herds [13]. These emphases in part reflect the different environments and fauna of the different regions. In part they also reflect food preferences. Gender was significant: in Zimbabwe paintings of kudu cows far outnumber those of bulls.

The frequency of particular images is not necessarily an indication of importance. In Zimbabwe, the elephant may have carried a much greater weight of symbolism than the kudu although it was depicted much less often. The same is probably true of the rhinoceros, lion, and leopard.

14

Only one animal in Zimbabwe—the zebra—is ever shown bleeding from its nose. This is not a reflection of a natural weakness but a characteristic symptom of people in trance. There are enough of these indicators to demonstrate that the prime significances of not only the zebra but also other animal imagery may have been metaphoric or symbolic. The problems of disentangling successive layers of imagery are well illustrated here.

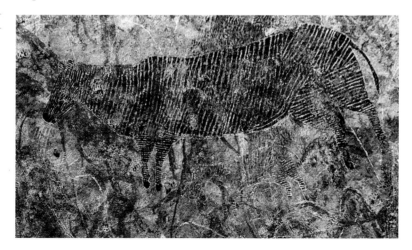

Studying the art

The background

In the 1870s a German linguist, Wilhelm Bleek, collected a considerable body of verbatim Xam San accounts of their beliefs, customs, and folklore.[11] Naturally, he was also interested in the additional evidence of San beliefs provided by rock paintings. The interpretations of paintings gathered by Joseph Orpen from Qing, a Maluti San, were particularly significant. Bleek concluded that 'the fact of Bushman paintings, illustrating Bushman mythology . . . teaches us to look upon [the paintings] as an attempt, however imperfect, at a truly artistic conception of the ideas that most deeply moved the Bushman mind and filled it with religious feelings.'[12]

Over fifty years later a German ethnographer, Leo Frobenius, reached similar conclusions to Bleek though his background, interests, and sympathies were very different. Iconographic analyses led him to believe that much of the art of South Africa could be attributed to the 'shamanistic thinking' of the southern San but that many paintings in Zimbabwe were quite distinct: a 'symbolic art derived not from nature but from symbolical concepts'. 'Concepts of the mind' and 'very advanced speculation' produced 'transliterations of phenomena of the interior life'.[13] Frobenius wrote only in German and was devoted to diffusionist explanations for the art and much else. He conflated evidence from very different prehistoric periods as he sought to understand the Zimbabwean art. His interpretations were readily discredited by most archaeologists and his work almost entirely ignored. This was largely because he was disliked and mistrusted throughout British Africa and plagued by rumours of sharp practice and political interference. Nevertheless his insights now seem far in advance of their time and in large part sustainable.

David Lewis-Williams

Another fifty years later, David Lewis-Williams successfully pioneered a new way of interpreting the art. Like a lot of such work, its strength derived in part from the narrow focus of its author. It was always likely to be seen eventually as oversimplified and incomplete. Equally predictably, the interpretations and their author were vilified by most of the popular writers on the art: Fry's distant descendants. Lewis-Williams responded with uncompromising defences of his 'scientific' methodology. He claimed that his hypotheses were elegant and efficient, unified and comprehensive, and displayed a logical structure with considerable heuristic potential. They could also be reconciled readily with current anthropological research.

Lewis-Williams took Bleek's and Orpen's accounts of the Xam and

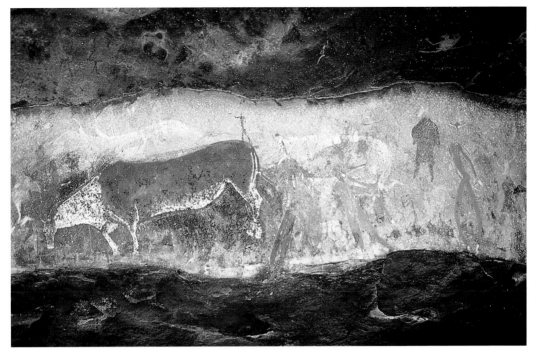

15

An eland staggers, head lowered, representing both its death agony and entry into trance. Composite creatures—therianthropes—behind it have eland hooves and human bodies. They thus also carry many references to trance.

Maluti San and attempted to correlate them with the Drakensberg paintings. When explaining the paintings to Orpen, Qing appeared to be talking primarily about San trancing through a dense array of metaphors. Lewis-Williams found correspondences in the paintings with San beliefs and practices associated with male and female puberty rituals, marriage, rainmaking, divination, but, above all, with many different aspects of trancing or shamanism.[14]

The eland figured large in Drakensberg San painting, myth, and ritual. It is the largest of the African antelope, slow, stately, and easily overpowered, often with such a great weight of highly palatable fat that it seems androgynous: it became the prime symbol of trance and its fat the prime container and agent of trance. Anthropomorphic or 'therianthropic' paintings appeared to confirm San beliefs [**15**]. Many of the San descriptions or metaphors for trance were depicted or could be matched in the paintings: difficulties in breathing, sensations of weightlessness and drowning, tense bodies that made the back ache and the trancer adopt a crouching posture with his arms held stiffly back, the sensation of being stretched out as if on a rack, beliefs that trancers were 'spoilt'—a euphemism for 'dead'. Many seemingly abstract designs and garbled images were taken to be illustrations of the hallucinations or visions experienced by trancers at different levels of trance. Once it appeared that the key to understanding San paintings had been discovered, interpretations within this mode proliferated. But few other researchers attained Lewis-Williams's thoroughness and caution or matched the subtlety of his arguments.

Lewis-Williams then tried to demonstrate that San beliefs and practices could explain the images on 2,000- to 2,500-year-old painted stones found in Later Stone Age graves.[15] They also seemed to explain some of the images in the few published rock paintings of central Tanzania.[16] This all pointed to the existence of a single long-lived and widespread 'pan-San cognitive system'. With this assurance, the detailed anthropological studies of the Kalahari Kung San begun in the 1950s could also be harnessed to help in understanding all prehistoric art in southern Africa and beyond. The validity of this approach was reinforced by the apparent close fit between Kung San beliefs and the Drakensberg art and the ability of the Kung to interpret paintings in the same terms as Lewis-Williams even though they themselves had no tradition of painting.[17]

The association of the paintings with shamanism was Lewis-Williams's triumph. Doubts about his methods and interpretations have now begun to grow among some other able professional researchers. This has brought Lewis-Williams to clarify and redefine his thinking.[18] For him, shamanism 'suffuses and informs the whole structure of San thought'. It can be defined as beliefs in a 'tiered cosmos (realms above and below the level of material life with points of breakthrough between realms)'. Shamans perform 'mediating roles between realms'. They do this while in 'altered states of consciousness' or trance.

The painted images 'comprise symbols (or, more emically, concentrations) of supernatural potency, . . . images of trance dances, . . . "processed" (recollected and formalised) visions, . . . transformed shamans (including the so-called therianthropes), monsters and beings encountered in the spirit world, . . . and "scenic" groups, . . . and complex groupings [that] show the interdigitating of the spirit world with the material world'. 'Key symbols [like the paintings of eland in the Drakensberg] are central in the sense that they lie at the heart of a belief system and, as such, have diverse associations—a semantic spectrum rather than a meaning.' 'The context of a key symbol determines which part of its semantic spectrum is prominent; the remaining segments act as an allusive penumbra that gives the symbol its affective power.'

Lewis-Williams has come to recognize that 'context' includes the surface or field on which a painting is placed. He sees this as a 'veil' between the material and spirit worlds, a veil that the shamans penetrated. The paintings themselves then become a revelation of the spirit world.

The challenges to Lewis-Williams

Pippa Skotnes and Anne Solomon have led reactions to Lewis-Williams. Skotnes, herself a practising artist and a teacher in a

university school of art, insists that the art itself must be reinstated to a position of primacy, that San art cannot be reduced to an epiphenomenon of the trance state. The trance hypothesis is an anthropological argument and reduces the art to ethnographic illustration or cartography. She believes this is compounded by the general use of monochrome tracings to illustrate paintings.[19] The interpretative work of Lewis-Williams and his colleagues tends to be logocentric, to see paintings as visual signs of verbal meanings, a code in which each image has a single literal meaning. Despite their many claims to the contrary, they see the art as illustrative to a degree that denies it its full complexity and ambiguity, its multiple levels of reference and multiple references.[20] Paintings must be recognized as in large part irreducible, outside the realm of words.

Skotnes further emphasizes that art is a conveyor of meaning, that form is a site of meaning, and that analyses of formal devices can release significant content. For Skotnes the meaning of images is largely determined by context and style. Therefore style must be reinstated as a significant and useful conveyor of meaning even if it has been so long discredited because it was defined in such loose, subjective, and general terms.

Skotnes recognizes that we have always to be conscious of the 'otherness' of San art. We are dealing with modes of perception and conceptions of the universe that are entirely outside our own experiences. The ways that San paintings were viewed are alien to us. San art occupies a continuous unframed space. We are forced to move around to grasp the imagery, to use different viewpoints and spaces. Paintings on flat ceilings have no horizontal or vertical axes. Some are centrifugal compositions that may originate in trance experiences. Landscape is not represented but may be registered by the ways that sets of images are stacked to form compositions that occupy space in particular ways. Different configurations of the same images may convey different meanings. The same is true of scale.

Solomon, an archaeologist particularly interested in the theoretical bases for interpreting the art, probes the relationship of art to mind and rejects approaches to painting that present painting as little more than the concrete realization of an idea—or concept or perception—conceived in the mind of the artist. Rather, the idea is mediated, even formulated, in the act of painting. The image mediates and may determine the thought. One must now become more aware of the contexts of the imagery and not interpret it through overarching generalizations and rules. If each interpretation is to take account of context, then each interpretation must be site specific. Art mediated through its multiple contexts will have considerable regional, temporal, and historical diversity. Every site should be recognized as the focus of particular San thoughts, practices, and social life.

San art, like San beliefs and practices, was almost certainly more diverse and changeable in its significances than Lewis-Williams allows. His insistence on a uniformity of belief, practice, and modes of representation is inherently improbable. While considerable strength is added to the trance hypothesis by the ways that many different visual themes can be brought to cohere in a conceptual unity, this may all be a chimera, the result of the methods of analysis.

Solomon seeks to emphasize the connection between the art and the whole of San cosmology. Skotnes and Solomon both emphasize that the San universe, made up of different realms, natural and supernatural, living and dead, was perceived as a single interpenetrating unity. All experience was equally real. So, for example, trance death and physical death may not be distinguished. A ubiquitous aspect of San cosmology, neglected by Lewis-Williams and his colleagues, are the beliefs in two stages of creation. In the first, animals were 'people of the early race' and undifferentiated from humans. In the second creation, all creatures received the precise characters and forms by which we know them today and with these came mortality. Images of 'therianthropes' may represent creatures of the first creation rather than or as well as Lewis-Williams's transformed or 'trance-formed' trancers. In the same way, what he interprets as images of people in the death of trance may be seen as images of the spirits of the physically dead. It is necessary to distinguish trancers from different types of spirits, some benevolent, others malevolent.

Although both Skotnes and Solomon share a concern with art practice as a conveyor of meaning and hence the importance of formal analysis in all its aspects, Solomon is also very concerned with the interpretation of the foundation texts of the trance hypothesis and those of Qing and Orpen in particular. Lewis-Williams interprets these metaphorically. Solomon demonstrates why one can accept them literally—at face value. One then is compelled to place San myths at the centre of the art. This connection has been rejected by many on the grounds that the art is not concerned with narrative. This is certainly true at one level but Solomon points out that it is of the essence of a great deal of art that it is not confined to illustration but 'represent[s] an order of time (narrativity) in an order of space'.[21]

Solomon is ambiguous about the extent to which she accepts or values any of Lewis-Williams's work. Still, the approaches of Skotnes and Solomon can be read as presenting additional approaches to interpretation that promise to extend and enrich the pioneer work very considerably, rather than supersede it. The debates are still in their early stages and have yet to influence fieldwork. The number of participants is still few. However, already they have resulted in an increasing demand for precision and definition in our implicit understandings of the nature of painting and artistic representation, of the problem of

'meaning', of methods of analysis and interpretation. This may not be remarkable in a wider context but it is leading to a sophistication of theoretical discourse on prehistoric art in South Africa that cannot be matched elsewhere in Africa—as we will become aware in succeeding chapters.

An approach to interpretation

This is not the place to discuss the many interpretations of images that have been proposed within the shamanistic paradigm. The depths of the analyses, the extent of the comparative studies on which they are based, and the degrees of conviction that they carry vary enormously. Interpretation—the integration of formal and iconographic analyses with relevant ethnographic evidence—is but the last stage of the process of study and understanding. It is worth looking at one regional study in Zimbabwe using formal or iconographic analysis.[22] This demonstrates the unity of the art and the strong networks of interconnections, conflations, and patterns of association between key images which superficially appear entirely disparate. What seem to be scenes of everyday life, the family, and the hunt, naturalistic representations of animals, entirely invented creatures, and almost entirely geometric and abstract patterns are not only all part of a single comprehensive cognitive scheme but can be recognized as such. The art reflects the artists' conceptions of a single unified universe in which the natural world interdigitated with the supernatural. The art is a single structured whole. The art is also a comprehensive examination and affirmation of San perceptions and conceptions of every significant facet of their life and society. The paintings operate on several different levels: through illustration, emblems, metaphors, metonyms,

16

Each oval has a dark rectangular core and is capped top and bottom with white hemispheres. The cores are covered with lines of white dots. The interstices between ovals and between them and the enclosing circle can be filled with irregular flows of dots. In their most fully realized form, the dots form a shape like a flying bird, a bird's footprint, or a conventionalized arrow. These can flow out of an elongated orifice in the enclosing circle and travel far across the rock surface. The circles can be spiked with triangular protrusions.

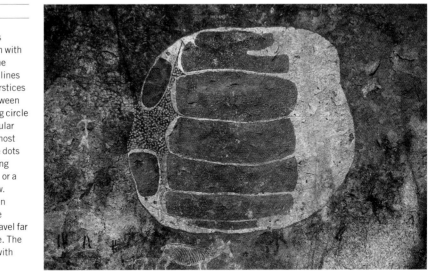

Ghost-like figures with fleshless limbs and animal heads with large ears, are often attached to oval shapes, sitting on them and clambering over them.

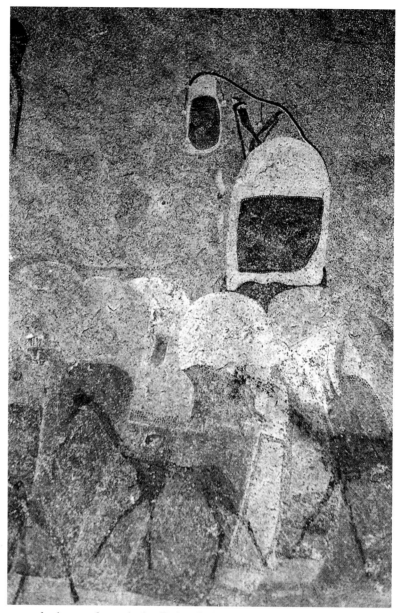

synecdoche, and symbols. Behind these still stand the artistic and visual fundamentals: the conceptualization and reproduction of the ideal and the stereotype in the most economical, legible, and comprehensible way.

In almost every panel of paintings in Zimbabwe there are representations of simple oval shapes, frequently embellished with carefully painted ranks of dots [16]. They are all fundamentally similar and must therefore express a single concept, but their elaboration and detail vary considerably. In their most elaborate forms several ovals are clustered or nested together, either horizontally or vertically, within the line of

an enclosing circle. Oval designs may be progressively added to and the designs thus enlarged so that they provide a field on which all the paintings of a panel are superimposed. The finest designs display what seem to be infinite arrays of receding oval shapes.

The associations of ovals are extraordinarily varied. Trees can grow from them. Their dots can envelop many different images. These include plant forms where arrowhead shapes seem to be in the process of transforming the plants into new oval designs. Elephants or other strange, heavy creatures, with single stiff forelegs and hindlegs, can be trapped in the interstices of ovals. A genre of small semi-human creatures with large ears, pointed snouts, and fragile fleshless limbs, yet in vivid human postures, can peer over and gambol on the ovals [**17**]. Small elementary motifs, loosely describable as leaf-, paddle-, or whisk-shapes, are occasionally attached to the outsides of oval designs. These seem to be emblems with little reference to external reality; they are more usually attached to the shoulders of otherwise ordinary human figures.

Elements of ovals can form components of other images. They can be attached to human figures, become major elements of such figures or be completely conflated with them [**18**]. These figures are usually recumbent but still alert and in full control of their limbs: they are not asleep, unconscious, or dead. In other conflations the cusps of ovals form the backs of invented creatures, often with strong references to elephants, or of elephants themselves.[23]

Elephants appear to have had a special role in the Zimbabwean imagery. They feature particularly in what seem to be hunts. The huge

18

Both the head and chest of this recumbent figure are made up of a series of oval shapes. The stick-like, fleshless limbs have spikes at the shoulders, elbows, and knees: an emblem with a very restricted distribution. Notice the figure with the swollen stomach placed beside it.

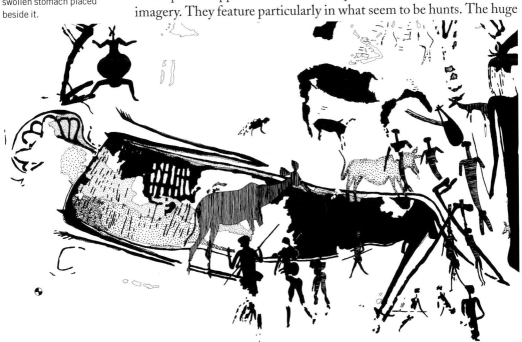

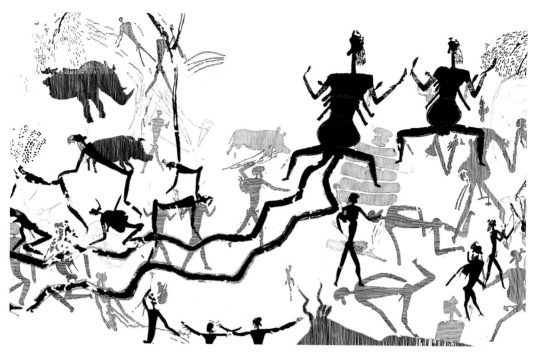

19

Figures in strict profile, each with only one arm and one leg, crawl up a polychrome line that emanates from a woman with an abdomen grossly swollen with active energy. She has an important role in creating or sustaining them. They have a tusk protruding from their faces, alluding to an energy or potency strongly associated with the elephant.

creature is surrounded by diminutive and agitated hunters aiming arrows at it. It is often pin-cushioned with arrows, wounded in many places and bleeding profusely. Often the arrowheads are inverted openwork triangles or forked. All these images depict the impossible. San arrows were too light to kill an elephant; they worked through poison and not through causing extensive loss of blood; the arrowheads depicted would be difficult to make, heavy, aerodynamically unstable, and lacking all penetrative power: quite useless against the hide of an elephant. Other paintings show that such arrows were usually part of the apparatus carried by dancers rather than hunters. One painting shows the arrows being deliberately bathed in the flecks of potency emanating from an oval design. The elephant hunt can only be interpreted metaphorically.

One of the most curious of the emblems attached to the human figure is a single, very carefully painted, small elephant tusk protruding from the face [**19**]. This emblem may be particularly associated with ornate but incomplete figures attached to carefully painted polychrome, striped zig-zag lines. These often emerge from the genital areas of women with grossly distended abdomens or stomachs. These lines are more than fluids: they are often rigid and geometric with sharp changes in direction; they may have spiky protrusions at every change of angle. These spikes are reminiscent of those on ovals and those on some recumbent figures. One painting shows that these lines can also rise from a recumbent figure and be transformed into a writhing snake's body with an animal's head not unlike that of a

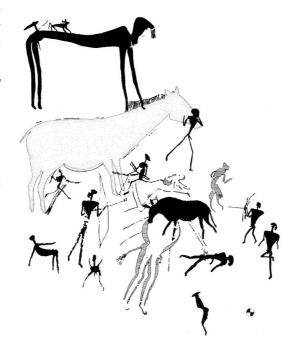

A single extraordinary figure (lower centre) is a summation of the ways that there was a network of visual relationships between the key concepts and images in Zimbabwean rock art. This man has a distended stomach and an elephant's tail. He is pierced by many arrows, characteristic of elephant hunts and recumbent men in trance. He has a tusk emblem on his face and the very common tulip-shaped emblem emanating from his penis.

fleshless semi-human figure [21]. There is a firm association of curvilinear emanations with incomplete or ill-formed human figures. Both hold onto the lines and suggest that they may gather strength and full humanity from them. But the same figures can adhere to flecks that have congealed to form ladder-like lines. Thus the flecks, snakes, and lines share the same creative potentials.

This approach to analysis is capable of considerable extension and much greater precision, definition, and detail. But here the important thing is to illustrate a structure—indeed a very complex set of visual relationships—through which the art can be recognized as a single conceptual unity [20].

An interpretation of the structure

Interpretation is secondary to this recognition of structure but it has been attempted—in terms of San shamanism. The oval designs may represent a source of supernatural energy. They may have had their representational origin in the human abdomen and its organs—liver, spleen, stomach—which the San believe are the seat of potency. The dots, flecks, and 'arrowheads' then represent the potency itself: potential and actual, latent and active. The recumbent figures represent trancers. The elephant is used as a metaphor for the trancer, its blood being potency, its hunt the trance-dance. The triangular arrowheads remind one of the invisible arrows that experienced trancers were believed to shoot into novices to induce trance (alternatively, they may

21

Lines rising from a recumbent figure transform into a reptilian body with an antelope's head. Figures that are not fully formed or fully human clamber up the lines and attach themselves to the snake's body.

represent the invisible 'arrows of sickness' in the magical armoury of malign trancers). Distended figures have their abdomens enlarged by active potency 'boiling over'. The release of this form of potency is represented by the zig-zag lines [19]. It seems from the imagery that potency took many different forms—pervasive, creative, transformative, curative, sustaining, and probably predictive. It was also a necessary prerequisite for rainmaking. Emblems define the different forms of potency present in most human beings. Thus potency and the world of the supernatural permeate all aspects of this world.

The fleshless figures may belong to a non-material realm; perhaps they are spirits of the dead. The incomplete figures clambering along zig-zag lines may be in the process of being created or re-created—and associated with San beliefs in two major episodes of creation. The tusk attached to many of them then becomes the emblem primarily associated with creation [20]. The zig-zag lines and the animal-headed snake are conflated and therefore in some sense synonymous [21]. This is reinforced by many dramatic images in south-western Zimbabwe, where large serpents with animal heads also seem to have incomplete humans and animals in the process of creation along their humped backs. Such snakes may then be equated with distended women with genital emissions. In the same parts of Zimbabwe the lion hunt may substitute for the elephant hunt. The heavy animals trapped in ovals somewhat resemble the heavy bovine-like creatures identified as rain-animals in South Africa, so they may be the rain-animal of the Zimbabwe San. From this one can suggest that some ovals may carry subsidiary connotations of the primeval pools in which San believed rain-animals lived and which were also entrances to spirit realms. The elephant is reminiscent in form to rain-animals. It, and other creatures with cusped backs who bleed so profusely, may be shedding rain as well as blood or potency. Perhaps the metaphoric elephant hunt had connotations of rainmaking.

In every examination of the art one must be conscious that all the imagery carries multiple connotations, associations, and resonances. Much will seem ambiguous to us; this is more reassuring than disturbing. Visual art can never be reduced to precise verbal explanation. To attempt this always involves impoverishment. Paintings are not a code but an affirmation.

Little or much can be made of the differences between the paintings of the different regions of southern Africa. In South Africa many give primacy to the paintings as direct illustrations of beliefs and insist on a narrow focus on trance phenomena as the primary explanation for the majority of all paintings. In Zimbabwe I have given more weight to the paintings as visual conceptualizations. I see the art as reflecting wider concerns than trance, though focused on the nature of spiritual energy or potency. These are differences of emphasis. They should not raise

doubts about the fundamental and overriding fact that all the paintings are concerned with presenting and celebrating many different aspects of a San conceptual universe.

Nubia

3

The River Nile

Nubia stretches for 1,500 km along the Middle Nile River. Like its northern neighbour, Egypt, it was dependent on the river's waters, its annual flooding, and deposits of alluvium for its sustenance. In Nubia the river flows over alternate areas of sandstone and granite, the former the basis of a largely featureless landscape and the latter restricting the valley and circumscribing the cultivatable land. Where granite and sandstone meet, cataracts impede the passage of boats [**Map 3**].

Lower Nubia lies between the First Cataract at Aswan and the Second Cataract. Dams have been built and progressively heightened at Aswan over the past century. The areas of flooding were almost always investigated by archaeologists before they were lost. This culminated in intensive international efforts in the early 1960s to study all the remains of the past between the First and Second Cataracts before the valley was flooded to create Lake Nasser. As a result, Lower Nubia is better known archaeologically than anywhere else in Africa.

The Third and Fourth Cataracts bound a long southerly loop in the Nile flowing through sandstone. It had a wide floodplain supporting savanna vegetation, extensive basins subject to annual flooding and was further enriched by alluvium accumulated at the mouths of wadis. It was the most productive area of the Middle Nile. At the downstream end, just above the Third Cataract lies Kerma, centre of the earliest centralized state in Nubia, which flourished from 2500–1500 BCE and was the progenitor or earliest manifestation of the kingdom of Kush. At the upstream end, just below the Fourth Cataract, lies Jebel Barkal, the ceremonial centre of Napata, the second capital of Kush.

The Nile then rounds a long northerly loop to the Fifth Cataract. Upstream of this the River Atbara, flowing down from the Ethiopian highlands, joins the Nile. The two rivers delimit the Butana (or Island of Meroe). Meroe, the last capital of Kush, lies below the Sixth and last Nile Cataract, with subsidiary towns reaching a short way into the Butana. This is a land of regular seasonal rainfall, acacia woodland, and grazing sufficient to support large herds of livestock [**22**]. Its nomadic pastoral peoples are no longer tied to the rivers. The Meroitic towns and villages were always subject to pressures exerted by the pastoralists,

Map 3 Nubia

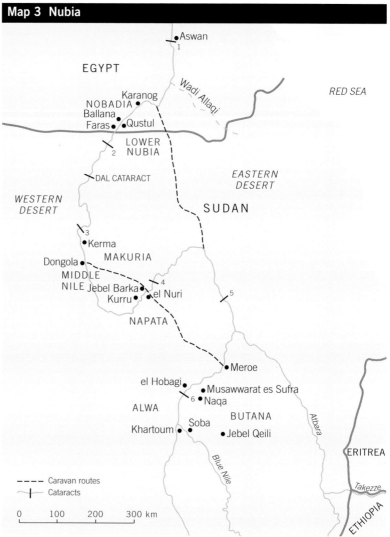

the most northerly representatives of the way of life of much of Africa
to the south and west. From here travel is possible, even reasonably
easy, across the sahel and savanna as far west as the Atlantic coast and
up the Nile to the Great Lakes of east Africa. Thus the Middle Nile has
long been hypothesized as the corridor of commerce, culture, or civi-
lization linking east and west Africa to Egypt and the Mediterranean.
However, no convincing material evidence for this has yet been
recovered. Indeed, Egypt seems to have been remarkably unsuccessful
in transmitting any aspects of its culture to Africa beyond Nubia.[1]

Race and culture

There is no sharp racial divide between Egyptians and Nubians; rather,
a gradual change in human physique, physiognomy, and skin colour is

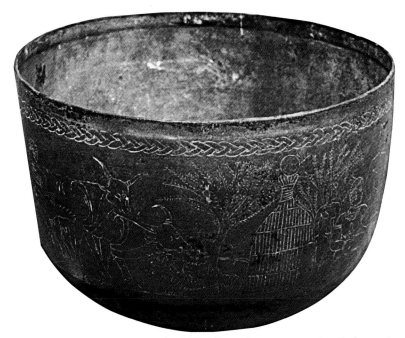

An engraved bronze bowl from the tomb of Viceroy Maloton at Karanog, Lower Nubia. In a celebration of the delights of the Butana, an elaborately adorned woman sits in front of a domed, hut with an ostrich egg at its apex, still a local indicator of status and with sacred significance. She is obese—a widespread African signifier of wealth. She is being offered milk from a herd of affectionate cows. Their deliberately deformed horns are a sign of a prized herd. It exemplifies an African ideal of peace and prosperity. The composition, balanced groups, rhythm, and space derive from late Roman imperial art.

apparent as one moves up the Nile. Egyptians cannot simply be typified as innovators and Nubians as inert and passive recipients. Egypt may have been one of the founts of civilization but there is implicit bias in thinking of Egypt as therefore somehow not really part of Africa. It is equally wrong-headed to construct Nubia as the northernmost outpost of a primitive black Africa, or its art as simply provincial and derivative.[2]

Culture is not determined by biology. Neither is it a single fixed package tied up within permanent boundaries. Cultural boundaries are so mobile and permeable that often they can be said scarcely to exist. Different cultural traits cross boundaries for different reasons and in different directions. Throughout its history and like every other society, Nubia learnt from many different sources. Nubians were always keen to select, adapt, and develop foreign ideas. They were as eager to innovate, re-create, and integrate all this in distinctive new unities. Culture is a human creation. History plays an important role in moulding culture. The history of the interactions between Nubia and the rest of the world is a particularly long and complex one.

Relations with Egypt

For 3,000 years and more Nubia and Egypt were very closely linked by traffic down the river and along caravan routes that cut across the two great bends in the Nile, linking Meroe, Napata, and Kerma. Nubia was the source of the luxury raw materials most valued by the pharaonic courts of Egypt. Gold was mined in the Wadi Allaqi and other wadis

23

This small clay figurine was found with a second in the grave of an adult woman and a young girl and has been dated to about 3000 BCE. Such figurines—of a seated woman with emphasis placed on her large, protruding (steatopygous) buttocks, plump legs sticking straight out and tiny feet—first appear in pre-Kerma Nubia and continue into Meroitic times. Thereafter they become almost ubiquitous in early African cultures. The connections, if any, that this may suggest remain speculative. Heads, arms, and breasts are generally rudimentary or absent. They are always naked save sometimes for a loincloth.

of the Eastern Desert. Slaves, ivory, live elephants, lions, and other exotic animals and their pelts were all easily obtained from the wilder reaches of the Middle and Upper Nile. Diorite and many different granites for statues was quarried in the Western Desert. There were also sources of semi-precious stones like carnelians and agates. Egypt in return exported manufactured luxury goods like textiles, glassware, jewellery, oils, and wines and, one must add, technology, craftsmen, priests, and bureaucrats.

Relations were not limited to commerce. There were raids, invasions, conquests, and periods of colonization. Pharaoh Thutmoses I first invaded Nubia, reduced Kerma, and occupied Kush at least as far as the Fifth Cataract in 1580 BCE. Kerma then fades from history. Pharaohs Seti I and Rameses II (1304–1257 BCE) established and enlarged the Great Temple of Amun at Jebel Barkal (Rameses also built the famous temple of Abu Simbel). Nubia, or at least the Nubian court or state, now adopted Egyptian religious beliefs, the ideology of pharaonic kingship, the Egyptian vocabulary of government, and Egyptian artistic expression in everything from royal inscriptions and texts to architectural and sculptural styles. After Egypt finally withdrew—about 1086 BCE—the Kushite kingdom (and perhaps even the ancient royal dynasty of Kerma) gradually revived. It was now centred on Jebel Barkal in the district of Napata, after which this phase of the kingdom is often named.

By 748 BCE, the tide had turned so far that Kushite rulers occupied the throne of Egypt for 85 years as the 25th Dynasty. Of the five Kushite pharaohs, Piye (Piankhi) and Taharqo were the most notable. Ironically, they were responsible for the most profound Egyptianization of Nubia.

In 591 BCE the tide turned again and the Pharaoh Psammetik II occupied Kush as far as Napata. This may have been the impetus to develop Meroe, far upstream. It became the most important of the Kushite capitals. In retribution for a Kushite sacking of Aswan, Meroe itself was invaded by a Roman expeditionary force in 24 BCE during the reign of the Emperor Augustus. The Roman intrusion was brief: a treaty generous to the Kushites was agreed and Rome withdrew. This excursion opened Meroe to the influences and commerce of the Mediterranean, and thereafter it can be seen as part of that world rather than an extension of Ptolemaic Egypt.

Kerma

At its height, the town of Kerma was a large agricultural settlement, not surprisingly since it was the centre of the most highly productive reach of the Middle Nile. Its domestic architecture was modest and included many circular houses with thatched roofs. Many houses had

cattle pens attached to them. Kerma's status as capital was manifest in palaces that have been identified both inside and outside the town, the massive wall with several towers, and an elaborate system of ditches and ramparts that surrounded it. Charles Bonnet and teams from the University of Geneva have been excavating Kerma for many years, starting in 1976.[3]

The town was dominated by an enormous structure of mud bricks, the Western Deffufa, now heavily eroded and weathered but still imposing. It can be compared with Egyptian pyramids in size and grandeur but was very different from them in form and function. The surviving mass contains only a staircase with a small sanctuary halfway up. It seems to have stood on the remains of a very early shrine and to have been rebuilt many times. It is now inferred that the increase to its final height was intended to ease communion with the gods and that it had a temple on its summit. Its long history suggests that it was the town's chief temple and closely connected with the institution of kingship. The temple also became the centre of a religious institution involved in many aspects of the capital's life, including manufacture. A shrine in the complex of buildings at the foot of the deffufa contained hundreds of small figurines of cattle—a foretaste of similar figurines later made throughout sub-Saharan Africa and all attesting to the social, economic, and religious values and significance attached to cattle throughout African history [**24**].

A second almost equally vast and imposing Eastern Deffufa contained two interleading columned halls painted by Egyptian artists with scenes that included local animal life. A third deffufa, now much degraded, had its chambers even more vividly painted with cattle, donkeys, giraffe, and hippopotami. Both are interpreted as royal funerary chapels, the Eastern Deffufa serving the huge tumulus

24

The most important secular building at Kerma lay close to the Western Deffufa (far right). It was a complex circular structure of wood and mud brick (foreground), with a large square hall and ancillary rooms. It is significant that a traditional African design was considered fitting for the formal appearances of the ruler. It saw much rebuilding and was in use for centuries.

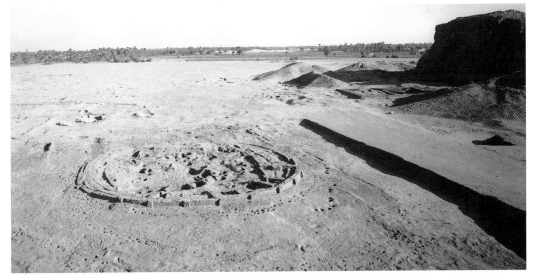

described below. It dominates a cemetery of at least 30,000 graves, many of them with multiple burials. Thousands were excavated by George Reisner of Harvard University and the Boston Museum of Fine Arts between 1913 and 1916.[4] Through their typology and spatial arrangement, he established a sequence of tombs spread over nearly a thousand years.

The earliest tombs were low circular structures faced with black granite slabs and quartz pebbles. Other tombs were marked with circles of sandstone stelae. Bodies lay on cowhide blankets. As funerary practices elaborated, the body, dressed in loincloths of cowhide or tanned leather, lay on a wooden bed, its footboard embellished with ivory inlays of wild animals and its legs carved in the shape of a cow's hooves. Later, flocks of sheep, their heads decorated with discs of ostrich feathers—thus preceding the ram of Amun by several centuries—were sacrificed at the tomb. Rings of cattle skulls also surrounded the tombs. Women and children might lie on blankets beside the bed, having given themselves in sacrifice. The bodies were never given any special treatment or mummified, save through their natural very rapid desiccation in an extremely dry climate. Nor were they protected by coffins or sarcophagi.

The climax came with eight royal tumuli. The largest was over 90 m in diameter, ringed with black granite and the mound covered with glistening white quartz pebbles. It was once surmounted by a marble monolith. A brick-lined corridor led to the burial suite. This was filled with grave goods—jewellery in gold, silver, and faience, bronze weapons and toilet instruments, inlaid wooden chests, ostrich egg shells and feather fans, even something made from giraffe hair, and Egyptian luxuries obtained through trade or looting. In the corridor were the corpses of an estimated 400 sacrificial victims—family, servants, slaves, and prisoners—as well as dogs and horses still decked in elaborate trappings.

The burial tumulus is a simple and almost universal monumental form. Though tumuli and stone funerary circles are later found in very large numbers right across the African savanna as far as the Atlantic Ocean, there is as yet no imperative to derive them from Nubia and Kerma, however seductive some detailed similarities may seem. If there is a relationship, its complexities, significance, and history have yet to be explored.

The monuments of Kerma exhibit an extraordinary splendour. Despite the borrowing of Egyptian artists and craftsmen, they have little reference to northern design. Foreign workers enhanced many of Kerma's monuments but they did not determine their forms. The rulers of Kerma had little understanding of the functions and symbolic importance of Egyptian art and therefore felt free to exploit their own ideas, styles, and techniques.[5]

Their monuments drew their visual power primarily from their scale rather than their refinement. They are positive assertions of southern confidence, strength, and wealth. Above all they emphasized cultural difference and southern roots—in their forms, materials, beliefs, and practices. Interestingly, the artists of Kerma gave their animals—particularly horses—special prominence and delighted in paintings depicting the local fauna. The artistic influence of the pastoral infrastructure of Kerma has still to be fully addressed and revealed. Southern farmers and landowners had risen to absolute political and military power and were aspiring to empire and divinity.

Napata

Rearing 100 m high out of an otherwise featureless landscape, the flat-topped and cliff-girt Jebel (Mount) Barkal closely resembles the eroded deffufas of Kerma on a gigantic scale. It became revered above any other site in Nubia as 'The Pure Mountain', the earthly residence of Amun [**25**].[6] The sacralization of natural features is as universal a human trait as the creation of monumental burial mounds. It is a

25

A small sandstone shrine representing the Jebel Barkal, found in the debris of the great Amun Temple at Jebel Barkal. A statue, presumably of Amun, was originally seated within the shrine and the opening closed by a door. On it was probably carved a uraeus. Adoring kings alternate with winged goddesses on either side of the door, standing above a frieze of papyrus.

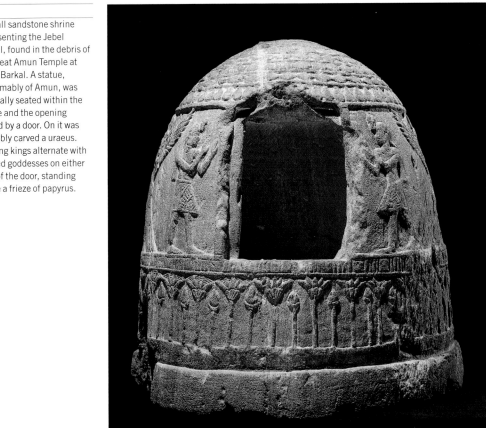

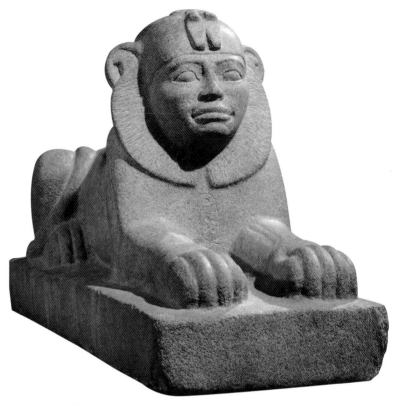

A granite sphinx of Taharqo, reigning 690–664 BCE, from a temple at Jebel Barkal. The head has the ears of a lion. The wide mouth, thick lips, high cheekbones, round fleshy face, and bulging eyes do not only emphasize his Nubian identity. This 'brutal realism' deliberately manifests a new, stern, and ruthless ideology.

subject to which we shall return when discussing the royal residences of Zimbabwe.

The early Napatan kings, who also ruled Egypt as its 25th Dynasty, enlarged and embellished the vast Temple of Amun with a palace attached to it at the foot of the Jebel Barkal. It was an entirely Egyptian institution, served by Egyptian priests. The architects, artists, artisans, and design were also purely Egyptian. It long remained the most powerful economic and political institution of the Napatan state. It 'elected' or ratified each new king.[7] Similar temples of Amun were established in every important centre of the kingdom. They long perpetuated an often unpopular Egyptian influence on every aspect of government and art.

The Kushite pharaohs asserted and represented the nature of their authority in their public and funerary statuary. They validated the legitimacy of their rule over Egypt by reviving an archaic sculptural style. Some of their works are recognizable copies of statuary of a thousand years before. They asserted their identity and the contrast between them and their Egyptian predecessors by giving their sculptures distinctively Nubian physical features. Royal effigies were wide-shouldered, thick-set, and stocky. The relief of musculature and bones was smoothed away. They abandoned the elegance, refinement, and remoteness of their predecessors and conveyed instead a sense of

involvement and immediacy. The sense of consciousness of divinity recedes. This is not to suggest that their images were portraits. They remained stylized archetypes. They manifested new concepts of kingship: a stronger and more physical sense of authority and an awareness that authority must often, especially after a change of regime, be combined with the strength to assert it.

The tumulus was abruptly abandoned as a model for royal funerary monuments in favour of the pyramid. Cemeteries of royal pyramids were established at Jebel Barkal, at nearby Nuri and el Kurru, and later at the other capital in far distant Meroe. They will be discussed with other Meroitic monuments.

Meroe

Meroe was probably always a Kushite capital and seat of the royal family. After the Egyptian invasion of 591 BCE it probably grew in importance. After 270 BCE all the royal tombs were built at Meroe. The town has large residential areas, workshops, what may be the remains of iron smelting on a considerable scale, a large temple of Amun, an equally large palace attached to it, and two large cemeteries with royal tombs. Not far away are Musawwarat es Sufra and Naqa [**27**].

Musawwarat es Sufra contains a complex of apartments, temples, avenues, courts, and terraces: the Great Enclosure. It was built in several stages from the third century BCE. Its layout is unlike that of any

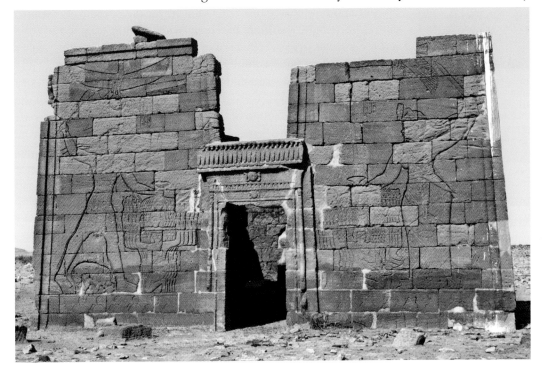

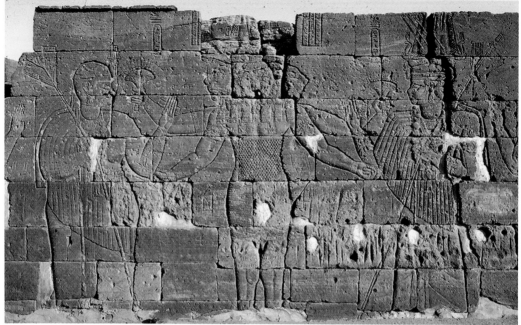

28

On the external rear wall of the Temple of Apedemak at Naqa, Apedemak, offers the staple grain, sorghum, to the king and candace. He has a single fused body, four arms and three heads—one facing the front and the other two in profile facing his supplicants on either side. This innovative artistic device enables him to undertake two different actions simultaneously. The central head unites the composition. This then is not a representation of a god with three heads.

other building in the Nile valley. It is now convincingly interpreted as a pilgrimage centre. Its sculpture seems to place such emphasis on the elephant that this animal may have been the focus of the cult.

At Musawwarat es Sufra was a temple of Apedemak, 'Head of Nubia, Lion of the South, Strong of arm'. This lion-headed divine warrior and hunter was the focus of a strong and specifically Nubian cult. The temple was built by King Arnekhamani (reigned 235–218 BCE). Egyptian pylons define the entrance. The single small chamber has two rows of three columns. Large recessed reliefs, some of the earliest surviving in Meroe, and incised drawings cover the walls. They depict encounters between Apedemak and the king. The design of the temple and the composition of the reliefs have been shown to be based both on the Egyptian system grounded in the proportions of the Golden Section and a Hellenistic system based on regular subdivisions of a basic module. The combination of the two established the balance and distance between figures, the length of their steps, and the spread of their gestures. The poses are Egyptian but the structure of these poses is Meroitic.[8]

Naqa, 15 km away, has a second temple dedicated to Apedemak, built over 200 years later by King Natakamani (reigned 1–20 CE or possibly slightly earlier) and his Candace (Queen) Amanitore, who might even have been the 'one-eyed and mannish-looking' candace who signed the peace treaty with the Emperor Augustus on Samos [27, 28]. The temple has much the same size, design, and decoration as its predecessor. The strength of its southern elements is, however, even greater. On the pylons, the king and candace are given equal

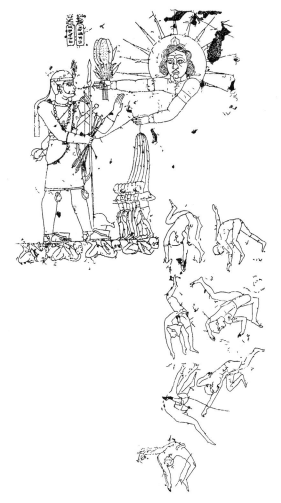

prominence—as they were in government. She is the king's equal in strength and military virtue. She also embodies southern ideals of feminine beauty with a plumpness that reflects her divine—and earthly—good fortune. Their costumes and regalia are not only equal but unlike anything in Egypt. On the side of the pylons the lion-headed Apedemak has the body of a serpent rising up from a lotus flower.

Meroitic art is certainly eclectic but it is also in most instances vigorous, dynamic, and experimental. The emphasis is on form, mass, and volume—in marked contrast with decorative Egyptian compositions on a flat plane.[9] Figures have an intense physical presence, continuing a tradition that began with Taharqo.

With this thrust towards a new art, synthesizing elements from many worlds, there were bound to be aesthetic failures. On the approach to the Naqa temple is a 'kiosk'. It is ultimately derived from Roman buildings but it shows considerable misunderstanding of almost all the principles of Classical architecture [**30**].

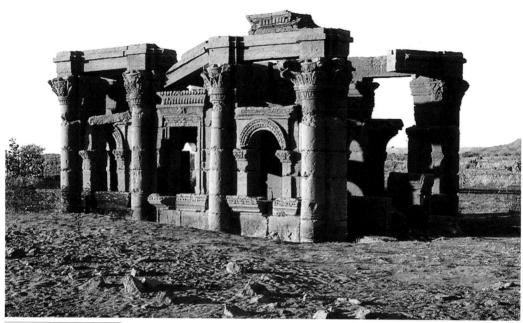

30

The 'Kiosk' at Naqa, probably contemporary with the Temple of Apedemak. The entrance and window lintels are Egyptian in form and carved with uraei. The walls are articulated with engaged Corinthian columns with incongruous plain shafts. The foliation of the capitals is coarse. The mouldings beneath it are a new elaboration. The bays are almost completely filled with alternate square and round-headed windows with heavy Classical mouldings and heavier sills. The Classical frieze that surmounts the building is overpoweringly heavy, coarse, and plain.

The pyramids of Kush

Three cemeteries of royal pyramids were established in Napata (at Jebel Barkal, el Kurru, and Nuri) and later three at Meroe. The pyramids were modelled on those of nobles of New Kingdom Egypt (1567–1085 BCE, and thus the time of Rameses II and the most significant invasion of Nubia). The change from tumulus to pyramid was abrupt. One of the earliest pyramids, at el Kurru, encased an uncompleted tumulus. The change was never a complete one: tumuli continued to be built and used throughout the time pyramids were being erected. The royal pyramids were surrounded by lesser tombs.

The tombs themselves were a series of chambers cut into bedrock. Where they were shallow and protruded into the subsoil they were roofed with barrel vaults. These became technically more sophisticated, developing from corbelled vaults, through false barrel vaults that needed no formwork, to true barrel vaults. A flight of steps led down to the tomb. As the pyramids were built only over the tomb itself and did not seal the entrance, the tomb chambers were always accessible from outside and the tombs and pyramids could be built and approved during the future occupant's lifetime. Taharqo for instance ordered his pyramid enlarged from 30 m to over 50 m square before his death. Only after the funeral ceremonies were complete was the entrance to the

tomb sealed and the steps down to it buried. A small chapel was attached to each pyramid. It had a single entrance flanked by pylons. A niche, presumably for a statue of the deceased, stood opposite it. Reliefs of the deceased suggesting Isis worship and military strength were often sculpted on the side walls. Bodies were now no longer laid on a bier but sealed in mummiform coffins or sarcophagi. Grave goods filled the chambers. A few victims sometimes still accompanied the primary burial to the grave.

The faces of Kushite pyramids inclined inwards at an angle of 15–30 degrees from the vertical: a significantly lesser angle than that used in the earliest Egyptian pyramids, which took the form of an equilateral triangle. The Kushite pyramids achieved height and economy of material at the expense of the overpowering mass and sense of majesty and inevitability of their remote Egyptian predecessors. The earliest Kushite pyramids were built of courses of large rectangular stone blocks, each course set back from the one below. The blocks at the corners were sometimes fully shaped and dressed, producing a smooth, crisp, defining frame to each face. Later pyramids had a rubble infill, and later still pyramids were built of fired or mud bricks. All except perhaps the earliest were covered with a lime plaster. This shining reflective finish, blindingly bright under the desert sun, entirely masked the underlying structure. The plastered faces were decorated with bands of painted patterns and even inset faience roundels. The apex was not left as a simple point but held a carved finial or perhaps a statue, presumably of the occupant. The final effect was of a prettiness and delicacy and a variety of detail. There is little of the stark simplicity of the Egyptian pyramid. Its overpowering symbolism of immutability, death, and eternity reduced to their primary absolutes was much diluted. It would indeed seem that the Kushite pyramids signified less stern and uncompromising attitudes to kingship, life, and death.

Minor arts

Despite the robberies of antiquity, an extraordinary range of objects have been found scattered in and around Meroitic tombs and temples. As we have no information on their original contexts, we know nothing of their original significance or purposes. Roman and Hellenistic imports were not only traded, they were ambassadorial gifts or war booty. The celebrated and very fine bronze head of the Emperor Augustus, broken from a larger-than-life statue, was probably the latter—booty from the Nubian invasion of Aswan that triggered Roman retribution in 24 BCE. There is a fifth-century BCE Attic rhyton. It is suggested that this was then a gift from Greece to Persia and later from the Persian King Xerxes to Meroe.[10] There were a

pair of Greek bronze heads of Dionysus, many sculpted bronze lamps, a silver gilt goblet with fine narrative reliefs round its side, a silver porringer of even greater elegance, an Aksumite coin, and so on. The nobility of Kush certainly had access to fine works of art of the Roman and Hellenistic worlds and even further afield.

The end of the kingdoms of Kush

Pyramids were no longer built after the mid-fourth century. The lapse of Meroe into obscurity has generally been blamed on an occupation of the city by the Negus (King) Ezana of Aksum about 330 CE. This is now considered doubtful. The Aksumite stele describing his campaign can as well be read as describing internecine Ethiopian wars. What is more significant is that Aksum exported the same raw materials as Meroe to the same markets and was strategically placed to benefit most from the growing Roman trade down the Red Sea. Meroe had to rely on arduous desert caravan routes. There was also constant and increasing pressures on Meroe from nomadic pastoralists.

After Meroe

At the settlement of el Hobagi, 70 km upstream from Meroe and at present dated to between the fourth and sixth centuries CE, the cemetery is dominated by seven royal tumuli. The resurgence of royal tumuli on the periphery of Kush can be attributed to dynastic change. The largest royal tumulus, 40 m in diameter and close to a large uninvestigated building, is the only one to have been excavated.[11] Subtle reasoning on the evidence of the grave goods has enabled the nature of the funeral ceremonies and hence something of the ideology to be reconstructed.

There was continuity in the Egyptian and Meroitic rites of libation and censing. Large engraved bronze basins and cups, made by Meroitic craftsmen, were engraved with crocodiles, frogs, and lotus leaves, cows, and bells. This suggests that libations were poured with traditional Nile water, milk, and wine. A perfume bottle suggests censing. In contrast, the procession of sacrificial victims—prisoners, the royal dogs that guarded them, a horse, oxen, and a dromedary—has a close similarity to a Roman triumph. This theme is continued with the weaponry in the grave—lances, quivers full of arrows, axes, swords, and a dagger. This interpretation is made even stronger by the find of a 'shield ring' engraved with a bearded head crowned with laurel, implying recognition by and perhaps allegiance to Rome. It seems the divinely elected king may have been superseded by the individual virtue and charisma of the military leader. Finally, the great number of very large vessels used in the funeral feast may be a reference to the ruler as a fount of prosperity.

A *ba* statue. These winged figures are common in the graves of senior officials, priests, and their wives in Lower Nubia. They are very different in style and content to other Meroitic works and contain no Egyptian, Roman, or Hellenistic elements. The heads all show a strong tendency to simplification and abstraction. They were painted in several colours and originally had sun discs on their heads. They bear so little resemblance to Egyptian representations of *ba*—an aspect of a dead person's personality or soul—that their identification is in doubt.

The Ballana culture[12]

On the opposite periphery of Kush, in Lower Nubia, are the cemeteries of Ballana and Qustul, in use during the fourth to sixth centuries CE. They were expertly excavated by Emery in 1929 in advance of an earlier raising of the Aswan Dam.[13] The four largest tumuli are once more, by their size and opulence, interpreted as royal tombs. This is confirmed by the crowns worn by the deceased [32]. Processions of people and animals—especially horses laden with ornate trappings—slain as they went down the ramp leading into the tomb, once again convey reminders of Roman triumphs. Iron weaponry and an incised drawing in one tomb of a king on horseback lancing an enemy strengthens this connection. The king wears a short Roman mail tunic and a flowing cloak, while a winged victory hovers over him. He also wears a Meroitic diadem. The many crowns in these tombs show great local technical and artistic skill and invention. Most of the symbols they bear

A silver crown found on the head of a burial in a Ballana Culture tumulus, fourth century CE. It has a frieze of Horus hawks at the base and uraei cut from sheet silver round the top. At the front is a crescent moon supporting a rod. This device is also depicted on the crowns of eparchs (provincial governors) in Faras Cathedral. The cabochon mountings of the jewels are believed to derive from the Black Sea. The technique was probably transmitted via Alexandria.

are Meroitic but there are also faded reflections of Classical taste and techniques. At least one wooden chest, probably also designed and made by local craftsmen, shows a similar syncretism, with its ivory inlays of Egyptian and Classical deities. In contrast, the jewellery is comparatively simple and rejects the complicated details and forms of Egypt and Meroe. The military strengths of Ballana were counterbalanced by the absence of writing and particularly of the use of the Meroitic script. It seems the people of Ballana may no longer have been literate. Ballana houses were structurally simple and no monumental building has been identified or investigated.

Christian Nubia

Christian Nubia was divided into three kingdoms. Nobadia was in the north, between the First and Dal Cataracts, with its capital at Faras

(Pechoras); Makuria covered the length of the Nile between the Dal Cataract and the Atbara River, and had its capital at Dongola; and Alwa (Alodia) was in the far south, with its capital at Soba, across the Blue Nile from present-day Khartoum. The now deserted city of Meroe was thus in Alwa territory. The Nubian kingdoms were stable and prosperous. Irrigable land was greatly extended by the introduction of the waterwheel (*saqia*). Tenant farmers grew several crops a year of wheat, barley, and millet, as well as cultivating grapes and harvesting dates.

Christianity certainly pre-dated the official dates of conversion. There were Christian relics in Ballana tombs. The earliest Christian church so far revealed is a fourth-century structure beneath the early palace and cathedral at Faras. Christian hermitages and monasteries were established late in the next century. Given the passion for doctrinal clarity and precise definition characteristic of the Greek cast of mind of the time, the early Christian churches were riven by disputes. The churches of Armenia, Syria, Alexandria, Aksum, and Nubia thus became distanced theologically from the Christianity of Byzantium and Rome.

The expansion of the Persian Empire culminated in its occupation of Egypt in 616. The Persians were soon replaced by Arab invaders who established the Fatimid Dynasty as the rulers of Egypt. Christian Nubia's connections with Alexandria and the eastern churches, frequently tenuous, became even more so; but they were never severed and a trickle of Nubian pilgrims continued to make their way to the Holy Land. Egypt's relations with Nubia were regulated by a *baqt* signed in 641: a friendship treaty that provided for the free access and protection of travellers, the extradition of fugitives and runaway slaves, and a compulsory trade in Nubian slaves to Egypt in exchange for wheat, wine, and cloth. This treaty was upheld for an extraordinarily long time, to the end of the Fatimid dynasty in 1171 and even beyond.

Foreign interest in Nubia was stimulated not just by religious zeal but by a desire to outflank the Persians and Arabs, both of whom had disrupted trade with Asia through the Red Sea, Sinai, and Arabia. The Mediterranean countries also wished to retain their links with Aksum, cut off from the rest of the Christian world when Arab expansion almost surrounded it. The cultural links between Byzantium and Nubia were strong. Government was modelled on that of Byzantium. Bishops sat in council with the king on important affairs of state. They played important roles in government and the king interceded in church matters. Dress was Byzantine. The language of the court and church was Greek. Nubian ivory was an important resource and stimulus for Byzantine artists. The Nubian elite had a taste for Byzantine ornaments, jewellery, and glassware.

At Faras, the royal palace was converted into the first church.

(a) The traditional Nubian church: a three-aisled basilica. The apsidal sanctuary was flanked by a sacristy and baptistery, connected by a narrow passage. The narthex was usually divided into a room whose purpose is unknown, an entrance porch, and a staircase. The external wall is almost always a simple rectangular envelope giving no indication of the different spaces it contains.

(b) The Church of the Granite Columns, end of the seventh century, Old Dongola. A bi-axial and centralized cross-in-square plan, with wide nave and apsidal transepts and two aisles on each side. It had a flat timber ceiling supported on rafters.

(c) The Church of the Mausoleum, Old Dongola, has a very large square central space. Transepts and nave are equal in size and identical in plan, treatment, and volume. The narthex, sanctuary, and subsidiary rooms are much reduced in size and importance. The exterior gives rich and full expression to the internal spaces. There is a mausoleum projecting behind the sanctuary and on its axis. It may be that the primary purpose of this building was to commemorate the person buried in it and that it is modelled on *martyria* of the Near East.

(d) The Cathedral of Faras, rebuilt at the end of the tenth century. In a development of the cross-in-square plan, the interior volumes are further articulated by their different vaulting systems. The nave is emphasized by its barrel vaults. The crossing has a large dome; smaller domes roof the side aisles.

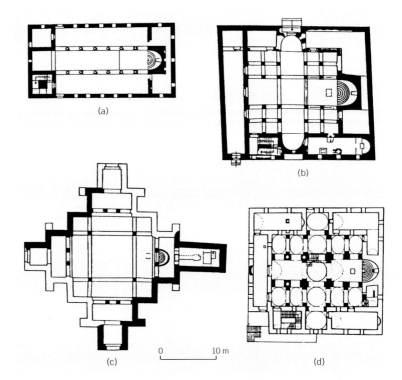

(a)

(b)

(c)

(d)

0 10 m

Meroitic friezes of doves and eagles, scroll work and beautiful foliated capitals and volutes were carved in sandstone and are all that remain. They preserve the old Hellenistic influences of the Eastern Roman empire.

The basilica building form, with columned aisles and flat wooden ceilings [**33a**], survived unchanged for centuries in provincial and village churches.[14] Stone was used extensively in major structures but the main building material was baked brick. Buildings were reinforced by horizontal timbers laid at intervals along both faces of the walls and braced by timber cross-ties. This occurred at least in the cathedrals of Faras and Dongola. It was probably a great deal more widespread and possibly universal. It is a mystery where such long straight timbers were obtained: it is unlikely to have been in the Butana. This is all significant because such idiosyncratic timber frameworks were also the foundation of Aksumite building design.

In 707 the Cathedral of Faras was built on the remnants of the earlier church: the design was probably inspired by the 'Church of the Granite Columns' at Dongola [**33b**]. Fresco secco[15] paintings covered the interior. Also 120 panels of paintings have been recovered in a remarkable state of preservation, still fresh and luminous after centuries buried in desert sand. In about 900 the cathedral was replastered. In about 1000 it was entirely rebuilt [**33d**]. Domes, vaults, and heavy piers replaced the former flat wooden ceilings and stone

The Great Nativity in the Cathedral of Faras marks the highest level of accomplishment in Christian Nubian art. It was the model for many other madonnas. The colours, especially of the vestments, are audacious. The various subjects are painted as distinct elements in a free composition. The altar-like manger has been said to derive from paintings in Jerusalem. This is one of the few instances in Christian art where the shepherds are named (Arnias and Lekotes); and the magi prefer horses to the conventional camel and thus echo the millennia-long love affair of Nubia with its horses.

columns. In 1169 the nave vaulting collapsed. It was never replaced and the nave was sealed off. These changes provide a framework for dating the development of the wall paintings within the cathedral. The dates are given further precision by the many paintings of named bishops, whose regnal dates are known precisely. There is thus a firm chronological framework within which the development of painting at Faras can be analysed. This can then be used to study the remnants of other church paintings.

While the Faras paintings constitute one of the most exciting artistic discoveries in Africa, the body of work is still small. At any one time the paintings may have been produced by a small group of artists working from a single studio and under the direction of a very few masters. It is foolhardy to consider them as necessarily representative of country-wide trends.

The paintings of Faras have been presented in terms of 'styles' determined by their dominant colours.[16] This is obviously a simplistic shorthand. The earliest 'style' is defined by the dominance of violet paint. More detailed study suggests that three groups of painters decorated different parts of the first cathedral, with different preferences within this somewhat restricted range.[17] These paintings have also been distinguished by the figures' enormous eyes, thick geometric lines delineating the faces, their heavy square heads, and clumsy feet. These features are shared by Coptic paintings of Alexandria, with even influences from Fayum and earlier resurfacing.[18] Another approach,

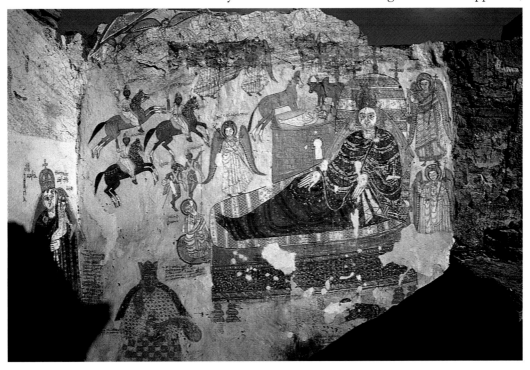

35

Painting of the Virgin
protecting Martha, a king's
mother. She is dark-skinned
in contrast to Mary, a
convention observed in all
Nubian Christian art. She
wears the vestments of a
priest and is crowned.

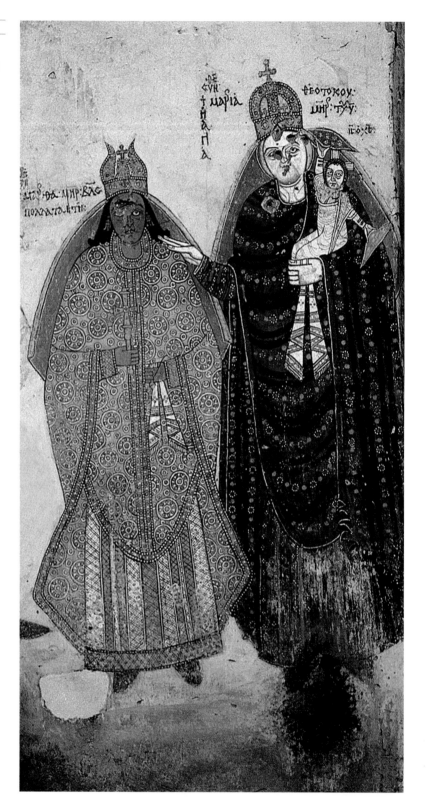

focusing on clothes and vestments, notes how simple the decorative motifs were and how little they contrasted with their background.[19]

For a short time after about 850–870, in the apse large areas of clothing were painted white, with violet used only to denote drapery or for the more solemn subjects. From about 900, the paintings are designated as orange-red. Nonetheless many vestments were still largely white and with both green and orange highlight details.

After 1000 the palette was greatly enlarged. Half-tints and shadows model the figures. The drapery is rhythmic and abstract, an ornamental distillation of the folds of real textiles. Incrustations of beads, jewellery, and embroidery cover every possible surface of the vestments, Byzantine in their richness [35]. The architecture of the new cathedral [33d] also suggests that we must look for sources near Byzantium. The designs of some Armenian churches are said to show even closer similarities. It is possible (but still disputed) that at this time Byzantium exerted more significant influences. The Madonna and Child no longer stare out at infinity but turn their gazes, with human love, towards each other and towards their supplicants. Thus esoteric doctrinal debates manifested themselves in art.

Insufficient comparative studies have been made to determine with any certainty the external sources or stimuli for the art or architecture. Paintings of three obscure saints of Antioch may signify less than has been made of them. For real scholarly progress, one must wait for expert analysts to compare Nubia systematically and in detail with the religious art and architecture of Ethiopia, Egypt, and that of the many Christian faiths of Palestine, Jerusalem, Syria, Antioch, Asia Minor, Constantinople, and Armenia—all possible inspirations for Nubia. This becomes increasingly unlikely as churches in these areas, especially Armenia, fall into decay or are systematically destroyed.

Decline

With the fall of Egypt's Fatimid Dynasty, Nubia declined. The *baqt*, on which her security depended, was frequently flouted or ignored. Nubia declined into a vassal state of Egypt, and became considered as a wretched country suitable only for raiding. The destructive infiltration of groups of Arab nomads became a massive influx at the end of the twelfth century. In the early fourteenth century a Muslim ruler superseded the last Christian king and the cathedrals and churches were converted into mosques.

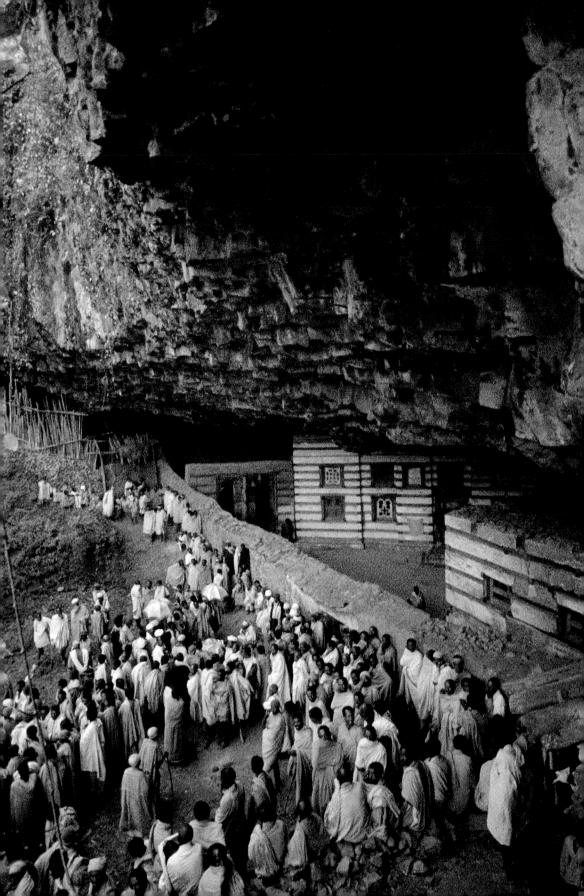

Aksum

The highlands of Ethiopia are extraordinarily rugged, beginning with a 2,000 m scarp only a short distance in from the sea, reaching up to 4,600 m above sea level and constantly broken by vertiginous gorges many hundreds of metres deep. It is the most demanding and hostile topography in Africa. Land travel has always been difficult and pack animals remain a significant mode of transport. What level plateau ground exists is fertile and heavily populated; its vegetation is now denuded and replaced by good grazing grasses. It is almost the only region in Africa where the plough has been used for millennia. The rainfall is adequate for most cereal crops and, because of the height, the climate is equable and changes little with the seasons. Perhaps most importantly, the highlands are free of the array of debilitating parasitic diseases that are endemic in almost all of tropical Africa.

In the first half of the first millennium CE, Aksum was ranked as one of the world's greatest empires. Alone in early Africa, it had an extensive maritime trade, its own coinage, written inscriptions and literature, and a distinctive Christian faith. Aksum was deeply involved in the politics of southern Arabia until the sixth century CE. Parts of Arabia were repeatedly conquered and occupied by Aksum, if never for very long.

The rulers of Aksum headed, perhaps by election rather than inheritance, a confederation of subsidiary, tributary, and vassal kings and chiefs, some ruling very small territories and populations but all nevertheless recognized as rulers. Hence the title of Aksumite and later Ethiopian rulers—*negusa negast*—king of kings—and their claim to rule not a kingdom but an empire.

Trade

With its access to the Red Sea, Aksum became a major participant in the extensive trade between the Roman provinces, the Mediterranean littoral, southern Arabia, India, Sri Lanka, and China. Along inland routes there were contacts with Meroe, the Nile Valley, and Egypt. Aksum exported valuable raw materials such as ivory, rhinoceros horn, hippopotamus hides and teeth, exotic animals and their pelts, gold

36
The cave church of Imraha Kristos (a Zagwe king). It displays most of the characteristic Aksumite motifs, even including corner towers. It is traditionally and perhaps correctly dated to the twelfth century.

Map 4 Aksum

from beyond the furthest southern reaches of the empire, emeralds from Nubia, and aromatics like frankincense as well as slaves and salt. Imports, mainly of manufactured goods, were of greater bulk but lesser value: wine, oil, textiles, pottery, glassware, and iron.

Aksum struck its own coinage in gold, silver, and copper, from the third century CE until the seventh century. The coins all bore the image of the reigning negus. Except in the earliest coins he was shown crowned and in pomp. In an idiosyncratic touch, the background to the royal heads on some of the silver coins was gilded. The coins bore first the pre-Christian emblems of the disc and crescent and later the Christian cross. The inscriptions were in Greek and Ge'ez, the indigenous language, which remains the liturgical language of the Ethiopian church. The weights, standards, and designs all corresponded to the Roman/Byzantine monetary system, for the coinage was intended primarily to facilitate international trade.

Religion

In the early fourth century the then negus of Aksum, Ezana, converted to Christianity and made it the official religion of Aksum, only a few years after Constantine had done the same for the Roman empire.

Aksumite clergy participated in the early councils of the church. The Byzantine persecution of the Eastern Churches led to a significant number of their dissidents, especially from Syria, taking refuge in Aksum and furthering the Christianization of the country. Aksum and then Ethiopia always retained rights in the Church of the Holy Sepulchre as well as a monastery and pilgrim shelter in Jerusalem. Contacts with the churches of Byzantium, Syria, and Armenia always remained significant. The church in Aksum was as authentic and ancient an expression of Christianity as any of the other early churches.

Although Aksum was to owe its decline to Muslim expansion, relations between the two religions were often close and friendly. It is probable that the Ka'aba of Mecca, rebuilt in 609, is, behind its veils, a classic Aksumite building.

Early sculpture and architecture

The most important earliest works of architecture and art that survive are at Yeha, 50 km north-east of Aksum; Hawelti and Melazzo, adjoining sites 15 km from Aksum; and Addi Gelamo on the eastern edge of the Aksumite highlands. The 'temple' of Yeha [2] was built with great precision of huge sandstone blocks, up to 3 m long, dressed and coursed. It is dated to the fifth or fourth centuries BCE. The only decoration is a frieze of ibex stiffly facing the front, heavy, simplified, and deeply recessed and undercut, as uncompromising as the building itself. A line of huge square and plain monolithic pillars are now the unintelligible remnants of a second structure.

The contemporary sculpture is more revealing [37, 38].[1] Several statuettes depict a seated woman, stiff, hieratic, and symmetrical. There are many smaller statuettes of sphinxes and bulls. Small square stone portable altars are raised on legs and have the emblems of the disc and crescent on their front faces. One, from Addi Gelamo, places these motifs between what we shall recognize as carvings of two characteristic Aksumite windows.

All this points to undeniable connections with south Arabia. The close-set monolithic pillars can be exactly matched at, for instance, the temple of Marib in Saba. The sphinx, ibex, and bull had important places in south Arabian belief and practice. The disc and crescent, which may represent either the full and new moon or the sun and moon, are the symbols of the moon-god Almaqah, the most important south Arabian deity.

This all once seemed to suggest that Arabian migrants settled in what was to become Aksum. But it does not necessarily demonstrate Arabian conquest, occupation, or colonization. The basic ethnic and cultural stock of the highlands from at least 1000 BCE were indigenous Semitic speakers. Their roots were in Africa and not Arabia, and

A side view of the 'throne' associated with one of two small fifth-century BCE temples excavated at Hawelti. The feet take the form of bull's hooves. The frieze is of ibexes. It is now suggested that both sides show a king and queen presenting insignia to the occupant of the throne rather than simple fan-bearers. Their dress resembles that of Meroitic royalty.

it was they who later formed the Aksumite state or states.

It is reasonable to propose that the continuity of Aksum may eventually prove to extend back to include all the buildings and sculptures we have described: all that is now labelled 'pre-Aksumite', 'Sabaean', or 'south Arabian'. An argument has even been put forward that the direction of influence flowed not from Arabia to Africa but in the other direction: that south Arabia derived its early arts from Aksumite territories and not vice versa.[2]

Secular buildings

Archaeological investigations of Aksum began with the work of the Deutsche Aksum-Expedition of 1906 [4].[3] French archaeologists

A seated figure from the Hawelti excavations. She may originally have occupied the 'throne' shown in **37**; certainly she fits it convincingly. Her corpulence, finely pleated dress, and necklace with a large pectoral and a counterweight at the back can all be matched in images of the candaces of Meroe. Her hair and features are like those found in sculptures in southern Arabia.

undertook considerable work between 1955 and 1974 but publication seldom kept up with excavation. Notes and summary reports are the main sources of information.[4]

Three major secular buildings, commonly called 'palaces', were published by the DAE: Enda Semon, Enda Mika'el, and Ta'akha Maryam. All were close together, near the centre of the old town and Aksum's holiest shrine, the Cathedral of Mary of Zion, which is built like them on a vast plinth. Two more such plinths stand nearby. A little further away, the 'palace' of Dungur was later excavated by a French team.[5] It also excavated four similar buildings in the Aksumite site of Matara in Eritrea. The dates of all these—and of so many ancient buildings in Ethiopia—is uncertain: most have been placed in the fourth and fifth centuries CE, with Dungur in the sixth century [**39, 40**].

The buildings were all set on massive plinths, usually with large squared and dressed granite corner blocks and sometimes with string courses of smaller shaped granite stones. Each 'course' of plinth walling was set back slightly from the one below to give a stepped effect. The buildings were approached by plain and monumental flights of granite steps without balustrades. Within the plinths were pillared, windowless basements supporting the superstructure.

The walls were constructed of ragstone, or random rubble, set in a mud mortar. This was stabilized and reinforced with a timber

39

Plan of the sixth-century CE 'palace' at Dungur. These austere fortress-like structures have a square building at their core with square rooms at each of its corners. The cruciform space at the centre was either a courtyard or a large roofed hall. The core building was surrounded by large rectangular courtyards. On the periphery were repetitions of the core buildings connected to each other by lines of rooms.

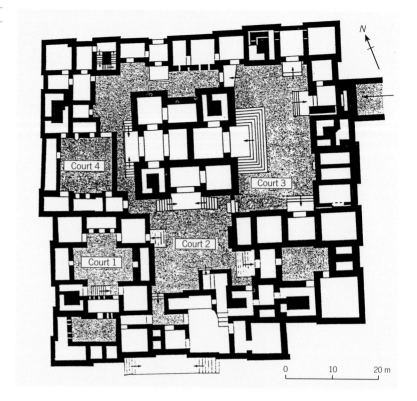

40

Reconstruction of Enda Mika'el. The corner towers of the cores and the more important peripheral rooms were emphasized by projecting them on the façades about 1 m. This may have had a defensive origin, allowing the towers to enfilade the walls between them, but this function had probably long fallen away and the projections became decorative articulations of the façades, expressive of function. The buildings were actually probably only two stories high and with thatched, pitched roofs rather than flat ones.

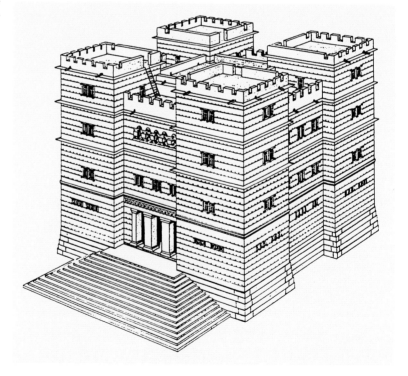

framework—of which more later. Windows were small and sparse. Lion-headed gargoyles discharged rainwater. The buildings had internal staircases and were probably all two stories high, with the towers possibly rising a little further. It is very doubtful that the walls could have supported more. We have only traces of timber beams to suggest some roofs were flat. Others may have been pitched and thatched.

Though the larger of these building complexes are called 'palaces', it is unlikely that they were all used by a single royal family or dynasty. From the repetition of core buildings, it would seem that several more or less independent groups of people of almost equal status occupied a single building complex or compound. The compounds show little of the decorative exuberance or ostentation of a palace and have few spaces that could have provided the suites of formal reception rooms of a palace. Each compound was self-contained, independent, and keeping a weather eye on the needs of protection and defence. Perhaps each compound was the headquarters of different tributary or vassal 'kings'. The core buildings were their residences and those of their of senior clan members and generals. The minor rooms then housed their armed retinues. Aksumite rulers, like their successors, were probably peripatetic, moving with large bodies of followers round their territories. The capital could be defined as where the ruler was living at that moment. In the course of these movements vassal kings would have lived at the capital Aksum only long enough to demonstrate their loyalty to the *negusa negast* and to attend him.

Although so little remains that one cannot be certain, it may well have been that Aksum was more of a ceremonial and religious centre than a truly urban city with all the institutions of production and trade. No civic, public, or military buildings have been identified. Certainly Aksum was primarily a ceremonial centre in comparatively recent times. Its focus was the Cathedral of Mary of Zion, the only cathedral in Ethiopia. It was possibly founded by Ezana on his conversion to Christianity but probably built by the Negus Kaleb in the first half of the sixth century. It consciously imitated the church on Mount Zion in Jerusalem, site of the Last Supper. It also recalled the Temple of Solomon. Aksum was very deliberately modelled on and known as the 'New Jerusalem', and the political ideology of the Christian state was seen to derive from the Jerusalem of the Old Testament and of David and Solomon.[6] The cathedral has always been believed to house the true Ark of the Covenant. It is also the place where all kings and emperors from Aksumite times onwards desired to be crowned. Aksum was holy ground, and it may be that everyone of any status wished to be buried there.

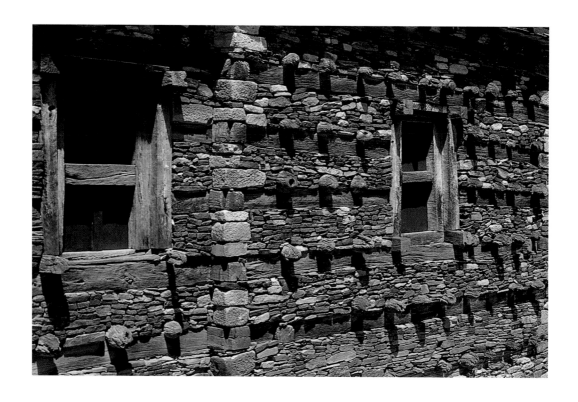

The church of Debre Damo

While no surviving church has been identified as definitely Aksumite, there are some surviving churches that were constructed using Aksumite techniques. The most important of these is the oldest of the churches in the monastery of Debre Damo, north-east of Aksum and close to the Eritrean border. The site was occupied very early: in a

The Old Church at Debre Damo, the earliest surviving example of the characteristic elements of Aksumite construction and design, with a timber framework used as the articulating element of every façade. The cross-ties were rounded timber poles grooved to fit over the lateral beams. Their ends projected beyond the faces of the lateral beams and walls to form 'monkey heads'. The cross-pieces and ties of the window openings were expressed as heavy square projections. Within the casing of windows was fixed a lighter and often intricately carved wooden grille.

hoard of Kushan gold coins found here, the latest was minted in the third century CE. The building of what was to be converted into the first church was considered pre-Christian by its principal investigator. It was then much rebuilt in the eleventh century and renovated in the twelfth to fourteenth centuries. Tradition attributes it to the sixth-century negus, Kaleb, the builder of the Cathedral of Aksum. It was again renovated extensively in 1948 when its structure was exposed and fully examined.[7] It may owe its survival to its isolation: it sits on a small plateau entirely surrounded by vertical cliffs.

Like the secular buildings of Aksum it has a stepped plinth and indented façades [41]. The most notable feature of the construction is the timber framework used to stabilize and articulate the stone walls. Dressed timber beams were laid horizontally along both internal and external faces of every wall about 50 cm apart to form 'courses' or 'levels'. The corner junctions of the beams were held together and emphasized by grooved blocks that gave the beams an appearance of exaggerated thickness and made it appear that they projected beyond the corners of the walls. The internal and external beams were fixed together or keyed into the walls by cross-beams or ties. Window and door openings are cased and supported by similar frameworks of rectangular timbers. Continual friezes of windows or of timber panels or combinations of both were constructed high above the nave.[8] Timber was also used to construct the sanctuary arch and dome, which are the only departures from the essentially trabeated or post-and-lintel construction of every other element in the building. Traces of timberwork survived in the secular buildings of Aksum but Debre Damo gives us a full understanding of all the principles and techniques involved in their construction.

Part of the flat, coffered ceiling of the narthex of the Old Church at Debre Damo, very possibly part of the original structure. Many of its panels portray the natural history of the terrestrial world, 'the Lord's Estate', a theme typical of Byzantine art of the late fifth and sixth centuries. It is found also on the beams of the nave in the Emperor Justinian's church on Mount Sinai.

Stelae

Two extensive groups of tall stone monoliths or stelae, marking pre-Christian Aksumite graves or burial vaults, still survive in Aksum [3]. There were other cemeteries but they have been entirely or almost entirely robbed of their monuments. The Gudit Field, adjoining the Dungur 'palace', still has over 100 stelae standing. All but six are unworked boulders. The worked ones are tall rectangular shafts usually with rounded tops. A single shaft grave has been excavated here. It contained unexpectedly extensive and refined grave goods: a range of pottery and a set of six glass goblets made in Alexandria in the early third century CE.[9]

The Main Stelae Field extends 700 m back from the cathedral and still includes 120 stelae. Attention has always focused on the six stelae carved to represent Aksumite buildings [4, 43].

The stelae represent towers up to 12 storeys high. Each storey

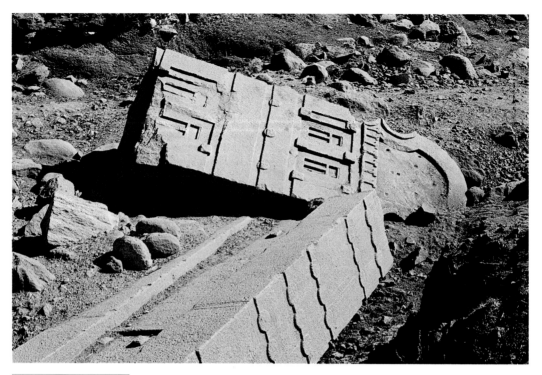

43

The largest stele at Aksum was a single block of granite, 33 m long and weighing nearly 520 tonnes: the largest monolith ever quarried or transported. The heads of the carved stelae are all different but most have a raised rim around what were probably metal plaques of the disc and crescent: fixing holes indicate their approximate shape.

consists of two plain courses and a panel of Aksumite windows. The corners project as the towers of a core building project, producing an indented façade on each face. Each course or panel is demarcated by representations of recessed lateral beams and the projecting cylinders of cross-ties. The ground floor is higher than the rest and has a frieze of mezzanine windows; in at least one example, there is an almost lifesize door in its heavy frame, represented to the last detail of its door handle or latch. There is no attempt to reproduce the actual proportions of rooms, door, or window openings.

Two flat slabs of granite were carefully fitted round the base of each stele. Several small shallow basins were carved in them. These presumably received libations. The edge of one base is carved with a vine tendril heavy with leaves and fruit: the only grace note on any stelae. They bear no inscriptions. This may be because they mark sets of tombs, each holding multiple burials, rather than commemorating specific individuals. One of the stelae has been shown to have been set on the axis of a sunken court that formed the entrance to two separate tombs.[10]

The technical expertise of the carvers is beyond criticism. Most surfaces are still immaculately even and smooth, edges and details absolutely crisp and precise. The perfection is so overwhelming that it may even render the stelae a little lifeless. There are few signs of weathering or decay. The stelae taper towards the top, an obvious trick of perspective to increase the perception of height and elegance. The overall effect is stark and assertive.

Tombs

Several tombs in the Main Stelae Field have been excavated by the British Institute in Eastern Africa, beginning in 1972, interrupted in 1974 by nearly 20 years of revolution, and resumed in 1993.[11] Everything found so far in these tombs suggests that they all belong to the third or fourth centuries CE. Stratigraphy suggests that they are contemporary with at least the large carved stelae. Clusters of shaft graves formed catacombs with a maze of tunnels and burial chambers. All had been easily dug in the soft clay bedrock. The more elaborate tombs around the carved stelae have corridors, lobbies, and small side chambers, in part excavated and in part constructed [**44**]. The latter were intended for coffins or stone sarcophagi: a few of the latter were found inside one such chamber, broken and empty. The burial vaults were neither deliberately hidden nor secret. They were entered down a flight of stairs roofed with flat granite slabs held together with metal clamps. The stairs often ended at the granite framework of an Aksumite door. The roofs of the corridors and chambers were again usually formed of granite slabs. In one case an entire tomb complex was covered by a single slab of granite estimated to weigh 360 tonnes and certainly impregnable to any break-in. Ironically, this slab was damaged and cracked by the fall of the largest stele.

One tomb interior retains traces of a coarse lime plaster and this has no vestiges of paint; another has a brick barrel vault. A third tomb has a brick wall across its entrance and brick cross-walls dividing its corridor; the bricks were set in a lime and not a mud mortar [**44**]. The

44

Interior of the Tomb of the Brick Arches beneath the main carved stelae of Aksum. The attribution of the material and forms to fourth-century Syria comes as no surprise in the capital of a nation with extensive religious and trading contacts. Much may have been built by expatriate craftsmen. But this should not be given undue weight: no systematic comparative analyses have been made that would enable the origins and development of the local architectural tradition to be properly understood.

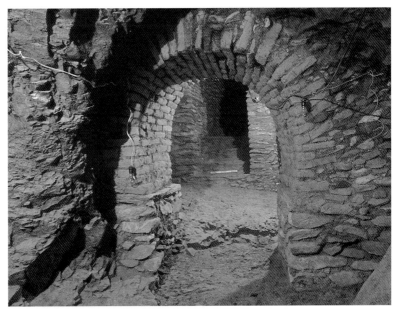

openings in the walls take the form of horseshoe arches, widest some distance above the lower portions of the doorways to form about three-quarters of a circle. The only other uses of bricks in Aksum seems to have been in minor and specialized fittings—like ovens—in the residential buildings. The brickwork is all in striking contrast to the uniformly trabeated structures of all other buildings and which is reproduced on the stelae.

Later, probably Christian, tombs retained many of the features of the earlier tombs. Stelae were abandoned, perhaps even desecrated and destroyed. Tombs were instead marked on the surface by what seem to be Aksumite platforms or plinths: two magnificent tombs were, for instance, united on the surface by a vast Aksumite plinth on which were built two pillared halls. One perhaps had the remains of a baldachin to shield what may have been a commemorative effigy. The halls may well have been memorial chapels.

Commemorative statuary may have been one of the outstanding features of Aksum and one that demonstrated its role as primarily a ceremonial centre. In and near the cathedral precincts are many 'throne bases'. These huge, thick, finely worked slabs of granite formed plinths that were grooved to take vertical slabs that must have formed the sides and backs of thrones. Some plinths probably had stone columns at each corner supporting a canopy. Seated statues may have occupied the thrones. These monuments seem to have formed two avenues leading to the cathedral—or the preceding structure whose plinth it occupies. Perhaps they commemorated the coronations of successive neguses and their consorts. Perhaps, like some of the earliest thrones, they commemorated victories. Statues were certainly erected. There is a plinth with two recesses into which the feet of a giant statue, about three times lifesize, had been fitted and fixed.[12] From early descriptions of Aksum at the time of Ezana, huge metal statues, some of gold or silver, seem to have been a notable feature. The thrones, canopies, and seated statues obviously take us full circle and back to the sculpture of Hawelti [37, 38].

Grave goods

In the tombs around the carved stelae, some side chambers and corridors may have been intended specifically for the storage of the possessions of the dead. But all entered so far have been robbed, probably in remote antiquity. All the robbers have left behind were remnants of the treasured household objects of an upper class: fragments of chests, caskets, trinket and jewel boxes and broken pieces of furniture. There was also a great deal of domestic pottery. Glass jewellery included beads, bangles, and earrings. Glass was also reworked and used as an inlay to metal objects. The iron and copper finds were largely

A pair of ivory plaques found in the Tomb of the Brick Arches. The tendrils of vines twist up them, with rich foliage and fruit. They entangle a variety of small creatures with almost human features. The deep relief seems more suited to wood: there is little of the delicacy possible when a master carves ivory. The use of ivory insets and the symbolism of the fruitful vine are reminiscent of Nubian practices. There are also reminders of the vines on stelae base plates and on the coffered ceiling at Debre Damo.

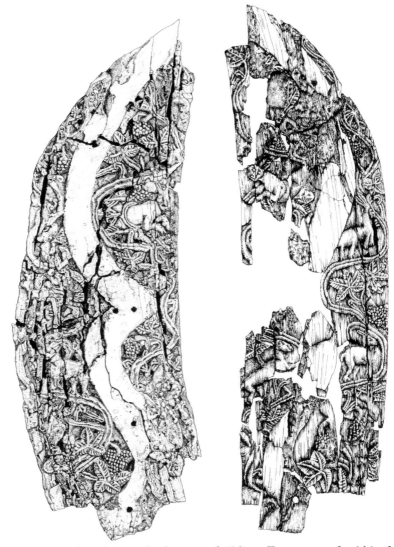

utilitarian, though some had traces of gilding. Fragments of gold leaf, gold wire, and thread hint at the treasures lost to us. Ivory carvings included a set of identical square plaques with a lathe-turned pattern of concentric circles—that probably once adorned a chest—and a small, turned cylindrical box. Most significant were two matching ivory panels [45]. Most appealing is a tiny broken figurine [46]. These few objects give us a glimpse of the private arts of Aksum. They still provide too sparse a context for us even to be certain what was of local manufacture and what was imported from abroad.

Craftspeople

From elsewhere in the state we have even less. Over 90 years ago what was interpreted as the remains of a jeweller's workshop—for it

A tiny broken ivory figurine of a slender naked woman from the Tomb of the Brick Arches. Her hips are twisted and her knees raised slightly: relaxed, sinuous, and sensual.

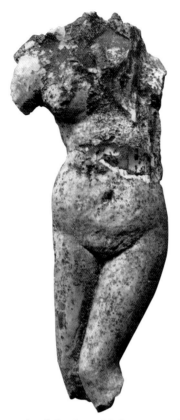

contained both gold ingots and finished jewellery—was found at Adulis. Matara has produced a hoard, dated to the seventh century, of gold and silver jewellery: gold crosses, chains, brooches, pendants, and a necklace formed of second- and third-century Roman coins.[13] There was also a large bronze lamp, attributed variously to south Arabia and Alexandria. Be that as it may, it is a fine illustration of Aksumite taste: the handle is a vivid little piece of almost free-standing sculpture that shows a dog leaping up to grasp the hindlegs of an ibex in full flight and mid-air.[14]

Clearly skilled specialist craftsmen, jewellers, artists, and traders in Aksum catered for a class that had the wealth, leisure, knowledge, and appetite to seek out and enjoy the pleasures of a cultured life. The sensibility seems comparable to that of Byzantium in its love of the finest materials: the texture, feel, and glow of ivory, the glitter of precious metals, the contrasts these make with glass and precious stones, combined with an appreciation of the gentler joys and fruits of nature. It is all in marked contrast with the uncompromising rationality of the architecture.

The two come together in a description of the Cathedral of Sana'a built by the Negus Kaleb, in the sixth century, after he had occupied Yemen. 'The doors were plated with gold studded with silver . . . the

columns of precious wood, decorated with colour and gold and silver studs . . . [a] mosaic contain[ed] trees and shrubs with golden stars . . . [another] a pattern of gold and silver crosses . . . The building was paved with coloured marble.'[15] The Cathedral of Aksum must have been at least as rich in its original finishes. This gives us a fuller insight into Aksumite sensibility than any of the remains left to us and allows a recognition of the extent of our loss.

Aksumite architecture and philosophy

It is easy to interpret the stelae—and indeed the buildings—of Aksum as displays of the power and wealth of those who commissioned them and those whom they commemorate. It is also a banal interpretation: the same is true of any monument. One must go further and consider why particular forms were chosen, what they might have expressed, and how they came to exemplify or symbolize the core values of the society that erected them. The secular Aksumite buildings, the churches at Debre Damo and elsewhere, and the carved stelae all emphasize the basic characteristic of Aksumite architecture. The architecture was based on the expression of its fundamental structural principle: the use of a timber framework to hold together rubble walling. The tensile strengths of the timberwork were combined with the load-bearing capacity of the stone. Both qualities were emphasized and celebrated on every façade. They were the basis of the articulation and ornamentation of all buildings. They gave buildings their scale and determined their proportions. They became the foundation of an entire aesthetic. The logic of building was laid bare. Truth stood unadorned. A respect for structure as good and beautiful in itself, the basis of all Aksumite architecture, is an unusual attitude to the built world. In few other cultures were structural principles the basis of design and ornamentation to the same extent.

If we turn to a consideration of the overall façades of Aksumite buildings we find that the same philosophy was applied. The projecting planes of façades signalled the importance of the rooms behind them. Recessed planes signalled the opposite. Elevation and plan were integrated. The exterior of every building reflected the interior with the same complete and uncompromising honesty and logic that was applied to the expression of structure. For anything comparable we have to wait for the Modernist principles of design of the twentieth century and perhaps even for the equally powerful discipline and logic of Mies van der Rohe.

Architecture is almost the only surviving pointer to the basic philosophical approach, to the sense of values of all Aksumite culture. As one recognizes that the two basic materials of the architecture—stone and wood—were contrasted in so sophisticated and revealing a way, so

one has to think about the symbolic roles these two materials may have played in Aksumite perceptions. One thinks not just about compression and tension but about things like organic and inorganic, living and dead. Such bipolar contrasts have been the bases for design and aesthetics in many cultures.

A final word on the stelae. One gets the sense that they are not just 'heavenly mansions' but that they still contain within themselves the lives of those they commemorate: that an invisible life continues within them, that they are the carapace of eternal figures, the locus and external aspect of life after death. In the late twentieth century the British sculptor Rachel Whiteread has made full-size concrete casts of very ordinary houses, rooms, and fragments of rooms in all their mundane detail. These also have an extraordinary impact with their evocations of hidden, secret, and continuing lives within them, from which we are excluded as we peer at blind windows and assess solid volumes as space.[16]

Later history

As Islam expanded across Arabia and north Africa in the seventh century, Aksum was cut off from its international contacts. An Arab account tells of the final sacking of Aksum by a queen, probably of the Agau, whom legend knows as Gudit. A 'new' polity grew up, with its capital at Roha some 300 km south of Aksum; a new dynasty of rulers, the Zagwe, took the throne there in 1137. One Zagwe king and saint, Lalibela, ruling in the early thirteenth century, achieved legendary fame for the cluster of monumental churches he ordered cut from the living rock at the capital. Legend has it that this was a response to the seizure of Jerusalem by Saladin in 1189, rendering it inaccessible to Christian pilgrims. Lalibela's churches, like Aksum long before, were once more to be the 'New Jerusalem': the canalized stream that flows between them is still known as the River Jordan. In his memory the capital was renamed Lalibela after his death.

Later church architecture

The Aksumite tradition of architecture seems to have continued unbroken into the sixteenth century. This is clear although the dates of all the relevant churches remain almost entirely speculative. There are no documented histories of their fabrics and no inscriptions. No datable deposits have been excavated—and the rock-cut churches by their very nature are without any substructural archaeological deposits. There have been no systematic studies or comparative analyses of the architecture. Most of the churches are still difficult to reach. Many remain unvisited and unknown beyond their small local congregations.

The interior of Imraha Kristos [**36**] has a particularly elaborate Aksumite frieze of blind windows and panels. The coffered ceiling is painted with Aksumite geometric and interlace patterns imitating carving. Other bays are painted with a rich bestiary of mythical creatures to rival those at Debre Damo [**42**] and on the ivory panels found in a tomb in Aksum [**45**].

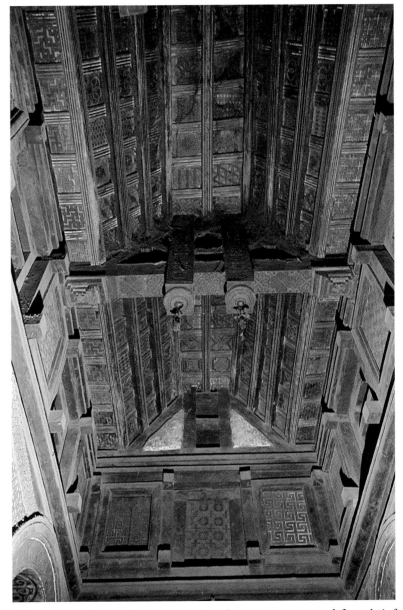

When research into the ancient churches was encouraged for a brief period before the revolution of 1974, startling numbers of churches built in caves or partially or completely cut from the living rock were revealed not only in Tigre and Lalibela but as far south as Addis Ababa. Soon at least 1,500 were known. At least as many more probably await revelation to the outside world. A whole realm of architectural history awaits recording, study, and understanding.

The rock-cut churches, at Lalibela particularly, were excavated out of tufa, which is comparatively soft and easy to cut when fresh but which hardens on exposure. All imitate the architecture of built

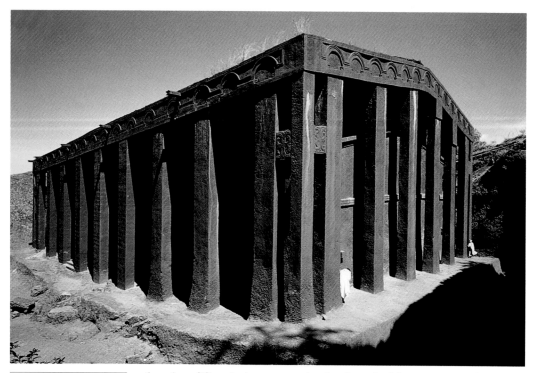

Beta Madhane Alem,
Lalibela, is the largest of all
rock-cut churches. It has a
nave and four aisles and is
surrounded by a close-set
colonnade of plain square
pillars. All this and even its
dimensions suggest it is a
conscious reproduction of the
Cathedral of Mary of Zion in
Aksum. The colonnade takes
us directly back to 'pre-
Aksumite' Yeha, to Saba and
Marib.

churches. The designs are eclectic though Aksumite motifs remain
dominant [48]. The normal plan is of a basilica with single side aisles,
usually three bays long, with a domed sanctuary at the end of the nave
and sacristies at the end of the aisles. Many have galleries over the side
aisles. Arched arcades and cross-arches are a departure from Aksumite
trabeation. A few churches have a cross-in-square plan, with barrel-
vaulted transepts and high flat nave ceilings. Beta Emanuel in Lalibela
has a barrel-vaulted nave. Other churches have domes 'supported' on
pendentives [49]. Many replaced Aksumite window designs with
openings with round, pointed, and ogee arches, particularly for
windows lighting galleries. Some of these windows were surrounded
with shallow and varied mouldings and scrollwork. All this demon-
strates the different exotic stimuli reaching and influencing Ethiopia in
the late first or early second millennium. Much of it probably came
either directly or indirectly from Byzantium. Lalibela has such a
variety of church designs and decoration that, leaving aside the enor-
mous skilled labour involved, it is difficult to accept that all were built
in a single reign. It seems unlikely that the Lalibela churches were
created in less than two or three centuries, thus shortening or even
eliminating the time gap between Lalibela and Aksum. Some of the
Lalibela 'churches' and 'chapels' were probably not even intended as
religious centres but were originally created as, for example, royal
retreats.

The architectural imagination responsible for the rock-cut churches

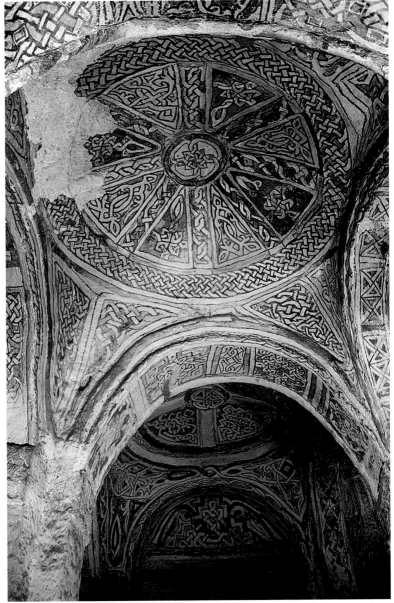

was extraordinary. The whole design, its spaces and volumes, projections and sculpted decoration, had to be envisaged in its entirety and in every detail—down to the gargoyles sticking out of the roofs—before work started. The design then had to be set down in drawings and plans which had to be followed with great precision. There were no means of adjustment, revision, or correction. The work—the cutting and hollowing out of the tufa—of its very nature could only start from the top and work downwards. Even if the spaces were only roughed out in the first stages of excavation, the final space was implicit in almost every part of its detail. As one cut out the apex of a dome, for instance,

one had to have a precise sense of its final diameter, of the span of its pendentives, of bay sizes, of column and arch dimensions, and capital and column forms. The churches are not only testimonies to masonry skills; they are even more monuments to their architects' powers of logical thought, foresight, imagination, and ability to control every aspect of the work.

Underlying the whole concept of the rock-cut church seem to lie the same metaphysical concepts as those that exemplified ancient Aksum. In the stelae, great baulks of rock were reduced to a carapace shielding, preserving, and symbolizing life after death. In the rock-cut churches the opposite took place: an inversion of the pre-Christian concept. Now the living worshipper is entombed in the rock. The rock embraces and swallows the pilgrim. The church is the mirror image of the stele. In both, life—before or after death—is enclosed in rock. These parallels, ironies, and oppositions seem too close for coincidence. Pre-Christian concepts have a continuity and reality down the centuries. The architectural world view that was born in Yeha continued for nearly two thousand years.

Painting

A great deal of research remains to be done on early Ethiopian religious painting, its origins and philosophical and aesthetic connections with Nubia. Zagwe painters and other artists ranked as artisans and were usually monks, trained in monasteries and producing work for churches and major patrons like abbots, nobles, and negusa. Their output included wall paintings, illuminated manuscripts, devotional images, processional crosses, chalices, and patens. Sculpture has little role in the Ethiopian or Eastern Churches.

Ethiopian church art derived directly or indirectly from late antique and mediaeval Byzantine models but rejected Graeco-Roman illusionism and the concept of paintings as windows looking out into space. The depth of the three-quarter pose was generally modified into a two-dimensional frontal view. Shading and modelling were transformed into simple areas of flat colour and bold lines.

In the fifteenth century, especially under Negus Zara Ya'qob (reigning 1434–68), contacts with Europe intensified and several emissaries from Europe were received at the Ethiopian court. With them came European artists and images, beginning with the arrival of one 'Boccaleone pictor Venetus'. These stimulated many innovations in Ethiopian art. This negus established the first permanent royal residence and court for himself, and founded a scriptorium in the adjacent royal church. He encouraged the development of a Marian cult, the processional use of icons, and the display of panel paintings. He may also have encouraged the hitherto foreign practice of authors signing

The interior wall-paintings, like the churches, are all undated. This image of a priest illustrates some of the features of probable early paintings: the stiff frontal pose, the large areas of flat colour, the limited colour and tonal range, the dark outlines and the enormous eyes. Generally the iris is shown, giving the gaze penetration and direction. There are resemblances to the frescoes in the rebuilt Cathedral of Faras in Nubia.

their works. Frē Seyon is the first Ethiopian artist who can be identified as the author of a small body of extant works [51].

The end

Much of Ethiopia was occupied by Ahmed Gragn between 1527 and 1543. His jihad devastated the Christian north: almost every church was razed to the ground, including even the Cathedral of Aksum. Only those indestructibly cut into the rock were saved. Gragn's invasion coincided with another and perhaps equally damaging one. In 1520 a Portuguese embassy reached the Ethiopian court. Its chaplain, Francisco Alvares, compiled the earliest surviving detailed and accurate descriptions of the monuments of Aksum and Lalibela. In 1543 Portuguese forces helped to kill Gragn and defeat his armies. With the conversion of the negus and the attempted imposition of Catholicism

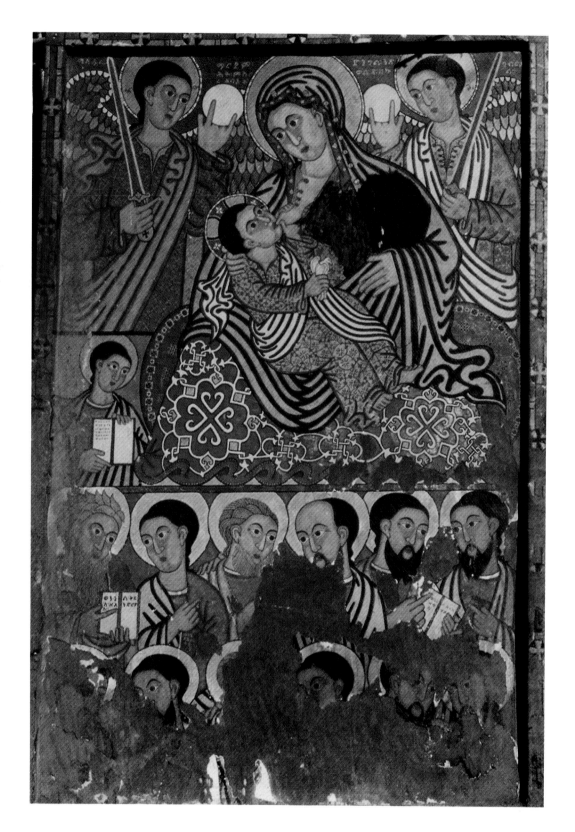

51
A mid-fifteenth-century panel painting by Frē Seyon. He retains the three-quarter pose derived from Italian painting. Christ holds a grey dove: the origin of this lies in Italian images of the Christ Child with a goldfinch, symbol of the Passion. The dove is an Ethiopian Marian symbol. Thus Ethiopian artists drew from Italy, but gave their imagery a specifically Ethiopian meaning.

on his subjects, popular disapproval and unrest grew to an extent that the negus was forced to abdicate and all Catholic missionaries were expelled from Ethiopia in 1632. The circular thatched church surrounding a square inner sanctuary that is believed to be traditional to Ethiopia was now adopted.

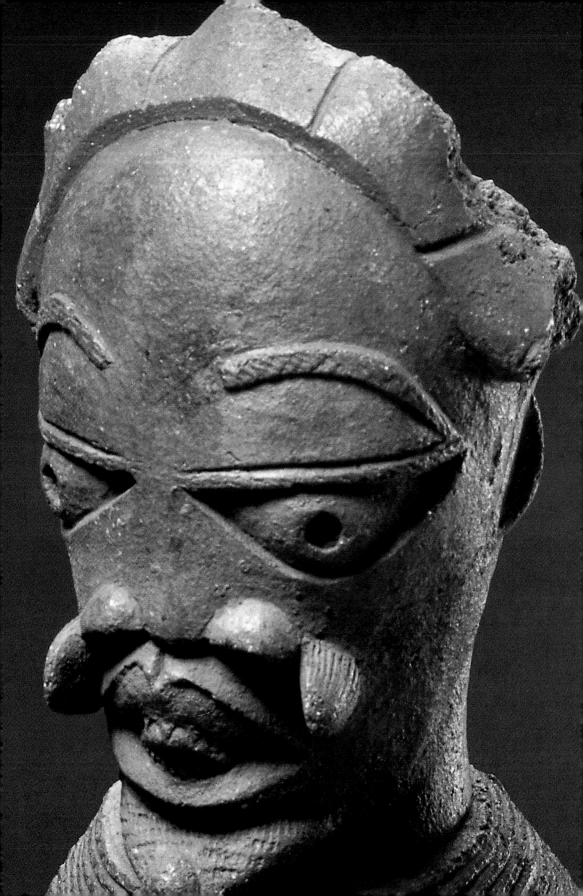

The Niger River

Jenne-Jeno

To approach some understanding of the traditions of pottery sculpture in the Niger River valley and its environs, one has to understand the significance of the Malian town of Jenne-Jeno (Old Jenne), partially excavated by Susan and Roderick McIntosh, who have worked on the site intermittently for nearly thirty years. It stands in the floodplain of the Inland Niger Delta—for part of the year as an island within the river. Here the river loops far northwards and breaks up to form an intricate braided network of shallow seasonal channels, lakes, and marshes. The river itself is rich in edible fish. The fertile, moisture-filled alluvium allows intensive farming to produce two crops a year. Local and regional trade along the river could supply dried fish, fish oil, cereals including rice, vegetables including chillies and onions, and fruit to less fortunate neighbours, especially downriver. Nowhere could be more favoured.

The earliest settlement was established in about 250 BCE. By 300 CE trade had extended, and iron ore and stone for grindstones were being brought in from significant distances. A distinctive form of burial—in tall pottery urns placed in among the houses—was introduced. By 500 CE a town with some 20,000 inhabitants had grown up: large for the region even in today's terms. Copper was coming from 1,000 km away and was worked in one of the earliest copper industries in sub-Saharan Africa. The fine local pottery, decorative rather than functional, was being traded 750 km upstream. Sculpture had begun to be made. Satellite settlements round the main town were being established.

In about 800 CE the town was surrounded by a very substantial wall of mud bricks. Subsidiary settlements increased greatly in number: up to 15 different settlements could cluster together, often only about 200 m apart. Here were grouped specialist workshops of iron workers, potters, sculptors, and doubtless carvers, jewellers, brickmakers and builders, shipwrights and traders, fishers, and farmers. Many different ethnic traditions were present, evidenced by different house forms and burial practices: inhumation, urn burial, and cremation were all practised. A long process of integration of different ethnic groups, craft guilds, lineage and kinship groups, had reached maturity and made up

Map 5 The Niger

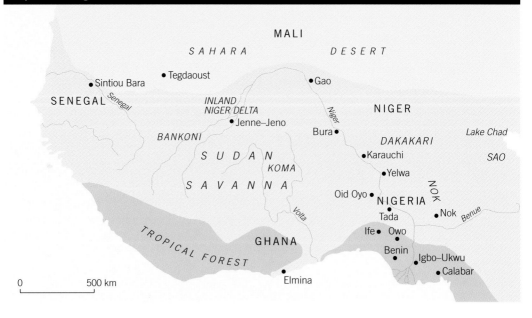

MALI

SAHARA *DESERT*

● Tegdaoust

● Sintiou Bara

● Gao

SENEGAL

INLAND
NIGER DELTA

NIGER

BANKONI

● Jenne–Jeno

Bura ●

Lake Chad

S U D A N

DAKAKARI

● Karauchi

SAO

KOMA

S A V A N N A

● Yelwa

Oid Oyo ●

NOK

Ife ● Owo

NIGERIA

● Nok

Benue

Tada

TROPICAL FOREST

GHANA

Benin ●

● Igbo–Ukwu

● Elmina

● Calabar

0 500 km

Tumuli

Tumuli occur right across the sudan. It is of course tempting to see in them a connection with Nubia. This has not been tested, let alone demonstrated. Large mounds erected over the graves of important people are a universal phenomenon extending far beyond Africa; so is the sacrifice of wives and servants to accompany the dead into eternity. If one has to seek a single point of origin for the phenomenon within Africa, the place to look would surely be within what is now the Sahara. There are indeed many ancient stone cairn burials within it—some going back 3,000 years.

The numbers of tumuli in the west African savanna are phenomenal. A survey of 32,000 sq. km in north-west Senegal recorded nearly 7,000 tumuli at nearly 1,500 different sites.[1] Earlier less reliable surveys accumulated a list of 23,000 tumuli in Senegal. The landscape of the floodplain of the middle Niger is dominated by numerous monumental tumuli. Many tumuli are now degraded to scatters of sherds and the stones that faced them. Many more, perhaps a very large proportion, of those recorded previously have now vanished entirely. Very few have been investigated, fewer still to the standards expected today, and even fewer adequately published.

Most tumuli are adjudged to have been built in the second millennium, and they continued to be built until the fourteenth century. The burial tumulus flouts tenets of Islam so it is certain they all precede Islamic dominance in the areas where they occur. Judging by the pottery associated with them, tumuli were built by several different ethnic groups. Burial practices also varied, from interments to burials within large urns to cremations. Scatters of sherds suggest many tumuli were associated with short-lived settlements of farmers.

a single urban whole. Specialist workshop quarters and efficient cartels achieved economy of scale. Competitive emulation encouraged innovation and the creation of new styles and techniques. The earliest gold jewellery to survive dates from this period.

All these developments took place before trans-Saharan contacts had been pioneered let alone established, and long before Islam reached the Niger. Jenne-Jeno was an entirely indigenous African town in its early stimuli, foundation, growth, and development. The trajectory of growth was determined by the interactions within the very mixed population and citizenry. There are no signs of any central authorities. Although excavations were far from comprehensive, no monuments, palaces, temples, barracks, or fortifications have yet been recognized. Even the town wall may have been built for protection against floodwaters rather than armies. Jenne-Jeno forces us to reassess all the presuppositions about the formation of cities and states in Africa. Jenne-Jeno's slow decline might have begun soon after 800 CE; it was certainly under way by 1000 CE. Islam had begun to penetrate. Jenne-Jeno's belief systems were under threat. This stress may have stimulated its production of sculpture: most of the very few dated pieces were made between 1000 and 1200 CE. But by 1400 Islam had triumphed, the town was virtually abandoned, and the new Muslim town of Jenne took its place.

The sculpture of Jenne-Jeno and Mali: a formal analysis

There are three ways to approach the Malian pottery sculptures:[2] through formal analysis of the objects themselves; through the social contexts in which they have been found, as revealed by archaeology; and through establishing ethnographic analogies between what is depicted and the practices of related peoples today. All have handicaps. Formal analysis carries considerable danger of being ethnocentric— but the same is true of all approaches. Contextual analysis in the case of Jenne-Jeno cannot go further than generalizations. Analogy rests on the untenable premise that little has changed over the centuries and that culture is timeless.

The art was immensely varied, more so than in other African traditions, and technically it was skilled and assured. Most of the sculptures are solid, standing about 30–50 cm high. Some had an internal reinforcement of an iron rod. A few were hollow and built up in coils of clay in the same way that the pottery was. Many were entirely or partly covered with a red slip, and a few show traces of different coloured paints. Much decorative detail was attached to the sculptures and there is also a great deal of incised patterning. There are examples of Malian sculpture in brass and wood: they differ little in style or subject from the pottery sculpture.

Early Malian pottery sculpture is distinguished by the upturned face, thrusting chin, multiple incised rings round the eyes, and neat incised chin-strap beard. The sharp-edged protruding lips and wedge-like nose look as if they are derived from forms characteristic of woodcarving. Some figures have a profusion of careful detail. In this example, this is particularly apparent in the bells, bridle, and headpiece of the horse. Bodies and limbs are simple tubes with little modelling.

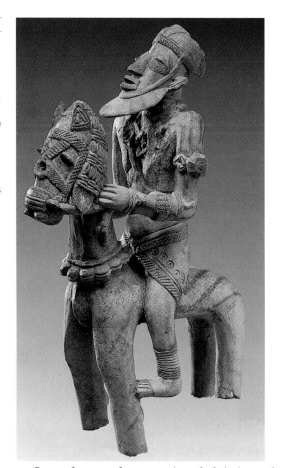

Some figures of men are bearded, helmeted, armed, and often on horseback [**52**]. They are idealized images of man in his prime. They are not individual portraits but generalized and archetypal displays of qualities. They exemplify the composure, dignity, repose, and profusion of ornament that so often denote kingship. But Jenne-Jeno seems a city without kings.

Very different and a great deal more common are much simpler figures of apparently ordinary people. They usually wear no more than fringed skirts and simple anklets and bracelets. Commonest among them are kneeling figures: the body rigidly upright and resting on the ankles, the hands together on the knees or crossed over the chest and holding the shoulders, and the head turned upwards—the characteristic Malian 'ecstatic tilt'. Many more similar figures are in more relaxed positions of every sort: sitting, squatting, and reclining. The mastery of the artists is demonstrated in the entirely convincing naturalism, asymmetry, and complexity of their poses. Some are in pairs, often in companionable contact. Their arrested gestures and movements introduce the sense of time in contrast to the static idealization of most African art.[3]

A disturbing addition is the widespread concern with the lesions, ulcers, and swellings of disfiguring tropical diseases [53]. Adding to the disgust are the numerous snakes that calmly curl, climb up and entwine bodies, penetrating and biting every part of them, even swallowing people whole. Every element in these sculptures engages our emotions: again, very uncharacteristic of later art. The vivid realism reinforces our natural sense of fear and horror; so convincing is it that one senses the grim inevitability of a nightmare. Every posture and gesture—the resignation of their lowered heads, the harrowed faces, the deep lines down the sides of their mouths—indicate a poignant submission. The victims endure without resistance, outcry, or complaint. There is no defiance; there is not even any loss of control. Dignity is preserved through every trial. The snakes do not bring strength; they increase suffering rather than diminish it; they are not familiars but agents of malignancy.

What conclusions can we reach from this consideration of the

53

A Malian sculpture of a suffering and submissive squatting figure. One snake crawls up his legs and bites his face. Another is coiled tightly around his chest. Large pustules, coming to a head, disfigure his back and thigh.

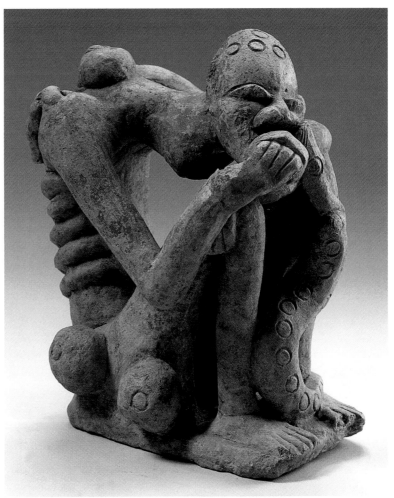

objects themselves? The scale and numbers of sculptures suggest that they were household objects, not communal shrine furniture. Only the bearded male figures can be allowed possible royal or divine connotations. They may represent heads of families or lineages or ancestral figures particular to small related groups. They may be commemorative, either in a specific way as the grave-markers or memorials of specific individuals, or in a more general sense, placed in a household shrine as the foci of the identity of that household. The kneeling figures and perhaps those that are diseased and distressed suggest suppliants: the former in a general sense, the latter showing their submission to divine power, seeking protection from evil and misfortune or pleading for remission of their sufferings. Perhaps they are

54

A Malian sculpture of a nursing mother. Convincing in its apparent naturalism, the composition is complex, clear, and resolved yet the modelling remains simple, even minimal. Her temples bear raised cicatrices and she wears a necklace of large beads. Her body is disfigured by sores and her expression suggests resignation without loss of dignity. The suckling figure has the proportions, slack muscles, and lined face of a mature person and thus seems to carry a symbolic load beyond our understanding.

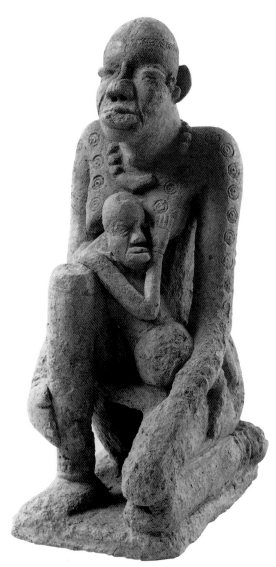

votive offerings, giving thanks for their release from all that is depicted. One can readily see them as also having a role in the furniture of a household shrine. The art of Mali does not appear suitable for any large, monumental, public, or social role. Most of it is about private and personal concerns, pleasures and pains. Painful, struggling humanity seldom has a place in the public realm.

Contextual analysis

Thirty-six sculptures, parts of sculptures, and fragments of reliefs were recovered from the controlled excavations at Jenne-Jeno. Few were undamaged and none were in their primary contexts: a sad diminution for the chances of contextual analysis.[4] All were in domestic surroundings. A pair of kneeling figures were on a platform built into the walls near the entrance to a house. A similar pair of figures—but with lesions—were found in a similar position in another building. They all seem to have been parts of sets of foundation offerings made when a house was built. Other offerings included such things as a bowl of rice, a water beaker, and a pot containing an infant's bones. They were buried when a wall was deliberately collapsed on top of them. Sculpted fragments were also found with a group of iron rods, pestles, mortars, and slabs of stone—analogous to a rainmaker's altar today—outside the entrance to a smith's house. A striking reclining figure was found headless on a rubbish dump at the edge of a settlement.

While all this provides no great insight into the sculpture in use, Roderick McIntosh has looked at the society as a whole for clues to account for the proliferation of sculpture. The varied ethnic and

Stone circles

The association of tumuli and stone circles is a firm one although not universal. In Senegal the circles tend to have a more southerly distribution than the tumuli, but the two overlap. Many tumuli and circles also share the same pottery associations. Some circles are earlier than any tumuli: one has been dated to 200 BCE. Stone circles are almost as numerous as tumuli and are also frequently clustered.

The stones of a circle are usually worked, either squared with flat tops or cylinders with rounded tops. Most stand to the height of a person but they can be 4 m high. Most circles are 8 m or less in diameter and demarcated by 30–40 stones. They can be much larger and contain 150 stones. A few are made up of concentric circles. In at least one, further stones demarcate a square within the circle. Much more often stones demarcate a rectangle extending from the circle. These rectangles are carefully oriented and may contain a stone with a groove in the top which seems to have been used for celestial sighting. Most excavated circles have been found to have burials at their centre. This obviously suggests that the stone circles were funerary monuments like the tumuli. But other interpretations are possible. The burials may have been sacrifices to render the circles sacred. All sorts of other intangible benefits may have been believed to reward their builders.

occupational groups in the dense and highly interactive population of Jenne-Jeno were mobile, changing, and competing. In such a situation each would have sought to legitimate, reinforce, and maintain its own specific sense of identity. This could have been done through distinctions in beliefs, customs, language, dress, food, and so on. Myths of origin and legends about ancestors would be strengthened and proclaimed. What was occurring was a proliferation of symbols of identity. The visual arts, in this case the pottery sculptures, would have an obvious and vital role in this process. For McIntosh—and no one else can speak with his authority on Jenne-Jeno—this is as far as we can go.

Ethnological analogy

Ethnographic analogy has its place in interpreting the pre-literate past. The rewards of such an approach have been amply demonstrated by our new understanding of southern African rock art. They are used repeatedly in this book. But analogy demands a great deal more than collating apparent and often superficial visual similarities. For convincing correlation, the art of the past and the belief system of today must both be laid bare at all their levels before comparisons can begin to be made. It must also be recognized once more that culture is a product of history, that cultures change, and that, as they change, elements within them acquire new significances and meanings. There must be the full recognition of the complexities and ambiguities and levels of meaning inherent in the visual manifestations of culture. All are imbued with symbolic significance. The values of forms and images with a symbolic content fluctuate. Their meaning is continuously negotiated. Aspects of it wax and wane. Symbols by definition all carry a multiplicity of meanings. Our assessments of these must take account of the many different levels on which every symbol operates. In correlating symbol and meaning a great deal more is required than in solving an equation or decoding a message. Our conclusions will never be more than tentative and partial.

Bernard de Grunne, whose father was once the owner of the largest collection of Malian sculptures, asserts, on the basis of interviews with a small and scattered number of Malians who claim knowledge and associations with the region's pre-Islamic past and its beliefs, that the sculptures were originally kept in communal shrines and that sacrifices were made to them. They represent gods: every deity could be recognized by a distinctive posture. Most postures and gestures also had specific meanings; they were ritualized prayers in themselves. Thus by adopting a particular posture one could bring down the curse of a particular god on a particular person. Snakes on the other hand represented royal power. Much of this is contradicted by the formal, contextual, and social analyses. None meets any of the many tests of

validity to which all ethnographic analyses must be subjected. One must also point out the extent to which de Grunne's approach is self-serving. If he is correct, the need for archaeological interpretation falls away: ethnography can reveal all. All that is required to understand an art is to find informants who claim that they can explain it, however implausible their relationship to the art may be. Furthermore, if this is true, looted pieces can then contribute as much to an understanding of the art as excavated pieces.[5]

Other sculpture from the Niger River valley

The Malian sculptures are parts of a much larger whole. Along the course of the Niger River pottery sculpture deriving from very different artistic traditions and exhibiting very different degrees of technical and artistic skills has been recovered. Of the majority we know little more than that they existed. The places where they lay have seldom been investigated professionally and their dating in particular is unknown or unreliable. All have now attracted the rapacity of collectors and are suffering the consequent destruction of sites and disappearance of most of the art into inaccessible private collections.

Koma sculpture

The sculpture of the western savanna is not tied to the Niger. It was probably a much wider phenomenon. At Koma, at the furthest reach of north-west Ghana, the Yikpabongo field of over a hundred tumuli contained what may be the final manifestation of sudanic sculpture.[6] In one tumulus the primary body lay on a platform, decked in copper jewellery and surrounded by human and animal sacrifices, grindstones, mortars, pots, and an extraordinary number of sculptures—in one instance 258 of them. It is dated, by imports of cowrie shells, to the seventeenth or eighteenth century CE. Most are standing human figures, 25–35cms tall. Wide eyes are circled with raised rims; vast, gaping mouths were perhaps designed to provide adequate venting of the hollow interiors; the lips protrude. The feet are thickened to provide a base and some have only rudimentary arms. Many are detailed with beards, jewellery, headgear, and baldrics. An idiosyncrasy is the placing of the ears high above the level of the eyes. Overall, the Koma sculpture lacks the assurance and finesse of the two long-lasting traditions of Nok and Jenne-Jeno.

Sao sculpture

A further distinct sculptural tradition has been named Sao, 'pagan', after the aboriginal inhabitants of the floodplains south-west of Lake Chad in the northern Cameroon.[7] Its context is the walled towns of minor kingdoms that lay beyond the greater states of Kanem and Bornu. There is a diverse collection of pottery sculpture, ill-formed and in a much softer clay than sculpture in other traditions, without their usual crispness and with little evidence of a developed canon of forms. Nevertheless, many have features we have often met before: vented mouths and nostrils, the former between projecting lips, the latter wide and flared . The head is again often upturned. A novel feature is the stylized, flat, mask-like heads decorated with patterns gouged from the wet clay.

55

A group of Bankoni works said to date from the fourteenth or fifteenth centuries CE. Their derivation from the earlier Malian sculptural tradition seems apparent in shared concerns and in some details. These examples do not share the highly developed technical, compositional, or expressive skills of the earlier work.

Bankoni sculpture

Far upstream from Jenne-Jeno near Bamako, the capital of Mali, Bankoni sculpture seems to have been very varied. Some works have the compositional complexity but not the full mastery of Jenne-Jeno. They share with it realistic postures, expressions of emotion, upturned faces, and twining snakes. Other pieces are much simpler: the bodies and arms are long tubes, the legs rudimentary. Breasts, umbilicus, eyes, nose, and mouth are pellets, the bangles heavy coils of applied clay. Ears and headdresses are raised pimples [**55**]. This genre shares the upturned faces, equestrian figures, and chin-strap beards of Jenne-Jeno but it all looks very provincial work. Bankoni sculpted pots do not: they have great elegance and the animal heads at the tops of the long necks exhibit a gentle, understated insight into character and humour [**56**].

Sokoto, Yelwa, and the Dakakari

Further downstream still, where the Niger enters Nigeria, the 'Tumulus of Karauchi' near Sokoto yielded a pottery head, broken from a larger piece [**57**]. It has been dated to between the second

56

A Bankoni sculpted pot. The vessel has characteristic light cord-impressed decoration on its body and a more firmly formed and decorated collar. This is sealed by a tall, tapered stopper surmounted by a sculpted head, often an invented form, assured, economic, and commanding attention.

57

A sculpted head, said to come from Sokoto and hence presumably the 'Tumulus of Karauchi'. The eyes are reminiscent of Nok (see **60**) although the brows are longer, lower, and heavier and there are no symmetrical arched eyebrows. The smooth forehead and circlet are also characteristic of Nok. The nose, mouth, and collar are very different. The beard is much more like those of Malian works.

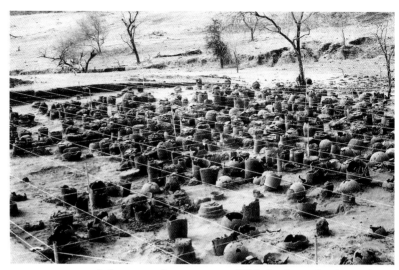

At Bura, downstream from the Inland Niger Delta and across the Mali border in Niger, is a cemetery securely dated to the third to tenth centuries CE. It is marked by several hundred upturned pottery urns. Some contained a human head; others may have held the viscera of the bodies buried below them and whose graves they marked. Some vessels were ovoid in shape with standing figures sculpted on their bases; others were hemispherical with only a sculpted head on the base; others were long cylinders with a horseman.[8]

century BCE and the second century CE. This is the only site to have yielded such sculpture and is seems that it has now been pillaged. Certainly sculptures that are claimed to have come from here have been exhibited for sale in a Parisian gallery.[9]

Not far downstream from Sokoto and near Yelwa, a mound of settlement debris stands beside the Niger River. It has been partially but systematically excavated and securely dated to the second to seventh centuries CE. The contents suggest a community not very different from those of Nok (see below), save perhaps for an increased reliance on iron. There were several pottery figurines, all rather small and very different in their forms: the collection is too limited and variable to define meaningfully.[10]

East of Sokoto and Yelwa live the Dakakari. Like so many societies in Africa, they mark the graves of ordinary people with domestic pottery. However, for the graves of those who have achieved a degree of fame, be they lineage heads, hunters, priests, or warriors, some of this pottery bears a statuette on its base and so resembles much of the prehistoric pottery we have described. The sculptures are predominantly of people but also once more include horsemen and their mounts; they also portray animals, including antelope and especially elephants. All are invariably made by women, strengthening a little our initial surmise that the artists of all western sudanic pottery sculpture are much more likely to have been women rather than men. It looks very much as if the Dakakari artists may be the last survivors of those working within an early western sudanic belief system and retaining something of the early sculptural tradition of the region.[11] Downstream once again and for the last time, the Niger flows past the western limits of the Nok sculptural tradition and enters the tropical forest.

59 (opposite)
The Bura sculptures of heads alone were stylized rectangles with applique features and cicatrices. The steeds had very elongated heads and elaborate trappings while their riders had rich necklaces, baldrics, and scarifications. Warriors were differentiated from hunters by their weapons. Some sculptures had pierced voids in place of eyes or mouths, giving them curiously vacant expressions.

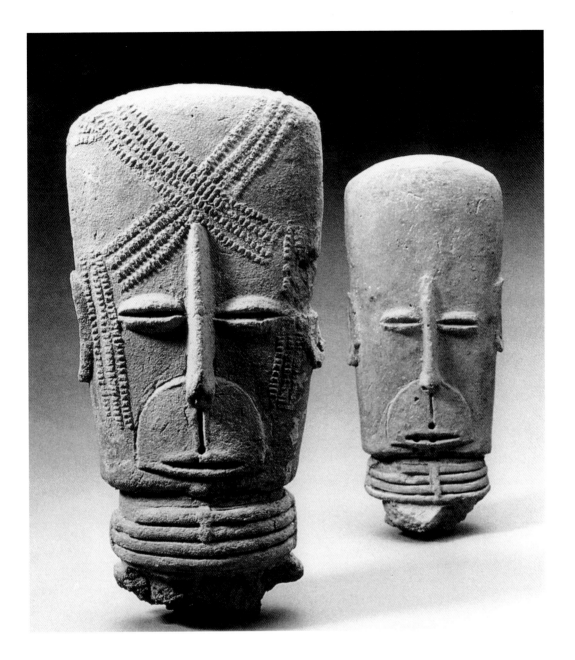

Nok sculpture

Nok (a village near which the first finds were made) pottery sculptures are found over a considerable part of the moist woodlands towards the southern edge of the savanna of Nigeria, immediately east of the Niger River and almost all north of the Benue River. Most of the earlier finds—the first was made in 1928—were exposed in the course of open-cast mining of alluvial tin deposits. They were usually buried under up to 8 m of sand and gravel. All had been moved by water

One of the earlier finds of Nok sculpture, the Dinya head is lifesize. The shape of the eyes is distinctive: the eyebrow is arched to echo the shape of the lower lid. The voids of the irises give an unexpected depth that becomes the focus of one's attention. The nose is scarcely modelled but the nostrils are flared. The lips are full and sensual. The hair is elaborately dressed and there is a circlet round the top of forehead. The clarity and simplicity of form and crisp, decisive modelling are basic elements of the Nok tradition.

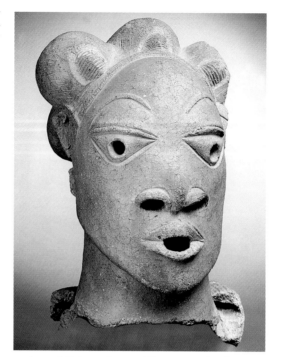

action. All but the smallest were broken and incomplete but many cannot have been carried any distance for they retained their original surfaces undamaged.

Only two Nok settlement sites have been located and excavated by archaeologists—both on a very small scale. Two sculptures found at Taruga, 55 km from the Nigerian capital of Abuja, led to excavation at the find-site.[12] The remains of ten iron-smelting furnaces were exposed, as well as raw materials and debris from smelting and abundant potsherds. The occupation has been dated to between 400 and 200 BCE. This makes it one of the earliest iron-smelting sites in Africa and has been taken to indicate that iron-smelting was developed in this region independently of any outside contacts or influences. At Samun Dukiya, in the Nok Valley itself, a thin layer of domestic settlement debris was exposed and dated to between 300 and 100 BCE.[13] The most useful results from these excavations was to give us the only dates we have for the associated Nok sculptures. Otherwise they showed that the art was the product of small farming communities, isolated from the outside world; and that though they had developed iron-smelting, they only used the metal sparingly and were still relying on polished stone implements for their heavier agricultural work.

Formal analysis

With no archaeological contexts, one can do no more than describe the objects themselves. A few small figures are solid. All the larger ones are

hollow and built up with coils of clay in exactly the same way that pottery was made. The fabric was well tempered with grit, if only because in the course of coil-building the clay had to support considerable weight before it dried and was fired. Given the size of many sculptures—some may have been almost lifesize—they had to be hollow to reduce weight and material, to allow for thorough drying and firing, and to reduce the stresses of firing. Vents were essential to reduce the pressures of the water vapour produced during firing and to allow its escape. They were provided in the natural orifices of the sculpted bodies: the irises of the eyes, nostrils, earholes, and mouths. A lot of the detailed modelling seems to have been cut into the fabric when the clay was almost leather-hard. Lines and forms are so crisp and sharply defined that it looks as if many pieces were carved. Many figures sit or stand on plinths formed by an upturned pot. This only further demonstrates how closely allied and integrated pottery-making and sculpture were [**61**].

The forms of Nok sculpture have a geometry, a structure, and a decisiveness quite unlike those of Mali. Nok sculptures may lack the compositional complexity of Malian art but they gain in their sense of monumentality and inevitability. The sculptural tradition clearly demanded of the artists that they thought through to the essence of their forms before they approached the clay. It is an art very clearly and precisely conceived before it was created. Basic forms were simple and simplified. There is little spontaneity or improvisation. One cannot deny that to some eyes Nok sculpture will have a greater purely aesthetic appeal than the art of Mali, despite the latter's more deeply involving evocations.

It is unlikely that in the normal course of everyday life people wore the apparel depicted. The adornments are so nearly universal that it is difficult to envisage that they represent people of a particular status. Rather, these images seem to represent people present at some rare and significant special event, participants in ceremony or ritual. Few men are armed although at least one sculpture does show a man holding a baton and shield. His body is covered with pendants and small human figures which can be read as protective amulets or charms. Other small identifying insignia are held by some of the more complete figures now appearing. The single static human figure was clearly the prime concern of the artists. But the corpus is enlarged by sculptures that are the creations of myth, belief, and imagination: Janus figures; a figure with human adornment but a bird's beak, legs, and tail, yet human hands though these are half-clenched in a bird's grasp;[14] an elephant head that nevertheless retains the distinctive human eyes and brow. A range of animals were also sculpted but these are much less common— as far as we know—and less attention was paid to their forms and details.

61

Figure of a kneeling man on an upside-down pot. A small, neat spade beard and tufts of hair at the corners of the mouth are characteristic of Nok sculptures. The bodies are naked and the feet are bare. Almost all figures are swathed in an extravagance of beads and pendants (if that is what they are: individual beads are not delineated, and they may represent coils of fibre). This is a pointer towards meaning. Pieces so complete and in such fine condition as this were unknown before widespread looting began.

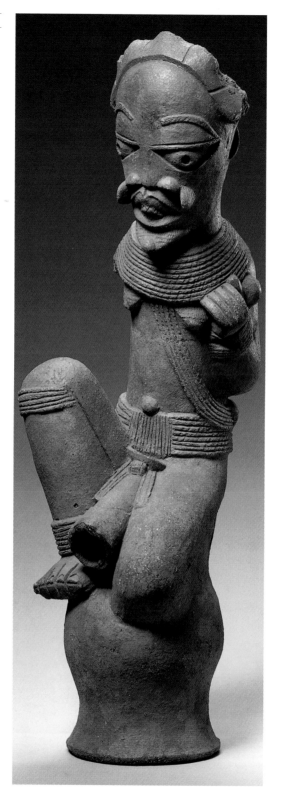

Calabar

Far within the tropical forest and close to Nigeria's border with Cameroon, a new and completely unexpected early sculptural tradition was revealed in 1995 in a cluster of some six extensive graveyards dated to the eighth and ninth centuries CE. Considerable numbers of domestic pottery vessels in a hitherto unknown style seemed to have been placed in and on the graves, together with sculptures of standing human figures. Investigations of the site had to be curtailed after only two days. When it was possible to resume, a year later, almost everything had been destroyed or pillaged, and works from the site were already on display and offered for sale in New York. The excavator was left still seeking funds for a proper investigation of the vestiges [62].[15]

Conclusion

Broad similarities between all of the sculptural traditions exist. There is a general concern with the armed horseman in the north—but not in the humid environment of Nok, where disease would have inhibited the use of horses. Frequently, but not in Jenne-Jeno, sculpture is set on pottery vessels. We now have firm evidence that at least at some periods such pots were used in funerals, contained parts of corpses, and served as grave markers. The combination of pot and sculpture strengthens the argument that, despite the concern with armed horsemen, the art was all created by women. The historical craft division in which all potters were women and all metal-workers men is rigid, long-lived, and universal, probably throughout the whole of sub-Saharan Africa. In the absence of firm evidence to the contrary, it is illogical and perverse to assume that the pottery sculpture of the Niger Valley, Nok, and, later, Ife were exceptions to this rule. We know nothing of sculpture in other materials. Inevitably, it is only the pottery that is preserved. Later experience would suggest that wood would have been the major vehicle for sculpture. If this was so, its forms and concerns are forever beyond our knowledge. All we can safely now assert is that many different peoples along the course of the Niger were expressing themselves and some of the fundamental beliefs of their societies in plastic art. In many groups, sculpted pots played an important part in funeral ceremonies, marked graves, and probably commemorated lineage heads, ancestors, and their wives.

More than most, this chapter illustrates many of the frustrations of African archaeology and art history. Researchers are few. Economic austerities confine them to their own very limited areas or even to their desks. The little work that is done is too often opportunistic. Few sites have been adequately excavated or studied. Seldom have the right

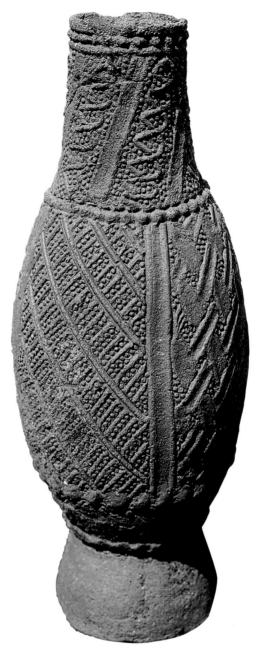

questions been asked of them—or indeed any questions at all. Too
often they are simply partially exposed and described and then
expected to speak for themselves. Change is neither defined nor dated.
On the possible relationships between traditions, there is almost com-
plete silence. No one seems to travel to the different museums of the
region and handle the great variety of material available for study or to
undertake the wide-ranging and systematic comparative studies that
are so urgently needed. The focus has been on the objects themselves

and not on the significances and meanings that they certainly carry. Descriptions of form, technique, composition, or 'style' and ethnocentric judgements are a pitiful substitute. The ethnographic parallels that have been trumpeted as the answer to questions of meaning are superficial and simplistic.

The work in and around Jenne-Jeno is almost the sole exception to this tale of woe and thus serves to highlight the inadequacies of so much of the rest, the opportunities that have been missed, and the rich rewards that are within reach given the right personnel, funds, training, and approaches. Meanwhile destruction, pillage, and theft continue on so large a scale that one begins to fear that in the not too distant future there will be nothing left to study.

West African Forests

6

To a stranger, the tropical forests of west Africa appear a uniformly forbidding environment. The zone is in fact a mosaic of different densities of vegetation: some easily traversable virgin forest, some impenetrable and now seemingly ageless secondary growth, fallow farm clearings reverting to bush, and productive farmland. The forest may have been comparatively densely and permanently settled for many millennia. It can be highly productive, producing foods like yams, okra, palm oil, wine and dates, edible fish and snails, and a variety of small creatures. There was potentially profitable trade in such products as ivory, slaves, and kola nuts, one of the few stimulants allowed to Muslims.

The grave and shrines of Igbo-Ukwu

Igbo-Ukwu lies not far from the eastern bank of the lower Niger River. A farmer began to find many bronze objects here as he dug a cistern near his house in 1939. This he reported to the authorities—to little effect. Many of the objects lay around disregarded for 20 years and many were given away. Only in 1959 was Thurstan Shaw, a meticulous archaeologist with wide west African experience, invited to investigate the site.[1] His finds were startling: 721 metal objects were recovered. Some, including great bronze basins and other more intricately worked containers, had, it seems, once stood on display in a small shelter or shrine; others were hidden together beneath a thin covering of soil. The richest concentration came from a single grave. The grave shaft contained the bones of five people [64].

Igbo-Ukwu posed many new problems: problems of dating, of the sources of the raw material, of the origins of the casting technology, and of the nature of the institutions that created so lavish a concentration of objects. The finds at Igbo-Ukwu broke all preconceived ideas: that such refined technical skills and art could not originate in a country with no known sources of the metal ores, or in one with few if any contacts with the outside world, or in one with no history of royal courts to support such artistry.

Three of the four radiocarbon dates that were obtained place the burial and shrines in the ninth to tenth centuries CE. These are so early

63
The life-size brass heads of Ife are powerful expressions of serenity born of divine authority. This was the most important quality of any ruler. The holes in the casts probably held veils of beads, that are still an essential item of Yoruba regalia. The veils are intended to make the extraordinary potency of a ruler's words less likely to cause fear and hurt. Mystery masks majesty.

Reconstruction of the burial at Igbo-Ukwu. The corpse was sat on a stool, wearing a diadem with high sidepieces, his chest covered with a great pectoral of hammered copper, his limbs with long tubular armlets and anklets. He wore several pendants and crotals and held the ceremonial insignia of a staff, fan, and fly whisk. Sculpted staffs, swords, scabbards, and three elephant tusks were arranged around him. He was further adorned with over 100,000 glass beads.

that they put Igbo-Ukwu beyond the reach of north African crafts-men. They caused particular consternation and argument but were resolutely defended by Shaw and have now gained general acceptance.[2]

The metals used at Igbo-Ukwu all came from a single source; cast-ings were not made from re-smelted or re-used mixtures of alloys. Local sources for the metal ores have now been located in the Benue valley, 100 km east of Igbo-Ukwu, and they show evidence that they were worked in pre-colonial times.[3] Some of these ores are a natural mix of copper, tin, and lead that match the compositions of the Igbo-Ukwu bronzes. More that this, the castings all contain an unusually

Lost-wax casting

The lost-wax technique of casting was used in almost all the Igbo-Ukwu objects. The prototype of the desired final object was sculpted in wax and then covered in a strong clay outer casing. The molten metal was then poured into the casing to melt the wax and replace it with the metal alloy, which thus took the exact shape of the wax. The detail of the Igbo-Ukwu castings is so delicate that many believe a latex, possibly from a species of euphorbia, was used instead of the more usual bee's wax. Most lost-wax castings are hollow castings in which clay core and casing are held apart by metal pins. At Igbo-Ukwu castings were not hollow but deeply undercut: a technique that had ceased to be used in the Mediterranean world a thousand years before Igbo-Ukwu.

The most elaborate cast vessel, set on a stand and enmeshed in ropework, was cast in several stages which were then joined together by brazing or burning in more bronze: a technique not found abroad.

65

Gours were the basis of many vessel shapes at Igbo-Ukwu, and actual gourds were decorated with bronze strapwork and handles. 'Every surface [is] breathing light, creating rather than occupying space, immaterial yet massive with energy . . . a glory in light as agent and end . . . an exquisite explosion without antecedent or issue' (D. Williams, *Icon and Image*, London, 1974, 211).

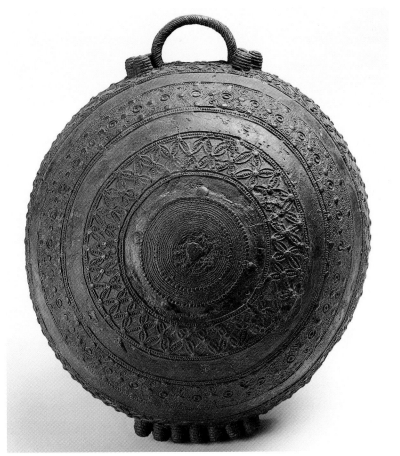

high proportion of silver—like the Benue ores. Silver this rich was refined out of all similar Mediterranean ores so that it could be fabricated into more valuable objects: so Mediterranean craftsmen were unlikely to have been a source for the Igbo-Ukwu castings.

The surface detail of many objects is not only fine, it incorporates representations of things as small as insects that seem to have just alighted on the surfaces [**66**]. There are many decorative twirls, discs, rosettes, and nets of what look like fine wire [**65**]. They are not: they are unexpectedly all integral parts of the castings. None were made separately and soldered or rivetted to the bodies of the objects. However masterful the results, to a foreign metalworker of a thousand years ago the technology of Igbo-Ukwu would have seemed inappropriate, inefficient, and archaic: a strong indicator of the isolation in which it had developed. Far to the north, in the tumulus of Sintiou Bara in Senegal and in a workshop of Tegdaoust, there are the slightest hints of another otherwise unknown early tradition of metalworking and inappropriate lost-wax casting.[4] If such a tradition did in fact exist, did it have the same indigenous roots as Igbo-Ukwu?

Prehistorians were once startled by demonstrations that iron

The bronzes of Igbo-Ukwu invite comparison with the finest jewellery of Rococo Europe or of Carl Fabergé. They are characterized above all by the intricacy and abundance of their detail and decoration. They focus on the natural world and what are usually considered insignificant parts of it: insects, snails, chameleons, or newly hatched birds (as here). Larger creatures were also represented occasionally.

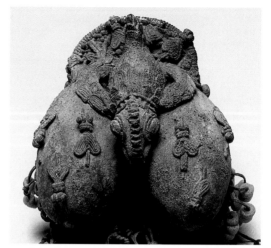

smelting and working were invented, and developed, independently of the outside world, in west Africa in the region of Nok and in east Africa in the region of the Great Lakes. Igbo-Ukwu now offers a further surprise: evidence of the equally independent invention and development of a rich and early African tradition of bronze casting.

The burial at Igbo-Ukwu was of a man with absolute authority over life and death. His authority was ratified by a highly developed symbolic system—witnessed by the many insignia of office on and around him. He owned very considerable wealth—evidenced not just by the metalwork but by the tusks and beads. Many specialist craftsmen with extraordinary technical and artistic skills were devoted to his service. The Igbo today seem a people without any of the social organizations or institutions that would stimulate such a centralization of wealth and power, supported by so sophisticated a symbolic system or by so many specialist craftsmen. There is, however, at least one Igbo public personage who might parallel the man buried so long before him: the Eze Nri, who is the senior member of a corporate society concerned with ritual surrounding the fertility of land and with resolving disputes but with no further political power. Several aspects of the burial and of the regalia of the corpse are said to have strong parallels with those associated with the Igbo Eze Nri or Ozo institutions.

The Yoruba

The Yoruba people of south-western Nigeria and Benin (Dahomey), living both within the forest and in the woodland and savanna immediately to the north of it, have long formed dense populations clustered in large towns and cities. Many Yoruba kingdoms grew up, from Oyo in the northern savanna to Owo in the east. The Yoruba are considered the most urban of all African peoples. They have always formally defined their identities and loyalties in terms of their home

cities. As so often in Africa, the concept and label Yoruba, although it has a linguistic validity, is a comparatively recent invention by Muslim and Christian intellectuals, providing administrative tidiness and a source of political power.

Ife (or more correctly Ile-Ife), a comparatively modest Yoruba town with little political, economic, or military power, has long been recognized by all Yoruba as having a spiritual primacy. Myths tell in great detail how the creator god, Oduduwa, here separated the earth from the waters and made all sentient creatures. The institution of kingship was established when the sons and daughters of Oduduwa were sent to rule the twelve major cities of the Yoruba and beyond—as far afield as the Edo city of Benin. They became divine kings and queens. Many Yoruba rulers still accept that their authority ultimately derives from the Oni (King) of Ife. During its history, Ife was several times almost entirely abandoned. Shrines and palaces fell into decay. There was thus a loss of continuity and understanding of the practices that surrounded the early art, its roles and significance. Nevertheless Ife more than most Yoruba towns is still a town of shrines, of sacred forest groves, of cults and fraternities—popularly called 'secret societies'—all dedicated to and serving different divinities within the compendious Yoruba pantheon.[5]

Art in Ife

Granite stelae, only minimally worked and sometimes inlaid with iron nails, and a few granite carvings are assumed to be the earliest surviving art of Ife. A culture of fine craftsmanship developed. Glass beads were manufactured on a considerable scale but it is still unclear whether this included the making of glass or only the remelting and reworking of imported beads. Ceremonial stools (like those shown in brass and pottery in **68** and **69**) were made from large blocks of quartz—a labour that challenges the imagination, for their shapes are complex and this most brittle and intractable material could not be carved but had to be ground to shape.

Buildings were substantial but the consolidated clay of which their walls were made was dug up in situ so that when they decay they are archaeologically almost invisible and irrecoverable—at least without the use of modern sensing techniques. All that remains of some walls is a scatter of small pottery discs, carefully ground from sherds, which once formed patterned mosaics on the walls. Many rectangular courtyards within buildings were paved with considerable precision with lines of quartz pebbles or broken potsherds laid on edge in herringbone patterns. Frequently the contrasting colours and textures of pebbles and sherds were exploited to form intricate geometric patterns. Some of these courts were oriented north–south or east–west with an exactitude that points to ritual requirements rather than

careful design or town planning. Many such courts had altars at one or both ends of their long axes: low rounded semicircular structures faced with potsherds laid like those of the paving. Many also had the neck of a pot embedded in the centre, around which the pavement was designed.

Ife brasses

Ife is most famous for its sculpture in metal, almost all of it in brass—an alloy of copper that contains small quantities of tin and zinc. In composition its sculptures are thus very different to the bronzes of

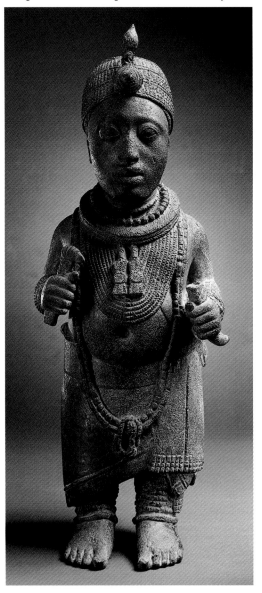

67

The smaller than lifesize brasses of Onis wear plain hemmed wrappers, solid metal anklets, an abundance of beads up forearms and calves, multiple close-set strings covering most of the chest and hanging down in a multiple loop to the knees, a necklace of a single string of different beads, and a possible metal torque. Beaded caps have an ornate crested cockade at the front. They carry a forest buffalo horn, probably a medicine container, and a short staff. The insignia of a double bow hangs over the chest.

Igbo-Ukwu. Each piece is again a unique product of the lost-wax method of casting. They exhibit less technical mastery than the Igbo-Ukwu material. Many pieces had encountered problems because the molten metal was not poured in a single operation and the first pour was allowed to cool before the second, or because wax and air were not fully ejected from some casts so that air bubbles were trapped in the molten metal. Repairs, brazing in patches of new metal, were sometimes necessary—though none of this is so obvious that it detracts from the final effect.

In 1910 the ethnographer Leo Frobenius gained possession of the first brass to be seen by outside eyes.[6] This half-size crowned head with a striated face gave rise to elaborate speculation about ancient non-African settlements and colonies on the west coast of Africa, focusing particularly on classical Greece—almost inevitably, given the preconceptions of the time in Europe and the discoverer.

In 1938 13 lifesize heads and one half-size head were found during the digging of house foundations in the Wunmonijie Compound just behind the royal palace [5, 61, 70]. The site was almost certainly once within the palace which was probably reduced in size as a consequence of disruptions in the late nineteenth century. A few months later five more brasses were found in further diggings in the same compound: another lifesize head, three smaller heads, and a torso. About the same time it was revealed that a lifesize mask cast from pure copper—a very difficult task for molten copper flows with much greater difficulty than bronze or brass—had always been kept in the palace.

In 1957 building workers found seven more bronzes, at Ita Yemoo on the north-eastern outskirts of the town near one of the later town walls and an important gate. These comprised a small standing man [67], a linked pair of royal figures of similar size, a much smaller female figure curled round a pot placed on top of a stool [68], and four staffs or mace-heads. The total corpus of known metal sculpture thus amounts to fewer than 30 pieces.[7] All were found accidentally and nothing has been recovered of their associations although it is safe to assume that the Wunmonijie finds were all originally held in the palace.

Analyses of the brasses

The heads are not portraits. A moment's consideration shows their degree of stylization [61, 70]. The artists' insight into anatomy and the underlying structures of muscle and bone was slight. The eyes give little sense of an eyeball in its socket: most are unnaturally small and have a strange, slanting, almond shape. Ear forms are greatly simplified and the projections of the rear of the crania are abbreviated. In the torsos and full-length figures the head is disproportionately large.

The usual approach to understanding more about these heads has

68

A brass vessel in the shape of
a ceremonial stool with a
queen wrapped round it. The
loop of such stools may
symbolize an elephant's
trunk, an animal of
impressive power. The tip of
the trunk touches the edge of
the seat itself. The seated
person's genitals were thus
very near the tip of the trunk
and thus derived strength
from it. The figure here
caresses the trunk.

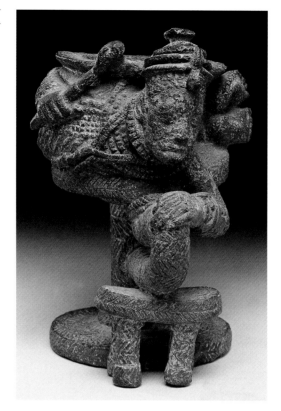

69

Reconstruction of a
ceremonial stool and part of a
figure. The pedestal (right)
resembles a traditional bark
container for medicines
generating spiritual energy,
The bands round the pedestal
may have been of copper with
glass bosses: a strip like this
was found in the same place
as this sculpture. A footstool
supports the loop and feet.

One of the lifesize brass heads from the Wunmonijie Compound, Ife. Close set vertical grooving covers the face. For a long time this was accepted as representing scarification and hence denoting ethnic, clan, or cult allegiances. But the Yoruba are not known to have scarified themselves at all like this. More subtle interpretations now look more likely. For instance, it seems possible that this light grooving was an aesthetic device used to enhance form, introduce texture, and minimize reflections that could confuse forms.

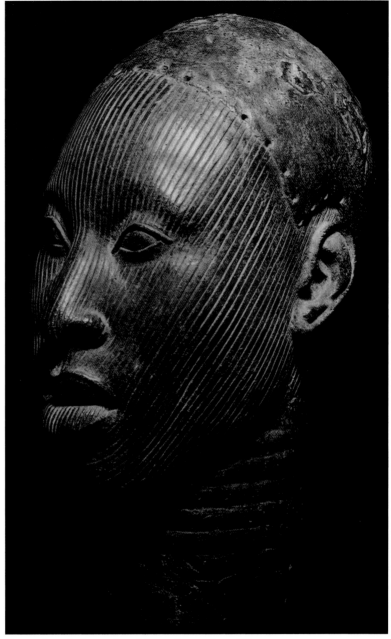

focused entirely on the objects themselves. There seemed to be a strong 'family resemblance' between many of the works and therefore they were taken to be representations of members of a single—royal?—family, or the work of a single sculptor. This encouraged some scholars to try to discern groupings, workshops, and individual artists. In one analysis the researcher selected 87 different criteria to produce five clusters of brasses.[8]

Samples of the brass have been analysed in terms of the proportions

of different metals in the alloys,[9] and these have also been arranged in groupings. These again are of dubious significance. It is likely that all the alloys used had been produced by melting down earlier pieces: a process that may well have happened several times. The resulting mixtures of metals are likely to be almost entirely fortuitous.

When it comes to seeking the purpose of the heads, one suggestion has been frequently reiterated: that they were originally effigies used in funerary ceremonies. They are seen as very lifelike; and lifesize and lifelike clothed effigies are used by some sections of some Yoruba communities in funeral ceremonies today.[10] This analogy is weak. If it is also accepted, as it usually is, that the heads represent Onis then they cannot be funerary. An Oni is divine; he therefore never dies; he has neither funeral nor recognized grave. In fact, parts of his body are said to be so potent that they are secretly distributed so that others may share in his spiritual energies.

It is worth remarking here that the brass mace and staff heads of Ita Yemoo are our first encounter with a very different aspect of Ife art to that exemplified by the other brasses. They depict small, rough, deeply undercut, vividly modelled, and very individual heads, displaying their age and emotions without reservation. Three are gagged. This would signify to the Yoruba that the subject was facing imminent execution. All their victims were gagged to prevent any utterance and particularly the release of the enormous spiritual force in a dying curse.

Ife pottery sculpture

The Ife brasses are an integral part of a much larger body of sculpture. Scores of pottery sculptures have now been found, though very few in their original contexts. General appearance, finish, and many details show that the concerns of much of this material were very closely similar to those of the bronzes. The subject matter is, however, a great deal more diverse.

Like the Nok sculptures, these works were very considerable technical achievements. They were in large part hollow and were built up in sections, each section being allowed to dry partially until it was firm enough to take the weight of the next section, yet not so dry that the junction between sections could not be luted together nor be liable to crack. The subsequent firing stresses would have been very great and potentially disastrous; vents had to be provided to allow the steam and gases generated internally to escape.

Much of this material was the result of chance finds. Pottery heads are still found regularly in the town today, eroding out of ancient deposits or recovered from various domestic or commercial diggings. Such finds frequently used to be deposited in shrines or groves, to be buried and then dug up regularly to be incorporated in rituals. They

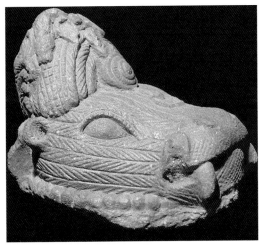

An animal resembling a hippopotamus, save for its protruding tusks, from the Lafogido site. Like all the sculptures from this site, it has heavy features, large eyes, overall incised herringbone patterns, great curving braids rising to a crest on the top of the crown and sweeping down the back of the neck, a cockade at the front of the crest, and necklaces of large round beads.

were thus separated from their original contexts and associations and their new functions had little or no connection with their original ones.

Archaeology provides the contexts

In 1959 and 1962 Frank Willett attempted to determine the precise contexts of the Ita Yemoo brasses. He excavated two pavements at the site. Their exact relationships to the brasses—if any—was never stated. He has never published a full record of his work: one is left to seek out snippets of information in his art-historical studies.[11] Pieces of pottery sculptures were found on both pavements. One deposit may have been of seven near lifesize statues.[12] The statues were said to have stood in a mud-walled shrine before they were smashed and jumbled together when the shrine collapsed. The second deposit, of the fragments of two figures of similar size, was even more disturbed and displaced. No attempt seems to have been made to reconstruct any of the figures.

The Lafogido site, Ife

In 1969 Ekpo Eyo excavated a small paved courtyard across the street from the Wunmonijie Compound and, like it, probably once part of the palace.[13] Around the pavement and indeed in part inserted into it, and so destroying five successive layers of pavement, stood 9 to 14 large plain pots. Two were still covered with flat platters on which sculpted animal heads were carefully placed so that they faced inwards. At least two more heads in this series were also recovered. They were all extraordinary objects. A ram and elephant are easily recognizable; others have features of a hippopotamus [71] and an antelope but are either invented or mythical creatures. It is easy to interpret them as representations of sacrificial offerings. Ritual decapitation of sacrifices—both animal and human—was a regular practice at many Yoruba shrines and

is represented in many sculptures. These heads probably signified in part the contents of the pots they covered. Their importance or that of the recipient or donor was signified by the elaboration of their adornments, some of which probably had royal connotations. It may be that they represented sacrifices at a royal grave: a depression suggested the presence of a grave. But excavation was halted at this point by the Oni of Ife because he believed that an ancestor and predecessor of his, Lafogido, was buried there.

Obalara's Land, Ife

In excavations in 1971 many pavements and fragments of pavements were exposed with large numbers of pots still resting largely undisturbed upon them.[14] Ritual and domestic vessels could be distinguished by their different forms, decoration, and colours. They provided a varied corpus of material which may provide, when other excavations take place, better indicators of relative dates, affiliations, and functions for different sites than is currently possible. At the moment this material stands alone. There was no doubt that all the deposits, structures, and finds from Obalara's Land were made, used, and discarded during a single occupation: there was no earlier period of occupation nor any later disturbance. Deposits of human bones, pottery, and sculptures were placed in distinct groups, some marked by stones or iron staffs. It is difficult to avoid the conclusion that these were once again shrine offerings, made when the buildings round the courtyards were still occupied, and offered very probably by the occupiers. They were original accumulations, not later random collections. A scatter of large iron nails may have been the fixings of the shrine itself or of a large item of shrine furniture. The most important deposit was more than forty human skulls collected together and carefully piled up. This took place after decomposition, for they all lacked vertebrae, and several had also lost their lower jaws. Carefully placed on and among them were three extraordinary pottery heads and fragments of their bodies and a sculpted pot [72–74, 78]. The sculptures all emphasize disease, deformities, intense and unpleasant emotions, suffering, and perhaps violence, thus resonating strongly with the skulls and articulating their significance. A second deposit contained the heads and broken remains of five male and female sculptures [75–77]. One large fragment of a torso was more than lifesize. All were simply dressed with only a bead girdle, baldric, and necklace. They seemed to wear plain close-fitting caps. More probably their hair was dressed or covered with a fine powder or clay. These remains were packed close together and carefully arranged, aligned precisely to the north and lying face upwards. With these were three conical heads, never attached to bodies, with features varying from delicate naturalism to

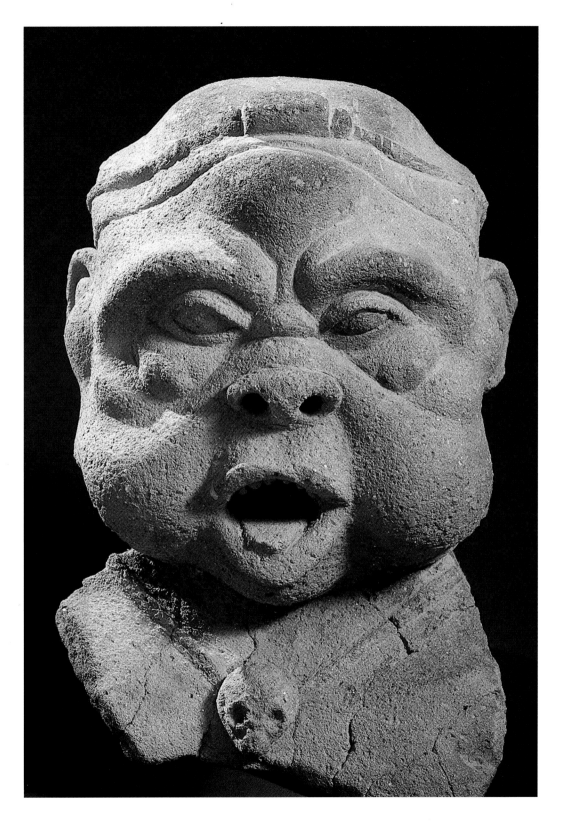

73

This pathetic diseased creature, also from the Obalara skull deposit, has a swelling on one side of his neck, a swollen upper lip, fluid oozing from his nostrils, and bags under his eyes. He was probably reclining with his head on a support. One hand holds his shoulder. The other was by his side and held by someone at the wrist. The body was much less carefully modelled than the head.

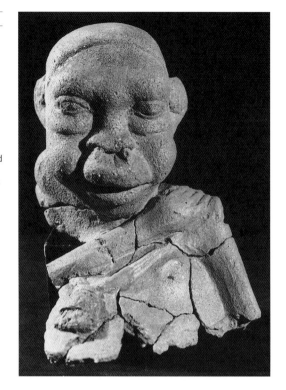

74

A sculpture probably from the skull deposit. It is anacephalous, with bulging eyes, a malformed jaw, and badly protruding teeth. From the corner of his mouth a weal—or gag—ran to his left ear. The emissions from the nostrils are almost certainly snakes and can be matched with much later Benin brasses. Fragments of the body show that an open-mouthed snake climbed up his right thigh and encircled his waist, reminiscent of Mali. Another snake rested its head on his right shoulder.

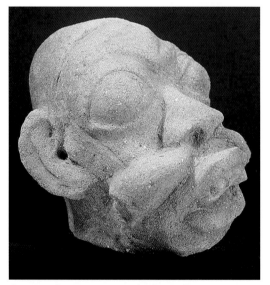

the simplest incisions. A short distance away, a pair of standing male figures, 39 cm tall, were buried together. They were almost identical and very simple, wearing only plain wrappers round their waists. One can guess that they represent servants.

A pot embedded, with only its mouth visible, at the centre of the pavement nearest the shrine, had its bottom broken and removed [76].

The deposit of broken sculptures in the course of excavations at Obalara's Land. Notice the large torso and the conical heads.

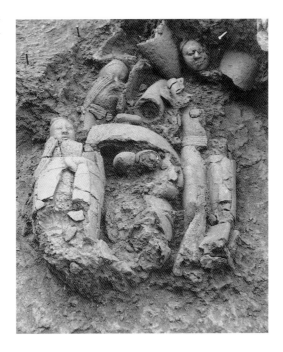

This pot found embedded in the centre of an Obalara pavement. The line of reliefs around it include an open-fronted box-like shrine with a snake resting its head on the fronds of the roof, three pottery heads standing in the shrine, the upended legs of a human body protruding from a basket, a pair of staffs, a drum, a knife, a whip, a pair of horns from a dwarf forest buffalo, and a ring.

It could thus serve as a channel between the courtyard—and its occupants—and the earth. It could receive libations and join two worlds. It was a ritual companion to the altar at the end of the court. Its contemporaneity with the pavement was beyond doubt. At present, it is the only pot buried in a pavement that was more than an undecorated neck.

The reliefs round this pot's sides are not to scale but each of equal

size—a 'segmented composition' of the sort still characteristic of Yoruba art. The central and most important relief depicts three pottery heads—a naturalistic one flanked by conical ones—in a shrine. It thus establishes indisputably what was long suspected but never proven: that pottery sculptures had always been objects of devotion and furnishings of shrines. Looking at some of the other reliefs, the pair of staffs resemble *edan*, the prime insignia of the Ogboni Society, or the bull-roarers that members of the Oro Society whirl to signal an

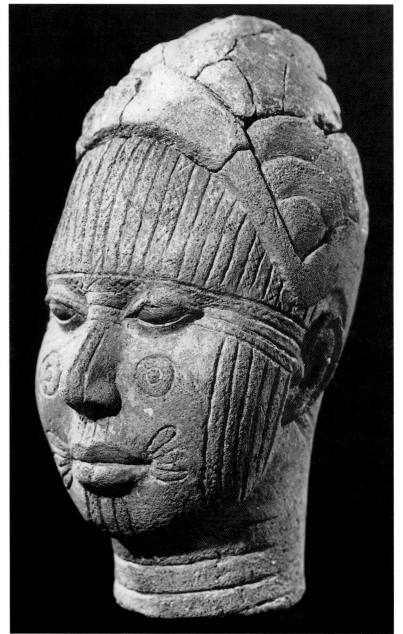

77

From the deposit of sculptures at Obalara's Land, this head retains a great deal of its original paint. The overall incised patterning closely resembles that on the Lafogido royal sacrificial animals. The 'cat's whiskers' are still a common form of Yoruba scarification. The neck rings are a widespread African indicator of wealth. The bottom seems to have been smoothed to provide a firm base after the head was broken from a body.

The fragments of this broken vessel were found under the skulls on Obalara's Land. It shows many of the same ritual instruments as the vessel in **76**: the snake, horns, ring, staffs, knife, and drums, although the two latter take different forms. A gagged, decapitated head replaces the upended corpse. A leopard, probably in the act of springing, echoes the pot mouth. The leopard may denote authority over life and death. Both pots have necklace-like collars.

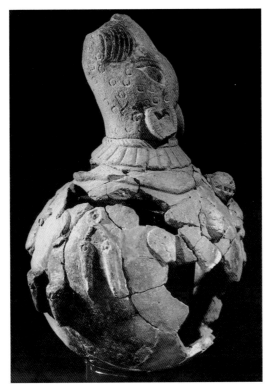

execution. The drum seems to be an *agba*, again of the Ogboni Society. This society is formed by the oldest and wisest elders of a town. They are equal in moral and political authority to the Oni and responsible for his selection and installation. They also judge and punish severe crimes. The Oro Society acted as executioners under the Ogboni Society. In this context the reliefs of the whip, knife, and corpse speak for themselves. The ring may connote the ring on the foreheads of some sculptures of Onis and their royal sacrificial animals. The horns of dwarf buffalo like those shown were often used as medicine containers or worn by diseased people as an insignia of their special status. A second pot [**78**], found beneath the pile of skulls, repeats many of these motifs, albeit in slightly different forms and ways. Its dominant motif is the leopard, recognized as the strongest, fiercest, and most feared creature of the forest. In these two pots we not only have a depiction of sculptures in an original context, we also have many items that indisputably set the art in the context of Yoruba institutions that survive in traditional society today. Direct continuity over more than six centuries can no longer be doubted.

Contexts of the Obalara sculpture

There were some other propositions one could deduce from the Obalara deposits. The two distinct clusters of sculptures emphasize

Dates

Several radiocarbon dates from Ife have only the most dubious human associations. Others derive from sites about which we only know that they were the products of human occupation. These go back perhaps as far as the sixth century CE. Lafogido yielded a single date from charcoal embedded in the surface of the pavement—1110 ± 95 BCE. It has uncertain associations with the sculptures, which may be significantly later. The deposits that overlay the pavements and contained the sculptures at Ita Yemoo produced dates with very large standard deviations, 1060 ± 130 and 1150 ± 200, which place them between the tenth and early fourteenth centuries. Thermoluminescence dates from samples taken directly from Ita Yemoo pottery and a pottery sculpture, 1275 ± 80, 1375 ± 70, 1200 ± 95, gave a mean of 1285 ± 75.[15] Samples from Obalara's Land most closely associated with concentrations of pottery, bones, or sculpture gave radiocarbon dates of 1190 ± 85, 1325 ± 75, 1370 ± 60, and 1470 ± 96, with a mean date of 1340 ± 95. There is thus nothing to separate Ita Yemoo and Obalara's Land in time. Five samples from two pavement complexes at Woye Asiri, adjoining Obalara's Land, dated the occupation to between 1165 ± 75 and 1405 ± 85.

Though thermoluminescence dates are not trustworthy without safeguards which can only be taken in controlled excavation, it is worth noting those obtained from the clay cores of Ife brasses. The cores of two Wunmonijie heads gave dates of 1490 ± 85 and 1440 ± 65. The core of the Oni from Ita Yemoo [67] gave a date of 1365 ± 70, and samples from the core of the Ita Yemoo royal pair gave dates of 1440 ± 50 and 1395 ± 55, with a mean of 1420 ± 45. These dates suggest that the brasses sampled may be slightly later than the pottery sculpture.[16]

again the polarity in Ife art between serenity and violence, calm and terror, health and sickness. Broken sculptures were treated and buried like the remains of human beings. Sculptures did not just represent humans, they embodied human qualities and were treated as human. Remains of diseased humans or the remains of those who had met an atrocious or sacrificial death were associated with broken sculptures depicting the horrors of disease and violent emotion. Sculptures depicting the characteristic serenity were buried much more carefully and well apart from the others. The actual objects—the skulls—and the representations of the victims—the sculptures—were treated identically. No distinctions were made between them.

One can envisage the whole Obalara complex as dedicated to or placed under the protection of a divinity but still with strong domestic connotations. It had references to ritual everywhere but this is still true of most houses and compounds in Ife today, all with several altars and their offerings. The labour that went into the pavements suggests lavish expenditure of wealth and specialist craftsmen. No certain connection with royalty is apparent in any of the objects. No sculptures display the elaborate headdresses or crowns of other sites and the site is almost as far as one can get from the present palace. One can best envisage the owner as a senior officer of a religious society or cult.

There has been an effort to discern stylistic changes in the Ife pottery sculptures. Two 'eras' are proposed: the Early Pavement Era, based on Ita Yemoo, and the Late Pavement Era, based on Obalara's

Land. In the first, sculpted heads are said to be refined, composed, and idealized. In the second, they are seen as more expressive, freer, and more natural.[17] Actually there is very little if anything to suggest the sites are not contemporary; the corpus of heads on which the judgements are based is tiny. Differences in 'style' are not necessarily time-based; there are also good indications these two sites were socially and functionally different. At present we have insufficient evidence to construct a sequence of sites or objects. It is unsafe to assert that all the art from Ife was not nearly contemporaneous: it could all have been produced in the fourteenth century. If we seek to place extreme outer limits on the art these would fall between the tenth and fifteenth or sixteenth centuries.

Yoruba aesthetic values and beliefs

Now that continuity has been established between the art of the fourteenth century and the institutions of traditional Yoruba society of today, it is rewarding to try to interpret the early art through traditional Yoruba beliefs, perceptions, and aesthetic values. Work in these fields by Rowland Abiodun provides a valuable starting point.[18] A person's *iwa* (character) derives from and reflects his inner energy and power, *ase*. Energy, not matter, is the true nature of things. The source of *ase* is divine. *Ase* permeates all things, from the gods through nature to curses. (One is reminded of the central place that spiritual energy had in San beliefs and in their rock art. *Ase* and San potency have many similarities, though this in no way implies any connections.) Personal *ase* resides in the head, and emanates and is expressed most strongly in the face, especially in the mouth and speech. The *ase* of a king is particularly powerful, even dangerous. Thus his face and especially his mouth should always be concealed or veiled. The prime symbol of *ase* is the cone. Hence royal crowns—generally made of beads—conventionally have a conical shape with a face embroidered on the front and a long veil of beads hanging down from them. The most important and valued aspects of *iwa* (character), and thus those most sought after in anyone, but especially a king, may be roughly translated as coolness, gentleness, patience, composure, and respect. Character can be equated with *ewa* (beauty). It is true beauty. *Iwa* and *ewa* are aspects of the same essence.

All this can be used to explain a great deal about the early art. The tops of several of the large brass heads were cut back when the wax prototypes were complete, apparently to ensure that some particular headgear would fit them exactly: a crown, perhaps in the form of a beaded cone. The conical head with only the face delineated was a prime symbol of the early art: two such heads stand in the Obalara relief of a shrine [76] and three were found in the concentration of Obalara

pottery sculptures [75]. These sculpted cones can be understood at different levels as representations of crowns or as symbols of *ase*.

If the brass heads were fitted with beaded crowns, veils of strings of beads may have hung from them. Such veils were almost certainly attached to the holes on the hair-lines and round the mouth. Evidence for this survives in the beads still wedged in some of the holes. Now the striations on many of the faces [70] can be interpreted on yet another level, not as scarifications or aesthetic devices, but as the shadows cast by veils of strings of beads. To put it another way, striations and veils mark the acceptable boundaries of the inner *ase* and prevent its uncontrolled and damaging escape.

On a practical level the heads can be seen simply as stands on which royal crowns were once displayed. But they were much more than this. As has been recognized for so long, they are striking exemplifications of repose and serenity, in fact of all the qualities of character—and hence of beauty—most sought after in a ruler. The heads are not portraits of individuals or of particular rulers. They are explorations of the nature of kings and kingship, of divine authority and its proper exercise. They are symbols of *ase* itself. Glimpsed through veils, blurred by grooving, one reaches a partial vision of the nature and power of divine kingship. The sculptures deal with *owu*, that is to say they convey an idea or concept beyond the object, the immortal not the mortal. Furthermore they are concerned with *orun*, the spiritual world, and not *aye*, the visible world. Harnessing *ase*, they energize, restructure, and transform a space, giving it a spiritual power. They do not simply depict or symbolize *ase*. They themselves are or are becoming powerful containers and active agents of *ase*.

There is a final point to make about the brass royal heads. Most have four holes around the neck to which something was once attached. One such hole still has a nail in it. The attachment may have been a heavy neck ring. A few pottery heads wear such rings. A ring is part of the reliefs on the Obalara ritual pots. Several large cast brass rings that would fit this purpose have been found in Nigeria in recent years and exported secretly, their contexts unknown. They have on them scenes of decapitation, and similar objects to those shown in relief on the ritual vessels that would associate them with the Ogboni Society [79]. So it is possible that the royal heads, with their serene majesty, once brought together the two aspects of Ife art. They literally rested on and were supported by the naked power and violence of the law, depicted so vividly on the royal accoutrements: the rings round their necks.[19]

So we come full circle. The foreigners who were so moved by the art and saw it as so serene were in fact near to touching on its true significance (almost suggesting that the art of Ife spoke in a universal language). This can now be fully recognized, explored, and appreciated once the art is set in the contexts which stimulated and generated it:

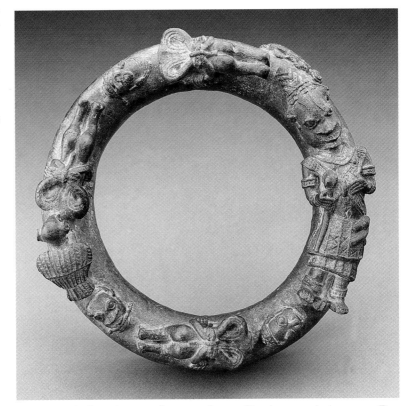

Yoruba beliefs, values, and perceptions of both art and character. But we cannot forget the obverse of the tranquility we all admire. Artists just as competent and expressive showed with equally impressive insight and conviction—and great intensity—the violence, horrors, agonies, and sufferings of another part of society. Mortality is set against immortality, pain against serenity, restraint against abandon, the victim against authority, the sacrificial against the divine. In comparison, the middle ground of ordinary life was ignored.

Yoruba art beyond Ife

The art of Ife has usually been treated as a localized phenomenon. This is not entirely true. Isolated pottery sculptures owing at least something to Ife have been found up to about 80 km from the town. At Tada on the Niger River nearly 200 km north of Ife, the largest and finest Ife brass was tended by Nupe villagers, perhaps for many centuries. It is a full-length seated man wearing only a decorated wrapper. It has been taken as an indicator of the direction of the trade that brought wealth and raw materials for the brasses to Ife. This argument is strained and tenuous. I prefer to admit to our near-total ignorance of the economy of early Ife.[20] The Tada brass is more likely to be a war trophy, possibly marking the boundary between opposing powers.[21]

80

A sculpture excavated at Igbo
Laja, Owo. The leopard
devours a human leg. It
carries the same
connotations of power,
punishment, and death and
is almost identical in style to
the leopards depicted in **78**.

81

Drawings of ritual pots from
Igbo-Ukwu (left) and
Obalara's Land (right).
Fourteenth-century Ife ritual
pottery was distinguished, as
today, by elaborate ribbing,
reliefs, and a red slip. There
are clear resemblances
between this and the much
earlier Igbo-Ukwu ware. This
provides the slightest hint
that these two great and
currently isolated artistic
traditions may have links.

The Yoruba town of Owo lies 160 km east of Ife and somewhat nearer Benin than Ife. Here in 1971 Eyo excavated concentrations of pottery and sculpture not unlike the concentrations on Obalara's Land, though the Owo ones were probably not all contemporary.[22] He also saw them as shrine offerings. The terracottas included heads, a fine seated leopard devouring a human leg [80], a basket of fruit and—the other side of the coin once again—a basket of wounded and decapitated human heads bearing marks or hairstyles of different ethnic groups, perhaps prisoners of war. Eyo has claimed that the Owo sculptures constitute a distinct entity or sculptural style drawing on both Ife and Benin. I cannot see this. Every feature he advances in support of his perception can be matched almost exactly and in every feature by pieces from Obalara's Land, where it gives no indication of being extraneous to the Ife corpus. The only difference, appropriately enough, may be the slight and enigmatic dimpled smiles that play on the faces of the two finest heads.

The myths and traditions of the city of Benin point to Ife as the origin of kingship and brass casting. This is supported by a single cast of a small figure from the palace of Benin which in some details looks as if it is an Ife piece.[23] Much more convincing indicators of an Ife–Benin connection are several common symbols: the snakes that curled down the gables of the Benin palace and the one that curls down onto the Obalara relief of a shrine; the figures from both towns which show snake-like processes coming out of nostrils; the leopard that has authority over human life and death. It is inappropriate to discuss the art of Benin here. The tradition only flowered fully when an abundance of trade brass began to reach Benin in vessels from Portugal in the late fifteenth century.

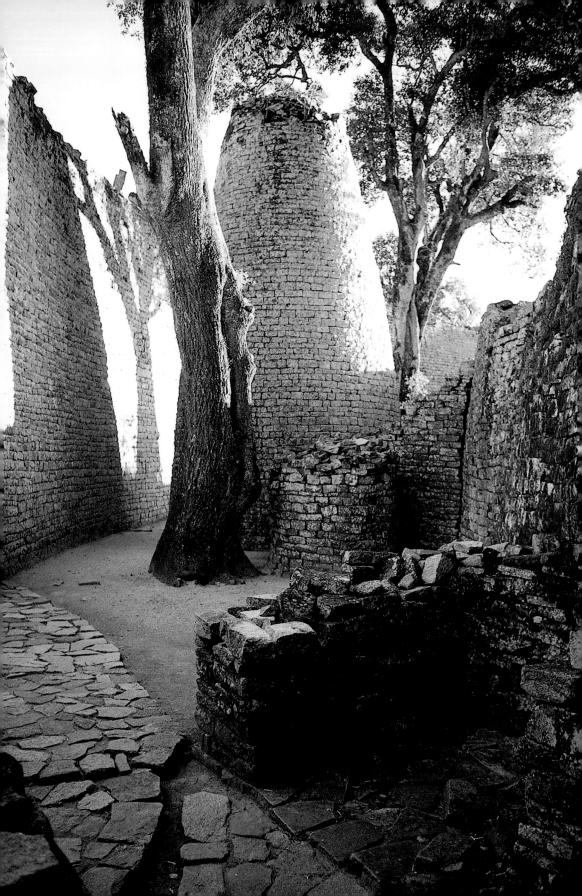

Great Zimbabwe and the Southern African Interior

7

Developments in herding and farming transformed the hunting and gathering communities of sub-Saharan Africa described in Chapter 2. The adoption of these new methods of livelihood was initially hesitant, uncertain, and unplanned. In good seasons people would plant sorghum and millets. In drought years they would revert to hunting animals and gathering wild plants for their subsistence. As village populations grew, new lands were cleared and new settlements established, but expansion was opportunistic and directionless. Ideas spread faster than people; crops, animals, and metal technologies diffused in different ways and in response to different stimuli. Different social adjustments and institutional preconditions were demanded. Non-nomadic populations, for instance, were prone to new diseases and strategies had to be developed to counteract these. As we have seen, iron was smelted at Taruga, a Nigerian site, in about the fourth century BCE. Similar developments probably occurred all along the northern savanna belt at about the same time. Claims are also made for a substantial and sophisticated iron industry some centuries before Taruga, in the area west of the Great Lakes of east Africa. It still may have been many years before iron tools became available in sufficient quantities to provide everyone with axes and hoes, thus allowing land clearance and farming to gather pace.

Because there are broad general correlations between the distribution of settled farmers, of ironworking, of pottery within the Early Iron Age traditions, and the current distribution of Bantu-speakers, at first it seemed obvious to package the four together and attribute their spread to a migration or migrations. For nearly fifty years archaeologists plotted apparent patterns of movements of different Early Iron Age pottery styles and speakers of different Bantu languages, and defined relationships between these groups. A great deal of this work has become less and less sustainable. It becomes more and more clear that pottery styles, ethnicity, and language cannot be correlated in any simple way. Genealogical 'trees' tracing language or ceramic relationships are misleading. Languages, like biological species, may differentiate if isolated. But they never are isolated, or at least not for the lengths of time required. A more appropriate model

82

The approach to the Conical Tower, a huge solid circular structure of coursed blocks. Its gently curved inward slope or batter gives rise to the misleading modern appellation. A much smaller round tower stands beside the large one. Low platforms protrude from the walls and a series of low buttresses delimit and demarcate the space round the towers.

Map 6 The South African interior

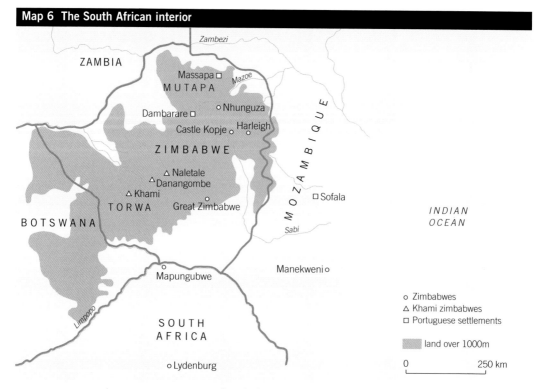

presents a web of changing relationships impossible to disentangle. Linguists have relied on archaeology to bolster their theories of relationships and vice versa. Neither has proved a secure support for the other. Linguistic evidence is incongruent with the archaeological. It can now be shown that language spreads without migration; that in traditional interpretations developments over many centuries have been collapsed into single events; and that the dynamics of language differentiation do not suggest or support migration theories.[1]

The differentiation of society

In about 700 CE, the new ideas, technologies, and socio-economic systems of the Iron Age were introduced to the dry grasslands on the eastern margins of the Kalahari Desert of Botswana. By 900 CE a settled and primarily pastoral society flourished there. The pattern of settlement reflected a hierarchical society with an integrated economy and system of cattle management, even if it did not manifest itself through large buildings or monuments or any of the other physical attributes so often associated with states. This all happened in an area with a climate only marginally suitable for agriculture, few natural resources beyond grazing lands, and no significant contacts with the outside world. It is as far as it is possible to get from overseas traders or trade routes.[2]

At much the same time in the Limpopo River valley, another society grew to prosperity. From the ninth century CE, massive dumps of food debris, ash, and manure testify to large herds of domestic stock. An unusually high proportion of bones of various carnivores and slivers of carved ivory suggest an export trade in pelts and ivory, perhaps making use of the river to reach the coast. Numbers of glass beads, probably manufactured in India, are the only imports to survive. From the late tenth century, the growth of cattle herds is evident. In the late eleventh century, a controlling authority becomes very evident in the royal court that was established on top of the almost inaccessible sandstone plateau of Mapungubwe. Gold reached the capital probably from mines in south-western Zimbabwe while on its way to the southern ports of the east African coast.[3]

These patterns of growing herds, rising prosperity, increasing regional interactions, and the rising power of a single ruler were widespread in the southern African interior. There is no need to propose any direct historical or political connections between the different polities. We are probably witnessing instead universal processes of growth stimulating new relations of production and culminating in Great Zimbabwe.

Early Iron Age Art

Figurines

A small but significant component of most sites in southern Africa, occupied between 900 and 1300 CE, are small fired-clay figurines, particularly of women and cattle [83]. They have strong similarities to much earlier figurines from Nubia [23] right across the west African sahel and savanna to sites like Jenne-Jeno. Many of the figurines are nubile, elegant, and clearly the product of a long tradition of stylization. Although they are the antithesis of the swollen, fecund 'Venus figurines' of the European Palaeolithic, inevitably they have also been interpreted as connected with fertility. Attempts to seek analogies to support this in surviving traditions or customs are unconvincing.

Cattle figurines generally show animals with humps and which once had horns. Their legs are rudimentary—little more than protrusions that enable the bodies to stand. They too are forms so standardized, refined, and stylized that they seem the products of an established tradition. It seems unlikely that they were made by children as playthings any more than the female figurines were made as dolls.

Figurines of both sorts are found in small numbers in household occupation deposits and debris, but none has been found in a primary context that suggests their specific function; nor have large collections

The head of this Early Iron Age pottery figurine is suggested by no more than a slight swelling or flattening of the top of the torso, sometimes above horizontal grooves. These features would enable the figurines to be suspended as amulets. They have no arms; the breasts are small; the navel protrudes; the torso is sometimes scarified. The hips are wide so the buttocks appear enlarged; legs may be absent, rudimentary, or set straight out, slightly splayed and at an angle to the torso that suggests the figures are seated. Incised lines or raised ribbons of clay suggest bead girdles or loincloths; otherwise the genitalia may be suggested by incised lines.

been found together. I envisage that, as tokens of perceived values, they may have been amulets, charms, or votive offerings, the only remnants of domestic cults—but there is no specific evidence to support any of this.

Pottery masks

A unique collection of sculptures was found in South Africa, outside the north-eastern town of Lydenburg, by a schoolboy in 1962.[4] They were eroding from one of many small pits filled with domestic rubbish. Charcoal excavated professionally from the pit gave a fifth- or sixth-century date, which should probably be calibrated and corrected to the seventh century. Recent analyses of the associated ceramics suggest that they are a mixed assemblage, that the sculptures were not associated with the dated charcoal samples, and that they date to the ninth or possibly tenth centuries CE.[5]

There were the broken pieces of seven lifesize or almost lifesize heads, hollow and shaped like inverted pots [84]. Two were large enough to fit over the head and form masks; the others had holes at

84

All the Lydenburg heads had bands of incised decoration round the neck and lines of impressed and cross-hatched decoration elsewhere. These elements show they were part of the same ceramic tradition as the local domestic pottery. Applied pellets of clay form protruding mouths, noses, eyelids, hair, and raised bands crossing the faces and foreheads—possibly representing scarifications. The largest have crests of small unidentifiable animals. All were once covered in a cream slip embellished with glistening black specularite.

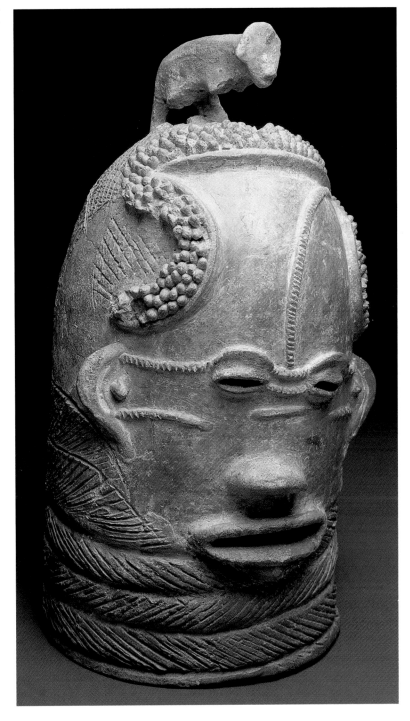

their bases by which they could have been tied to the top of the head to form helmet masks. All had bands of incised decoration round the neck and lines of impressed and cross-hatched decoration elsewhere. These elements show they were the work of local potters working within the same ceramic tradition as the people who made the local domestic pottery. One would think they were most impractical dance masks: heavy, rigid, incapable of adjustment, and fragile. They only confirm how little we know of early Iron Age crafts, beliefs, and practices. The only remotely comparable material may be a pottery head from a rubbish pit at Luzira, pottery figurines from Entebbe—both on the shores of Lake Victoria—and an eighth-century CE pottery animal head found at Liavala in central Angola.[6]

The environment

The open savanna woodland of the high plateau between the Zambezi and Limpopo Rivers is largely founded on granite. This is the same granite that provided the field of so many of the rock paintings discussed in Chapter 2. The granite soils are sandy, light, and easily tilled. Interspersed with them and derived from even more ancient rocks—which are also the sources of gold—are richer, heavier, and more fertile soils. The low veld to the south and west of the plateau was drier and the rainfall less reliable but it still provided excellent grazing for cattle.

Wherever there are granite exposures, there are the remains of stone walls in the hills and among the boulders. The most skilfully constructed of these surrounded clusters of round houses built of clay and thatched. These are the zimbabwes. The name derives from 'houses of stone' but came to signify 'ruler's house' or 'house to be venerated or

Dating

There are some 28 radiocarbon dates for Great Zimbabwe. Like all radiocarbon dates, they require cautious interpretation. The first four were counted in the pioneering days of the procedure and were later shown to be inaccurate, but not before propagandists used them to bolster theories that Great Zimbabwe was 'pre-Bantu'. The other 24 form a coherent sequence. The first signs of a settled population go back at least to the fifth century CE. Continuous settlement dates from about the twelfth century. Thereafter every aspect of material culture shows a continuous internal evolution. The first stone walls may have been erected as early as the mid-thirteenth century. Within a comparatively short time, perhaps only one or two generations, regular coursed and dressed masonry was developed, fully mastered and used almost throughout the fourteenth century. Great Zimbabwe remained a major power for little more than two centuries. Ceramic imports suggest that foreign trade was virtually severed by the mid-fifteenth century. Some settlement persisted at the site, perhaps for many years. All in all, we can say that Great Zimbabwe was continuously inhabited from about 1100 to 1550 and that its period of great building activity and prosperity was between about 1300 and 1450.

85

Plan of the stone enclosures at Great Zimbabwe. The complex can be divided into three main areas: the Hill Ruin, built among boulders along the crest of a near-vertical granite cliff; the Great Enclosure, the most massive single structure, atop a low ridge on the opposite side of the wide, shallow valley below the Hill; and the Valley Ruins which extend down the ridge and into the valley as a repetitive series of much smaller enclosures.

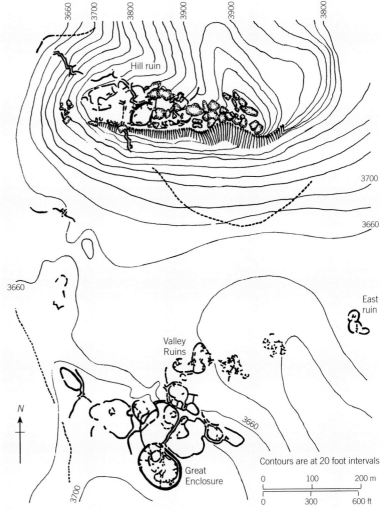

respected'. As this indicates, they were royal residences. Some 250 exist. Great Zimbabwe was pre-eminent among them, a capital of unique magnitude and wealth. This conjures up many vivid images to a mind formed in Europe. But in and around its stone walls there was no place for the market and commerce of the urban street. There is no evidence of the choreography of state: no avenues, axes, or vistas; no symmetry; no spaces for ceremonial, procession, parade, or spectacle. Such ideas are both ethnocentric and anachronistic. The builders of the zimbabwes long preceded the absolute monarchies of Europe and their concerns were very different. They embodied an authority beyond physical intimidation or coercion. They sought seclusion rather than display. This chapter seeks not only to begin to understand some of the social, political, and economic forces that shaped the zimbabwes but also to penetrate something of the symbolism of their architecture.

The history of the zimbabwes

The Portuguese first penetrated the interior in the sixteenth century. They knew the inhabitants of the interior plateau as Karanga, one of many closely related groups speaking very similar dialects of a Bantu language, much later to be subsumed under a new name, Shona, imposed by colonists at the end of the nineteenth century. The Karanga state with which the Portuguese established the closest relationships, whose ruler was known as the mutapa, was the most powerful of the successor states to Great Zimbabwe. The records that the Portuguese compiled of their many enterprises in the interior over more than two centuries—however infuriatingly obtuse, garbled, exaggerated, and only incidentally concerned with the people who were their hosts—describe a kingdom with many close similarities to those ruled from the zimbabwes. They were told about zimbabwes and even witnessed one being constructed. They were even told that a provincial governor presided over a very large and virtually abandoned zimbabwe in the far south of the country, almost certainly Great Zimbabwe. In the south-west the stone-building tradition only began about the mid-fifteenth century. Though new building in stone may have long ceased, some were still occupied by rulers of this area into the early nineteenth century.

Building techniques

The raw material used in the stone walling of the zimbabwes was, with very rare exceptions, exfoliated granite blocks. Large exposed outcrops of granite suffer internal structural stresses from marked diurnal changes in temperature. These cause it to split naturally into slabs with parallel sides. Initially these could simply be collected from the bare slopes of surrounding hills. The early walls used blocks of very different sizes and were coursed very unevenly. When these surface supplies were exhausted, granite was quarried by making fires on bare exposures and then rapidly quenching them and cooling the rock. The rock then split into slabs that were easily cracked into manageable blocks of a more uniform thickness.

It has been claimed that the regular coursing of walls is a product of fire-setting and quarrying.[7] Examination of the finest walls shows this is not correct: many courses have blocks of different but very carefully graded thicknesses, chosen to correct any unevenness or loss of horizontality in the courses. Coursing was always an intended goal [**82, 86, 87**].

While the outer facings of the stone walls were laid with considerable care and precision, the infill between them was loosely and roughly laid and the facings never tied into the core. Nowhere was a

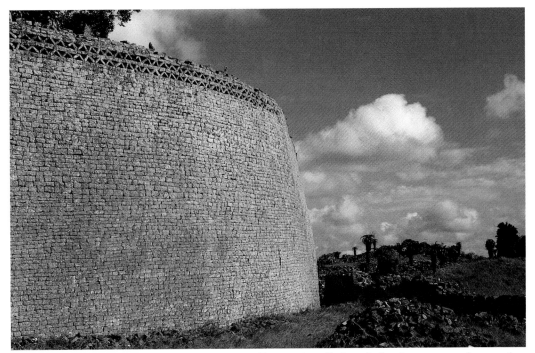

The outer wall of the Great Enclosure, 10 m high and 5 m thick, built of granite blocks, dressed only on the outer face. This wall, with the Conical Tower, is the perfection of coursed dry-stone masonry at Great Zimbabwe. The blocks give scale, texture, sparkle, and interest to an otherwise overpowering monument.

later or subsidiary wall intentionally bonded to its parent: a feature that has made it easy for investigators to determine the building sequence of every abutting wall. There were no true foundations though the soil was scraped level to allow even coursing from the start of construction.

Buildings in clay

The stone walls of Great Zimbabwe were an adjunct to the buildings they surrounded: circular thatched structures with low walls of solid clay. Vertical timber posts protruded at wide intervals from within the wall thickness to support the rafters or, perhaps more generally, posts were set in a ring round the outside of the external walls, protecting the walls from rain-damage and forming a narrow sheltered veranda.

The clay fabric of some structures has survived centuries of exposure. The strength and durability of the claywork and the smooth finish of its surfaces was achieved by 'puddling' the raw clay before it was set to bring the finest constituents to the surface. External floors, drains, platforms, and some faces of stone walls were surfaced with the same clays. Richly coloured, smoothly moulded, and perhaps painted surfaces of clay gave the interiors of enclosures much of their character.

Though virtually none survive now, the walls were originally often decorated with clay reliefs. Internal furnishings were all moulded in clay. Across half of some interiors, the floor was raised to provide sleeping platforms. Smaller, higher platforms, often decorated, served as seats. Still smaller stands with bowl-shaped indentations at the top

held large pots, for drinking water or, less probably, for beer or grain. Shallow indentations in the centre or at one side of the floor, with shallow moulded rims, formed hearths. Vertical poles in the interior, to support hangings and racks rather than the rafters, were surrounded by elaborately shaped and bevelled clay collars. Clearly most of these buildings served for daily living, sleeping, and cooking.

Given the diameter of the largest structures, 10 m and more, their roofs must have risen at least 6 m, overtopping all but the highest stone walls and creating as immediate and powerful a visual impact of size and monumentality as the stone walls themselves. The rafters would have been of a length and strength difficult to obtain in the surrounding woodlands. The quantity of thatching grass needed would have been almost equally formidable. The volume of clay required was as striking as its technical excellence. Deposits of successive clay structures on the Hill exceed 8 m in depth, and large pits where the raw material was dug still remain around Great Zimbabwe. The digging, preparation, transport, and erection, moulding, and decoration of the claywork necessitated the same organizational skills and management of a large labour force as those involved in the masonry work.

The largest clay buildings within zimbabwes correspond closely with descriptions of the royal audience chambers of the mutapas and one can suppose that they fulfilled similar functions. The mutapa's audience chamber was able to accommodate only a few of his subjects. The king sat secluded from them in a separate room, able to participate in their discussions but not be seen. At the Nhunguza zimbabwe a circular building over 8 m in diameter was divided down the middle by a wall reaching to the roof.[8] One half formed a single simple hall accessible directly from outside the stone enclosure. A single small door led from it to a chamber half its size, dominated by a large finely finished seat, invisible from the main hall. It had its own external entrance. Behind the seat and separated from it by a low wall was a small sealed and virtually secret chamber. In it was a stone platform encased in clay with a vertical hole in it, to hold symbolic spears or a wooden or stone carving. Flanking it was a series of lower clay platforms to display smaller objects. Here then was a comparatively large public space and a secluded 'royal chamber' with a 'throne'. This was backed, literally and figuratively, by insignia from which the ruler derived his authority. Similar internal arrangements are now discernible in clay buildings in other zimbabwes. One had traces of the gold sheets that once covered wooden posts next to the throne and an intricate tunnel running through the outer wall by which verbal messages or liquids could be passed unseen from the occupant of the throne to the outside world.[9]

In later zimbabwes in the south-west of the plateau, the largest of the exposed and now ruinous clay structures within the stone walls have small circular chambers at their centres—perhaps the equivalent

of the sealed regalia chamber at Nhunguza. Walls radiating from this core divided the structures into several chambers, indicating a complex series of non-domestic functions.

The stone architecture of Great Zimbabwe

The immediate response of outsiders to the stone walls of zimbabwes is that they must have been built for defence. The most cursory examination, however, disproves this: few walls achieve complete closure; many are short interrupted arcs, easily circumvented; others surmount cliffs that are already inaccessible; and there are no recognizable military features.

The structures achieve their effect through their massiveness alone. There are no visual aids to help us read this scale: no columns, pilasters, or mouldings define or articulate the granite fabric. The masonry, particularly in its most refined and dressed form, has a texture, colour, sparkle, variety, and interest that re-create in an enhanced form the essence of the granite parent material.

There is an analogy between the architecture of Great Zimbabwe and traditional southern African music. 'What distinguished African music from European . . . was its unawareness of proportion. African music is not deliberately asymmetric, it has no precise proportions: patterns are created by addition not subdivision. In many cases repetition

87
Original steps at the Northern Entrance, Great Enclosure. Continuous lower courses provided a threshold. Where steps were necessary, these were constructed within the wall thickness, each formed in a triple curve and set back through progressively sharper curves: a peculiarly idiosyncratic, unobtrusive, refined, and graceful feature of the architecture.

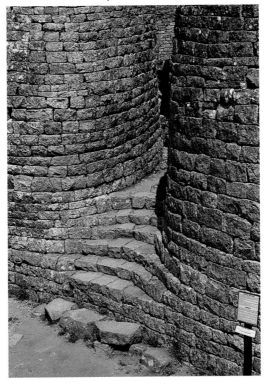

is not perceived. The music ends as abruptly as it begins, like birdsong. No rhythm is arrived at by calculation.'[10]

In the layout, everything was reduced to the scale of the individual. Internal passages and external paths were tightly bounded, narrow, long, and winding, forcing everyone to walk in single file and thus reproducing the experience of all travel through the African bush. In at least one instance a passage was entirely hidden beneath the floor of the enclosure. Entrances were unobtrusive, often narrowed and lengthened by low, protruding, non-structural walls with curved ends on each side of them. These 'buttresses' also narrow many passages, even those that are natural clefts in boulders. Buttresses also define spaces and mark points of transition. Many have a vertical slot in their curved ends, to hold a carved post or monolith. Small round towers and upright monoliths, usually of a stone other than granite and some with incised decoration in simple geometric patterns, surmounted the most important walls.

Even the most important and dramatic spaces, such as those beside the Conical Tower, were surprisingly restricted, allowing for small groups of people at most [82]. Today a large part of the romantic attraction of Great Zimbabwe is its solitude and sense of mystery. Strangely, this was probably always true. Everything about the architecture combined to give a sense of withdrawal. Zimbabwes were all intensely private places.

Symbolism and power

The power of the state is demonstrated by the monumentality of its structures. They signify conspicuous expenditure but they also speak primarily and directly of the ability of the state to harness the manpower, energies, and skills of its subjects, to coerce, organize, and manage them. These are monuments not only to the rulers who inhabited them but to the numbers and loyalty, or at least malleability, of their subjects.

It is now almost universally accepted that the prime function of the stone walls of all zimbabwes was to serve as symbols of prestige, status, or royal authority. But the question has never been asked why this should be so. One must try to penetrate deeper and try to discern the source of the power of this symbolism. Symbolism was as important to the Karanga rulers as it was to any other ruling authority. The symbolism of a courtly culture, its insignia, dress, way of life, architecture, the very zimbabwes themselves, were important agents in the establishment, acceptance, and maintenance of the kingdom. The choice of symbols was not random or fortuitous. Zimbabwe walling may well derive from the way it expresses a ruler's relationship with the ancestral land of him and his people.

The form of the Conical Tower, the most dramatic of all the symbols at Great Zimbabwe, suggests a grain bin. Traditionally, a Shona ruler receives tribute in grain and distributes this to guests, the needy, and in times of drought, making the grain bin a symbol of royal authority and generosity. It proclaimed the ruler as the protector and father of his people, and their source of sustenance. Beside it stood the largest of all stepped platforms [**7**, far right]. This resembles a *chikuva*, the stand on which a wife displays her pottery and which symbolizes a woman's value and role within the family; the *chikuva* also serves as the focus for prayers for ancestral intercession. It may be that tower and platform were symbols of male and female roles, the state and the family.

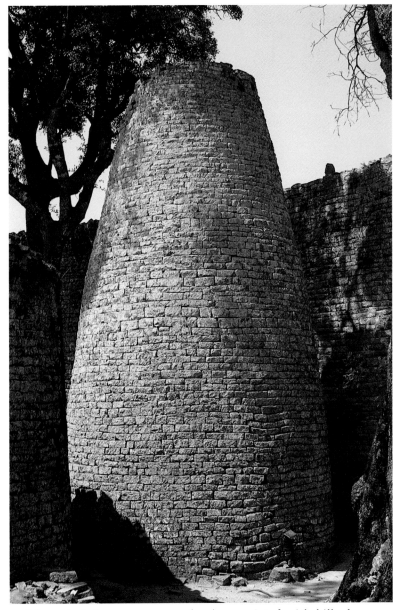

Most zimbabwes are on or closely associated with hills, however small, or around granite outcrops and boulders. Many natural formations are deliberately incorporated in their fabrics. The material from which the zimbabwes are constructed and the forms the walls take expand and express the natural forms of the landscape around them. Many details—the narrow passages, the curved entrances, the buttresses and towers—have strong resonances, even if they are not exact imitations, of the giant boulders of the hills [**82, 90**].

This is most apparent in the earliest enclosures. As the assurance of the rulers grew, so there was a greater human contribution to form.

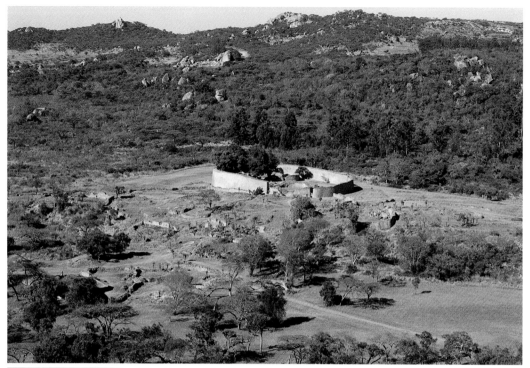

89

View of the Valley Ruins and the Great Enclosure from the Hill Ruin. As the stone walls had no structural function, no need to support roofs, they wander freely over the landscape. Seen from above the walls remind one of a river—large, calm, and silent pools, minor eddies, swift-running currents, and meandering rivulets. There is every indication that the process of building them was primarily responsive to location.

The form of the Great Enclosure is more assertive, the separation from the landscape greater [**89**]. The emphasis has shifted from a reproduction of nature to a manifestation of human achievement. This was carried even further in the elaborate decoration and flamboyance of later zimbabwes: celebrations of human ingenuity [**97**]. Material and its governance of form always ensured that references to the land could not be forgotten. All structures remained responsive to the essence of the landscape. The organic forms of the zimbabwes enhance the granite hills and boulders, echo their forms, and articulate and humanize their presence.

Beliefs

To understand the real significance of the architecture one must focus on Shona belief.[11] For the Shona, the dead of any family, especially the male family head, remain a living presence, caring for the welfare of all the family members, protecting them and interceding for them in all their problems with the supreme god. Prayers and sacrifices are regularly made to the dead. The ancestors of royal lineages are particularly important. They control in perpetuity the land they occupied in life, tend its fertility, and bring rain to it.

Land belongs to the ancestors. The current ruler 'owns' the land in trust and it always remains inalienable. His secular authority derives from his power to manage and allocate land. Land is experienced

The Eastern Enclosure of the Hill Ruin where the majority of bird sculptures were found, some of them echoing the form of the huge boulder that dominates the enclosure. The walls and platforms, in which the birds were probably set, reproduce and enhance the natural forms of the boulders.

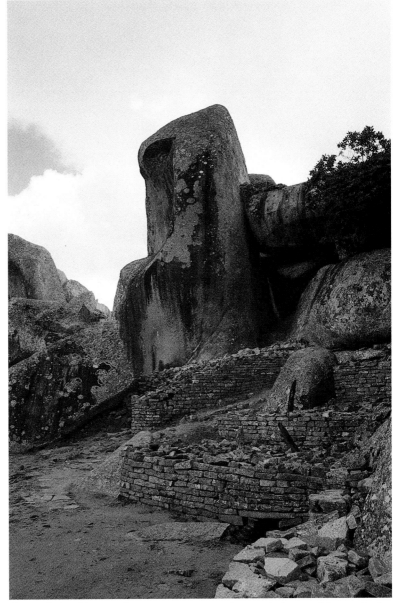

through its history, its past events, and associations with particular ancestors. Most prominent natural features and many apparently insignificant ones—hills, boulders, trees, and pools—may be replete with atavistic associations. Many if not most such natural features had a powerful historical, emotional, and spiritual content and significance, and delineated both current and ancestral territories and spiritual realms. The forms of the zimbabwes re-created these markers explicitly and emphatically. The zimbabwes embodied and asserted the spiritual and ancestral basis for the rulers' territories and authority. Occupation of land creates emotional bonds and exists on a spiritual

plane. Occupants of land sacrifice, pay tribute, and give some of their labour to the ruler.

A study of the last surviving network of traditional shrines in Zimbabwe shows how the creator god, Mwari, speaks from sacred rocks and is embodied in these rocks. The rocks are more than the medium of Mwari; they *are* Mwari. Thus, through those who serve the shrines, Mwari regulates the world and human society, makes seeds fertile, and brings rain in due season. Through his priests, he determines how land shall be used and the rhythm of agricultural activity. Political power is interpreted and understood through the shrines. The belief that many granite outcrops were shrines of a god who sustains his people was reinforced by natural phenomena. Run-off from large granite outcrops feeds sponges and springs at the foot of the hills. This in turn creates almost perennial rivulets and streams that become in their turn the headwaters of large rivers. Shrines today have remarkably little to indicate their importance. The natural setting is scarcely interfered with. Though the shrines are now sharply distinct from the seats of secular authority, there is no evidence that this was always so. Secular authority has always sought to associate itself with shrines and to gain in authority from this association, often establishing itself in close physical proximity to shrines.

A sense of the city

On the strength of a unpublished 1970s excavation of the houses of a single homestead, a picture has been built up of large areas of densely packed houses containing thousands of people outside the stone walls of Great Zimbabwe. Given this density, images are conjured up of a slum filled with dirt, garbage, stagnant water and sewage, flies, mosquitoes, and all the diseases that accompany them. This is unproven and probably false. One gets a better picture from the descriptions of the Mutapa capital. Portuguese estimates of magnitude, be it area or numbers, were always unreliable, but from various accounts it is reasonable to assume that the Mutapa capital had something like 4,000 inhabitants. Perhaps we should think of Great Zimbabwe as four or five times as big. The Mutapa royal court was numerous: members of the mutapa's family and his relatives, many of whom held specific offices; members of the dynasty who were also governors of provinces; advisers, functionaries, praise singers, drummers, musicians, and bodyguards; spirit-mediums, diviners, and herbalists. Many notables of both sexes were designated 'wives of the mutapa', and at one time they even included the senior Portuguese trade administrator, the 'Captain of the Gates'. These 'wives' lived in their own dispersed homesteads, 'a stone's throw apart' from each other, and spreading over several square kilometres.[12] It is in this sense that one should envisage

Great Zimbabwe. The ruler and his immediate family would live inside the most impressive stone walls, first on the Hill and later in the Great Enclosure. Minor royalty, senior officials, and representatives—usually senior sons or heirs—of junior and tributary kingdoms (held almost as hostages for their fathers' loyalty) would inhabit the twenty or thirty homesteads behind stone walls of the Valley. Lesser unwalled homesteads would have been scattered over a wide area. All may well have been considered in some metaphorical sense as belonging to the royal family as 'the king's wives'. Great Zimbabwe can be envisaged as a royal city, an administrative capital, or the channel between the temporal and spiritual.

It is probably true that, for nearly 500 years, all cultural, architectural, political, economic, and perhaps even religious advances on the plateau were developed at Great Zimbabwe. It—and the Mutapa state after it—had the greatest population of any capital and more complete control over foreign trade. It exerted a cultural hegemony over the ruling groups throughout the Karanga region.

Power and authority were always fragile in a region where the population was small, resources were not concentrated, land was readily available, and production never rose above subsistence level. It is important to recognize that there was never, except in legend, a Mutapa or Great Zimbabwe empire. There were indeed states of considerable strength but around them were many other similar states with similar culture, resources, and powers. The distribution of zimbabwes suggests that at the time of Great Zimbabwe's apex, there were some seven other states similar in extent to it, each controlling about 2,500 sq kms of territory.[13]

The decline of Great Zimbabwe is often attributed to environmental degradation caused by unnaturally large and permanent settlement in a fragile ecological region. This is too simple. Whatever its population size or density, Great Zimbabwe prospered for many generations: ecological problems had been successfully mastered. It was a complex and efficient political and economic system—but still a delicately balanced one. A minor disturbance in its equilibrium—drought, succession disputes, shifts in trade routes, plagues in cattle herds—would have had wide ramifications. The analyses to determine the relative importance of such factors have not begun.

Economics

The great economic achievement of the zimbabwe states was to minimize the effect of prolonged and recurrent droughts on a subsistence agricultural economy by diversifying it into mining, trade, and the management of large, wide-ranging herds of cattle. Cattle have been significant in almost every aspect of traditional Shona life: they

are the only real form of private property and investment, measure of wealth or status; they are the essential ingredient in sacrifice, bride price, in payments of tribute, fines, and recompense; and as royal gifts they establish and maintain alliances and allegiance. A Portuguese document describes how the mutapa opened new gold mines and the yearly mining season with gifts of cattle to the miners—and thus how, through cattle, gold production could be controlled and taxed by him.

There is good evidence from the Manekweni zimbabwe that cattle could not be kept at that capital but were moved seasonally to different grazing lands.[14] When the herds passed through the capital, the young mature beasts were culled to provide a prime beef diet for the royal inhabitants of the zimbabwe, while the rest of the population relied for their meat on sheep, goats, and small wild game. There is similar evidence from analyses of bones from the royal enclosures at Great Zimbabwe and Khami. There is thus every indication of centralized royal management amounting to 'ownership' of all the cattle of the capital.

The major zimbabwes or groups of lesser zimbabwes cluster round the edge of the plateau, enabling their cattle herds to take seasonal advantage of both highveld summer grazing and lowveld winter grazing, which differed seasonally in their palatability and nutrition. Such a system could not have been maintained without centralized management and protection of the herds.

It is generally held that the wealth that generated the zimbabwes was the result of trade with the Swahili towns of the coast. Certainly there is a very close correlation between the start of gold production in Zimbabwe, the rise in prosperity of the towns of the interior as measured by the scale of their building works, and a similar rise on the coast, especially at Kilwa.

The art of Great Zimbabwe

No carvings have been recovered from any pre-fifteenth-century zimbabwe except Great Zimbabwe, and there they are extremely rare. Almost all the significant works were found on the surface by treasure hunters in the late nineteenth and early twentieth centuries. We have only their reports—usually vague and contradictory—to give us some idea of their contexts. We will never be certain that any objects found on the surface were in their original contexts.

The best known finds are eight large 'birds' carved as the finials of long monoliths, the height of a person, from a soft greenish micaceous schist, steatite, or 'soapstone' [**91, 92**]. Remnants of the hooked beaks survive to suggest that in part they were derived from eagles or hawks. The only undamaged beak has narrow raised lips and looks more reptilian than avian. These sculptures are certainly not based on

91 (left)

One of the three of the Great Zimbabwe birds that squat, legs bent and pointing forward in a position unnatural to a bird, and with their heads pointing forward also. They take advantage of the unusual width and narrowness of their shafts. Some have delicately patterned raised lines of decoration round their necks or down their chests or back. Some squat above disc or chevron patterns. A crocodile is carved in relief towards the top of this one and a bovine on another.

92 (right)

One of the five birds that surmount cylindrical shafts and stretch their heads and beaks upwards while their fleshy legs hang limply down and grasp an embossed ring. Their wings are square-shaped carapaces, the plumage on them indicated by patterns of lightly incised lines with no suggestion of the feel of feathers.

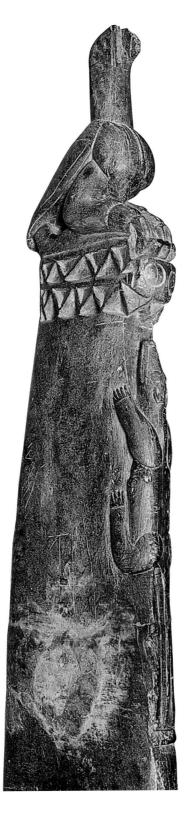

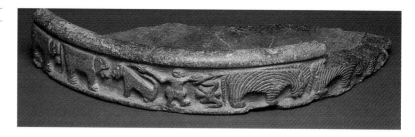

93

A carved stone platter with a carved frieze of a person, a bird, baboons, and zebras. This has none of the sophistication of the platters shown in **94**.

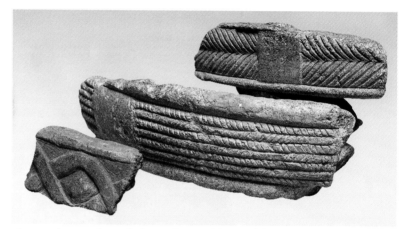

94

Three carved stone platters decorated with carved friezes in the form of cable patterns and guilloche. The former is a pattern common in the decoration of mihrabs on the East African coast (see **107**).

observation or knowledge of actual birds. They are instead curious constructions, surreal collages, of imagined creatures with some of the attributes of birds, reminders of an avian theme but with little further reference to reality. Stumbling and inarticulate, they are the work of several different hands. Tentative, uncertain, and unresolved, they are not the product of any established artistic tradition.

It seems pointless to try and associate these carvings with any specific species of birds. Analogies drawn with birds in current Shona beliefs—which assert that some species are messengers to God, or observers from him, or able to harness or deflect lightning, or clan totems, or intercessors and therefore metaphors for ancestors, or the spiritual embodiments of particular ancestral rulers—cannot be proved to be relevant.

Although their original contexts are uncertain, one can assume that the stone birds or similar carvings were originally inserted in clay-covered stone 'altars' or in the slots of buttresses or doorways. Finally, there is no harm in pointing out that the claimed original location of three of the birds in the Eastern Enclosure was at the foot of the most dramatic boulder on the Hill which, from the entrance to the Enclosure and particularly in the morning light, echoes exactly the raptor's beak, tall neck, and swelling chest of several of the carved birds [**90**]. Given the integration of natural and man-made forms at Great Zimbabwe, it could be that the birds were also deliberately intended to

resonate and articulate natural granite forms and, with the granite boulders, celebrate the essence of the place, the spirits within the stones. Given its rarity, one could suppose that the stone sculpture derived from a much larger body of work in wood and thus a widespread and lost tradition. In fact the work shows no evidence of this. The carved interlaced cable and guilloche patterns on stone platters have to be recognized as derived from very different visual concepts to any masonry or pottery motifs in the zimbabwes: a break-up of the surface plane, a new sense and expression of depth [**94**].

One can speculate that the carvers of all the stone objects might have come from the East Coast, where they were at home with the abstract patterns of Islam but uneasy and unfamiliar with commissions for naturalistic representations. The birds seem to have been an unsuccessful experiment, a unassimilable alien genre. On the other hand, some of the many small monoliths were lightly and irregularly incised with geometric patterns, quite closely but not precisely resembling the bands of incisions that decorated much of the local pottery. Are these the work of local craftsmen stimulated by the much more accomplished coastal craftsmen who were carving their Islamic patterns on some of the stone dishes?

The many small soapstone figurines found, once more without context, at Great Zimbabwe and nowhere else give rise to different problems [**95**].[15]

Clapperless gongs, singly or joined in pairs and made of shaped sheets of iron welded together round the sides, are identical to those found in central and west Africa, some of them centuries old and important insignia of royalty wherever they occur. They are an intriguing suggestion of wide-ranging African connections in the transmission of both objects and their symbolic content. One such gong was part of what seems to have been a royal hoard found in one of the Valley enclosures with foreign baubles, 30 kilos of coiled iron wire, over 100 kilos of iron hoes and some elephant tusks—both traditional items of tribute—and two elaborate decorative and non-functional iron spearheads, another traditional royal insignia through much of Africa. Four similar bronze spearheads were found in other parts of the Ruins.

Though ironworking was an important craft throughout most of the second millennium, there is little sign that it was practised within any of the zimbabwes. This would accord with the traditions of the Shona and most other craftsmen in Africa. Iron smelting was a semi-secret craft, conducted in seclusion.

More delicate craftwork may have been created within the enclosures. Copper ingots and the moulds in which they were cast, crucibles, tongs, and draw-plates used in making wire, and many broken lengths of finished coils of bronze wire have been found in the Great

95
A carved stone figurine from the Great Enclosure, Great Zimbabwe: highly stylized cylindrical female torsoes without heads or limbs, not unlike the pottery figurines of **23** and **83**. This is sufficient to suggest a continuity of belief and practice going back centuries and to early peasant communities. These communities cannot be seen as entirely distinct from the more complex and stratified societies that succeeded them.

Enclosure. Tiny, carefully tied standardized skeins of wire, suggesting that wire may have formed a rudimentary form of low-value currency, have been found in many zimbabwes.

Gold was hammered or cast into small beads, drawn into wire, and coiled and hammered into bracelets in exactly the same way that other metals were, but used much less lavishly: bodies buried beneath the floors of houses at the Castle Kopje and Harleigh zimbabwes wore only single strings of gold beads and bracelets of a few coils of gold wire.[16] A small bell-shaped cast gold pendant from Nhunguza is evidence of a slightly more ample and elaborate use of gold. At Great Zimbabwe (but no other zimbabwe) gold was also beaten into small, very thin rectangular sheets, some incised with geometric patterns and used to sheathe wooden objects using tiny gold tacks. How common the practice was or what objects were sheathed is unknown: the only parallels to the practice are those found at Mapungubwe in the Limpopo valley.[17]

Great numbers of circular ground and pierced pottery discs made from sherds and commonly known as spindle whorls have been found at Great Zimbabwe and all other zimbabwes. Their identification is not certain. Two sets of four discs were found on the floor of the Nhunguza throne room. This suggests that some at least were used as divining dice. There is mention of this usage in the historical records: men in the Mutapa capital are said to have all worn sets of four pottery divining discs round their necks as pendants. But it is very possible that there was considerable spinning and weaving, making the local cotton cloth that was the prestige dress as in the Mutapa court, or reworking to local taste the richly coloured and patterned imported textiles.

Clothes and jewellery

In the Mutapa state we are told that men wore long skirts—traditionally not dyed—either spun from the local cotton with a wrapper slung across one shoulder or made of skins, which, for notables, were probably of fine and rare pelts such as a leopard's. There is mention of the king having ivory and gold insignia of a hoe and spear (this may mean that they were covered with thin plates of beaten gold) and of the sheath of his knife being wound with gold wire. People wore necklaces, bangles, and anklets of iron, copper, bronze, or gold. Most striking was the elaborate mode of dressing the hair, drawn up in one or more long upright cones or 'horns'. Unmarried women were naked save for an apron covering the genitalia; married women wore a cotton wrapper in addition. More detailed information on appearance came from the excavation of the burial of a Karanga catechumen buried outside a seventeenth-century church in the Portuguese trading post of

Dambarare on the edge of the Mutapa state.[18] She wore a girdle of tens of thousands of ostrich egg shell beads, thin discs ground to a regular and uniform size, accented with a few clusters of two or three tiny glass trade beads—entirely covering her hips in lavish and luxuriant swathes of white interspersed with glittering coloured highlights. Her legs were encased from ankle to knee with thinly drawn bronze wire, tightly wound round a fibre core and the coils then wound round her legs. Her left arm was similarly encased but her right arm was comparatively free. In all she wore 10 kilos of bronze, enough to severely impede her mobility and dexterity.

Zimbabwes all contain a distinctive form of pottery whose entire outer surface was covered in graphite and highly burnished to produce a leaden sheen or gloss. It is the characteristic ware of every zimbabwe in the country.

The later zimbabwes of the south-west

As Great Zimbabwe passed its zenith, a kingdom with its capital at Khami [**96**],[19] ruled by the Torwa dynasty and known to the Portuguese as Butua, burgeoned on the western edge of the plateau. Here the terrain is lower and drier. It has long been primarily ranching country celebrated for its royal cattle herds. There are many goldfields in the area but it is much further from the sea and from any obvious and easy trade routes than most of the earlier zimbabwes.

Sites tend to be more open and built around the slopes of low rises. Granite stonework was now used primarily to face artificial terraces and house platforms constructed mainly of loose granite rubble sealed by clay floors. There are fewer freestanding walls and these are minor elements in the architecture—as terraces were in the earlier zimbabwes. The clay houses were little different in their construction from the earlier ones. The most important were, if anything, even larger, and the largest had a sealed circular chamber at their centres, perhaps protecting the insignia or treasury, with several walls radiating from it to form a series of chambers. Latrines, an innovation, were constructed beside

96
At Khami a low dark winding passage—lined with posts supporting rafters and a flat clay roof that formed the floor above—was originally entirely hidden, even though it was the main access to the most important summit houses. Off it were recesses which, undisturbed since the final fire which destroyed the capital, still held ivory tusks, a carefully wrapped bundle of spearheads—each different and possibly signifying a tally of different rulers or royal ancestors—and other objects.

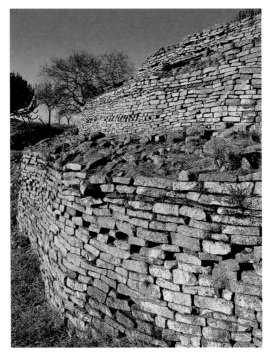

97

The decorated outer wall of Naletale Ruin. Even the smallest zimbabwe of this period usually had at least some decoration, while the outer facings of the major zimbabwes were almost entirely covered with it, in a great variety of patterns: lines and panels of coloured stones, sloping blocks, herringbone, chevron, and chequer.

many houses: tall, narrow, beehive-shaped structures lined with coursed masonry and sunk in the rubble fill of the platforms.

The most immediately striking innovation was the elaboration of the decoration of the terrace facings [**97**]. Such decoration only became practicable once coursing had been completely mastered. It had previously been limited to small areas of wall. The terraces formed the plinths of the houses, no longer hidden but flaunting themselves. The architecture was no longer forbidding and secretive but lighter, more open and flamboyant, with a new sense of luxury and delight in the total assurance of its craftsmanship. The principles of the architecture had not changed. Terraces were built in short, intersecting, organic curves. The court was visible but no more accessible. Narrow hidden passages ran through the terraces. The same symbolism determined the zimbabwes' significance even if it was overlaid by new subtleties.

The domestic pottery was as elegant as before but vessel shapes were more elaborate. Red burnishing was introduced and alternated with graphite in bands and panels, often emphasized by incised lines or alternated with hatching. Coiled wire continued to be the basis of personal adornment.

The Khami state, readily defined materially by all the characteristics described, was the contemporary of the Mutapa state but far less well-known historically. The Portuguese never penetrated it save for an expedition sent there in 1644 to intervene in a succession dispute, and which may indeed have assisted in firing the capital. Portuguese

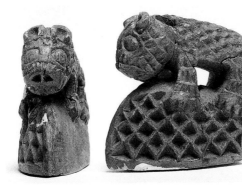

98

Finds from the Khami passage included four carved ivory divining tablets and two small leopards—all covered with delicate excised geometric patterns and some perforated but otherwise unworked bone pendants. All suggest the accoutrements of a ruler, his medium, or diviner-healer. A Songye cast-bronze ceremonial axe from central Africa found in a different part of the site again pointed to distant royal connections and exchanges.

baubles and relics of their incursion have been found at the second largest zimbabwe in the state, Danangombe (Dhlo Dhlo or Dana-mombe). It eventually became the capital of a successor dynasty: the Rozvi, under rulers all entitled Changamire. It is uncertain if they contributed anything to the building of their capital. The founder may have been a subject of the mutapa who rebelled and left his territories. A Changamire swept through the Mutapa state and drove the Portuguese from Dambarare and the whole of the plateau in 1693. The last Changamire died during the Nguni invasions of the early nineteenth century, bringing to a conclusion the history of the zimbabwes and, indeed, of all indigenous royal power on the plateau.

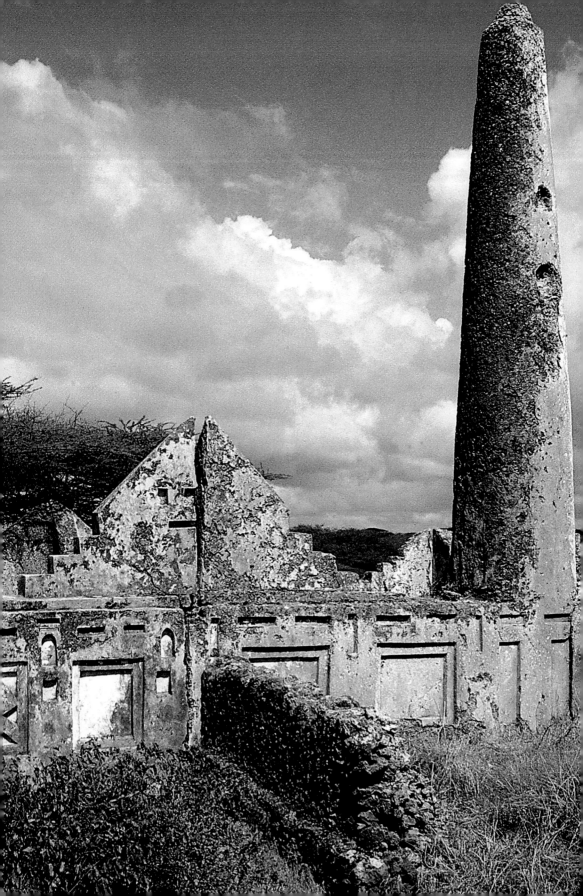

The East African Coast

8

The outlets for the African interior's riches were ports along the Indian Ocean coast. From the tip of Africa, at the entrance to the Red Sea, as far as Sofala, at the southern entrance to the Madagascar Channel, these ports received resins and incense, ivory from elephant herds hunted from southern Ethiopia as far as the Limpopo valley, gold from the Zimbabwe plateau, food and timber, human slaves and animal hides, and much more. Trade routes connected eastern Africa to the Red Sea, the Mediterranean, and ultimately Europe; some ran up the Gulf to Persia; others ventured straight across the Indian Ocean to India; from there both land and sea routes led on to China. The relative importance of the different trade routes and destinations changed over the centuries. For a brief period there were even direct contacts with China through convoys of enormous junks. For centuries the trade was stimulated and stabilized by the common religion and culture of Islam. The system only began to come under strain when the Portuguese entered the Indian Ocean at the end of the fifteenth century and, with unrestrained ruthlessness, sought sole dominance.

Settlements stretch 3,000 km south along the coast from Mogadishu. The southern Somali coast is barren and featureless with few inlets but it has the fertile Shebelle valley in its immediate hinterland. The Lamu archipelago, a drowned estuary of the Tana River, has the ancient deserted towns of Shanga, Manda, and Takwa and the more recent traditional towns of Pate and Lamu itself [**Map 7**]. From here south into Mozambique there are the remains of some 400 ancient settlements, some now marked only by a stone-lined well, a quibla or mihrab[1] of a mosque, or by a cluster of tombs, some marked with the tall stone pillars so distinctive of the coast.

For sailors from Arabia and Persia the southern part of the coast must have seemed an earthly paradise. Areas of fertile soil were watered by reliable rains and nourished rice fields, coconut and banana groves, orchards and gardens, cotton and sugarcane fields, and pastures for sheep. The shores were sheltered from the open sea by a nearly continuous reef and there were many creeks where ships could be safely careened. All that was needed for a settlement to be established was a gap in the reef, a firm bottom to the anchorage, and a freshwater well.

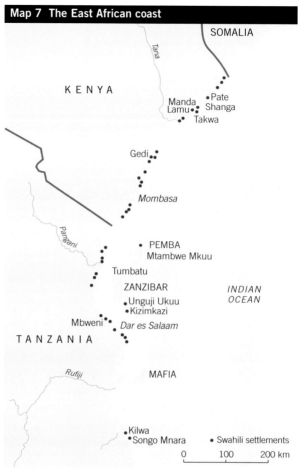

Map 7 The East African coast

SOMALIA

Tana

KENYA

Manda • Pate
Lamu • • Shanga
• • Takwa

Gedi • •

Mombasa

Pangani

• PEMBA
Mtambwe Mkuu

Tumbatu

ZANZIBAR INDIAN
 OCEAN
• Unguji Ukuu
• Kizimkazi

Mbweni • • • Dar es Salaam

TANZANIA

Rufiji MAFIA

• Kilwa
• Songo Mnara • Swahili settlements

0 100 200 km

The oceanic trade depended on the regular annual cycle of monsoon winds. As one moved south, the periods of reliable winds become shorter and the risk of missing the monsoon greater. Speed in acquiring and loading the return cargo became an imperative. South of Kilwa, the most southerly major trading port, these winds were very unreliable and the oceanic currents difficult. From here south as far as Sofala—and between all major ports—a local year-round coastal traffic took over.

Long familiarity with the coastal waters, reefs, and currents was of primary importance to the development of trade. Exports were brought to the coast by their inland producers and coastal agents ventured only to such major centres as the mutapa's court, where they were firmly established when the Portuguese penetrated the interior. Ships coasted to the main ports where goods were trans-shipped, bulked, and stored to await the annual arrival of the oceanic dhows. The people of the coast were agents, brokers, merchants, provisioners, and chandlers to the foreign merchants and ship-owners, who alone had the capital to build, equip, stock with trade goods, and hire crew for the

99

Graffiti of some of the early trading ships of east Africa incised at Kilwa in the wet plaster of Husuni Kubwa (top); the Great Mosque (central three); and a house at Songo Mnara (bottom): an unofficial record by building artisans of the basis of Swahili life and commerce. Some show the square matting sail of the *mtepe*, the archaic vessel of the coast whose hull planking was sewn together not nailed. Amulets hang from two curved prows.

large oceanic vessels. Under this regime, the people of the coast were the middlemen and as such always vulnerable to their partners on either side of the chain.

The Swahili

The attitudes of researchers to the origins of the Swahili ('the people of the coast'—the name 'Swahili' is a comparatively recent construction of convenience, as is the unity it implies) has coloured all research into east African coastal history. Above all, should the Swahili be regarded as fully and genuinely African? There was no doubt that for over a thousand years they had close trading connections with Arabia, Persia, and India, or that for over 400 years the Swahili ruling class and elite, the Waungwana, had claimed that their genealogical origins lay abroad. This is already clear in the *Kilwa Chronicle*, a local dynastic history written before 1552. In particular, the Waungwana claimed that Shiraz, the main port of southern Persia, was the original home of the first migrants. The strength and tenacity of this view lay in the class structure of Swahili society. The Waungwana for long sought to distinguish themselves from the rest of society, to establish their validity through the purity of their religion and blood, and to distance themselves from the stigma of mixed blood. Their claims are accepted and supported by one school of historians who consider the ancient towns of the coast to have been Persian or Arab trading bases or colonies and the Swahili to be essentially 'Afro-Arabs'.

In contrast many now agree that the Swahili and their coastal settlements are essentially indigenous to Africa.[2] The real problem is that identity and culture are too often perceived in racial terms.[3] If one looks at the Swahili more comprehensively, it is apparent that they developed and shared a distinctive common culture for a thousand years at least. The Swahili language is clearly Bantu in its structure and grammar, though the vocabulary incorporates several Arabic (most of these only within the last 300 years), Hindu, and Portuguese words. It is the only Bantu language with a centuries-old written literary tradition. The religion is Islam. Dress and cuisine are distinctive: the former characterized by the men's long skirts, the latter by an emphasis on fish, rice, and spices. Swahili society was hierarchical and based on class as much as tribal divisions. It was also intensely urban, with architecture consciously establishing identity and class. Individuals identified themselves with a particular town and took its name to describe themselves.

History

The coast enters written history in the first century CE in a mariners' guide to markets, ports, and harbours, the *Periplus of the Erythraean Sea*. The most southerly emporium on the coast was Rhapta. It has

been long and unsuccessfully sought especially in the area of the Rufiji delta of Tanzania. Many now believe that it lay much further north, in the hinterland of the Tana River and Lamu archipelago in northern Kenya, location of so many later ancient towns.

Throughout the second half of the first millennium CE, there is evidence of a fundamental uniformity in the earliest indigenous ceramics from sites all along the coast and on the islands, including the Comoro Islands. This general cultural unity for the entire coast suggests maritime connections between the settlements. It also demonstrates that the origins of the coastal settlements lay in the interior and that the population had its roots in Africa.[4]

At Shanga in the eighth century there was what is interpreted as an indigenous pre-Swahili village with two different forms of houses grouped in separate quarters and with their occupants adhering to different diets.[5] Both partly surrounded a single central cattle stockade and a well. It seems that different ethnic groups were already coming together. One can presume they had a common purpose: trade. The ninth century saw the first evidence of Islam, with a sequence of three small rectangular buildings of timber and clay built inside the stockade, which have been interpreted as mosques. The original worshippers are assumed to have been visitors off foreign ships; certainly these tiny buildings were not capable of holding more than a fraction of the total population. Their construction coincides with the first appearance of foreign trade goods—of which sherds of glazed ceramics are now almost the only survivors.[6] Much of this interpretation is disputed: it is claimed that the area excavated was too small to provide any firm conclusions; that there is no evidence that the stockade was ever used for cattle; and that the rectangular buildings lack mihrabs, are inaccurately oriented so that they do not face Mecca properly, and were probably not mosques.

In the mid-tenth century at Shanga, a large mosque was built over the stockade and the little early mosques. It used squared and coursed coral blocks set in a mud mortar. This building technique was used up and down the coast at much the same time. There is evidence in contemporary deposits at Manda of a sea wall constructed of massive coral blocks and of some use of clay bricks. The latter occur also at a few other sites but the structures they were used for are unknown and they soon ceased to be used. Very little indeed can be said about these early settlements as a whole: they now lie buried beneath deep subsequent deposits and very little of them has been revealed.[7]

By the eleventh century foreign trade was so firmly established as the basis of the coastal economy that many towns were minting their own coins in gold, silver, and copper. Several hoards of coins have been found, apparently hidden by their owners over nine centuries ago. At Mtambwe Mkuu on Pemba Island a hoard included both Fatimid

Egyptian dinars, the latest dating to 1066 CE, and coins of Ali ibn al Hasan, the founder of Kilwa, according to the *Kilwa Chronicle*.[8]

The most fascinating suggestion derived from the investigations of these early settlements is that, from the mid-tenth century, the trade of the coast was so significant and so securely integrated with the economy of the wider world that it fuelled a rebirth of some forms of art in countries across the Mediterranean, from Byzantium, Sicily, and Spain, and into southern Germany and the Holy Roman Empire.[9] The principal luxury exports were gold from Zimbabwe, ivory from tusks of the African elephant which were much larger than any available before, and rock crystal of a new size and clarity from southern Ethiopia. A new trade route was opened, up the Red Sea to Fatimid Cairo. The new raw materials stimulated new standards of craftsmanship catering for the wealthy of much of Europe. The products of the short-lived, eleventh-century rock crystal craftsmanship of Fatimid Cairo were much sought after. The same is true of the longer-lived production of Fatimid royal ivory carvings: caskets, throne backs (echoes of Aksum), and panels of vivid scenes of court and country life.

Husuni Kubwa

100
A reconstruction of the palace at Husuni Kubwa showing the pool, private apartments, audience court, warehouses and pavilions roofed with barrel vaults, trefoliate vaults, vaults with multifaceted pyramidal ends, and conical domes. At the intersection of the two ranges was a massive fluted conical dome.

Husuni Kubwa (Swahili for 'large fort') outside the town of Kilwa is not only the earliest surviving major building on the coast south of Somalia but also by far the largest and most sophisticated: a true palace [6].[10] It carried the coastal architecture to greater heights than were ever attained later. It can be precisely dated and its builder and owner named. A carved coral inscription in praise of al Hasan ibn Suleiman was found in the most luxurious part of the building; he figures in the *Kilwa Chronicle* and reigned from about 1320 to 1333; he was visited by

102

Reconstructions of vaulted rooms at Husuni Kubwa.

the inveterate Maghribi traveller, ibn Battuta, in 1331. Four coins of his father's reign were the only ones found at the bottom of the palace well.

As in all coastal buildings, coarse vesicular coral, the bedrock of so much of the coastal lands, was the basic building material. Fine-grained homogeneous porites coral was cut from the living offshore reefs and, while still soft, used for all the finer carved work. Coral was also burnt to produce lime. All stonework was covered with a thin hard skim-coat of lime plaster, a silky smooth and immaculate white finish. Close-set mangrove poles were used to support flat coral concrete roofs. Its quality as roofing timber was such that it has long been a primary export from the coast to western Asia. However it only grows to a limited height and this determines its span. Hence the module on which all coastal architecture is based: 2.4 m is the width of every room. As a result many of them resemble long narrow galleries.

The palace of Husuni Kubwa is built on a prominent headland at the entrance to the harbour of Kilwa [**6, 100**]. A monumental stairway rises up the cliff from the sea. At its foot is a small building with tanks or foot-baths on either side of its door, uncomfortably oriented to face exactly north, the direction of Mecca. It was probably a mosque, though this cannot be certain, for the sea has destroyed the qibla wall. Certainly there was no other mosque attached to the palace. At the summit of the headland, with fine views directly across the bay, were the private quarters of the sultan. At least two of the long rooms here were vaulted and decorated with panels and friezes of carved coral blocks [**102, 104**]. Such decoration was nevertheless minimal, used as an accent rather than overall patterning. The luxury of this part of the building is nicely illustrated by the broken pieces of a Chinese Yuan Dynasty flask found on its floor and dated to about 1300.

Inland these apartments faced onto a formal sunken courtyard flanked on both sides by open pavilions. This court is entirely secluded

and would have served as a private area where the sultan's wives and children could spend much of their time. At the shore end of this court were the core domestic rooms: two interlocking apartments in what became the characteristic form of all coastal houses, save that they also had a long range of servants' rooms, of various sizes and quality, and washrooms flanking them on one side. These led to another complete small house, presumably that of the member of the sultan's extended family or clan who acted as chamberlain, and then into the domestic courtyard with its well.

Directly across the main axis—and entrance hall and corridor of the palace—was a deep ornamental pool. The main corridor terminates in a long open pavilion with a raised seat at one end: the *diwan* where the sultan held court [**103**]. On an upper terrace overlooking this audience court were two ranges of impressive vaulted rooms. Perhaps they were used as formal reception rooms; more probably they were for the pleasure and refreshment of the women of the palace—for they opened onto high, secluded terraces open to all the sea breezes and views. They were the most ambitious of all the rooms in the palace and, indeed, of the entire coast. Perhaps they were over-ambitious, for it may have been the collapse of these complex structures that caused the palace to be abandoned when it was nearing completion or very soon afterwards.

Behind the palace and supporting the vaulted rooms was a quadrangle surrounded by 38 large storerooms. Each side had two units of four to six almost identical storerooms, each opening off a wide corridor

103

The audience court at Husuni Kubwa. The *diwan* where the sultan held court was at the head of tiers of seats or steps, where the courtiers probably sat, leading down to the sunken audience court, once again with flanking pavilions. The deep court is reminiscent of a theatre, but then holding court and a theatrical performance are not dissimilar. At night this similarity would have been heightened by the lamps in banks of niches down both sides of the court.

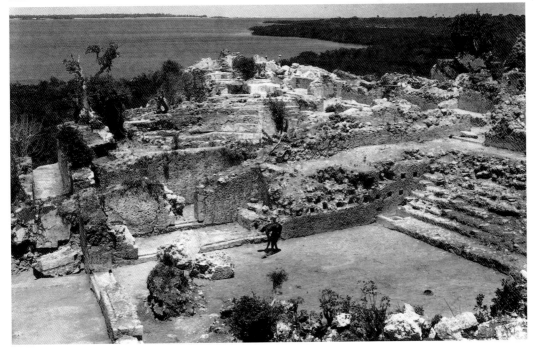

entered from a central hall. They were windowless, extremely secure, easily guarded and controlled, and fitted with storage racks. The volume of goods that could be held here would have been enormous: enough to load fleets of ocean-going dhows or the annual production of the whole town. There was far more storage space than would have been required to store only gold or ivory.

At the corner of the great quadrangle nearest the town, a wide flight of steps led to a large platform that terminates the terrace formed by the roofs of the storerooms: a site the sultan could reach directly from the vaulted structures and where he could be seen by and receive townsfolk in a setting as imposing as the audience court. In the rooms under this platform goods could be received, taxed, documented, and taken into storage.

Husuni Ndogo

Across a little valley immediately seaward of Husuni Kubwa is another massive building contemporary with the palace, Husuni Ndogo ('small fort'). It is little more than a single high, windowless curtain-wall enclosing a very large rectangular quadrangle. Polygonal bastions with cut sandstone quoins protrude from the corners and along the sides of the curtain-wall: two on the short sides and three on the longer sides. There is a single unassuming central entrance. The interior is empty, both of structures and deposits, save for a well, a small tank and short stub walls dividing some of the inside of the curtain wall into 4 m wide units.

There is nothing remotely like it anywhere else. It seems indeed to have been the only public secular stone building in any coastal town. Given the lack of local parallels, it is a particular puzzle. In descending order of probability it may have been a caravanserai, market, fort, barracks, or slave barracoon or, much less likely, a mosque. What it does do is confirm the unique power of al Hasan ibn Suleiman.

Assessing the Husunis

Husuni Kubwa was built as much for comfort as a demonstration of power. It was geometric in its layout, formal and ornamental. It was delightful in its variety of forms as well as in its situation and amenities. It was almost entirely single-storeyed and to this extent it was not monumental or imposing. Nevertheless it asserts authority through its size. Vaults and domes were daring in design and construction but they were not fully exploited to provide varied spaces beneath them. Decoration was restrained and austere. The whole complex was designed and built as a single fully realized entity and never altered or enlarged—indeed it may never have been finished or long occupied. It

was not precise in its planning—some axes had to be shifted and manipulated to fit irregularities of the site; the whole perimeter wall was angled to the palace to suggest a more northerly and 'correct' orientation; and the ranges of store-rooms were asymetrical. To a visitor from an Asian capital it may have seemed scarcely worthy of attention. Indeed all that ibn Battuta remembered of his visit to Sultan al Hasan ibn Suleiman, presumably at Husuni Kubwa, was his surprise that the sultan and his retinue were very black and African yet they were receiving visitors from the purest lineages of Iraq and Mecca.

The vaulted and domed pavilions and reception rooms, the stepped audience court, the pool, and the ranges of storerooms of Husuni Kubwa are all unprecedented and they were never imitated or repeated. The storerooms point to a single short period when a centralized trading system was imposed on the whole trade of the southern coast, with individual merchants operating under the authority of a single individual. He became qualitatively different in wealth and style of life from his former peers. Husuni Kubwa was more than the residence of a merchant-prince who had established a monopoly of sorts over the entire island's trade. It was a seat of government, a manifestation of political and territorial authority. Perhaps Husuni Ndogo was even a demonstration of the military power that backed this authority. The Husunis are a monument to an interlude, unattested in the written histories, when for a short time, wide-ranging political and economic authority came under the hand of a single individual, a true sultan. The power and wealth that this brought him and Kilwa could be lavished on a monument to their joint success. Husuni Kubwa was the extraordinary result: a unique historical document as much as an architectural masterpiece.

Mosques

The mosques of the coast show an individuality of design and continuity that distinguishes them as a valid regional architectural tradition within Islam. Almost all mosques, even Friday Mosques, were surprisingly small. The main axis of every mosque was at right angles to the qibla—there were no long lateral aisles parallel to the qibla which cater more efficiently for the unified physical actions of Islamic public prayer. Almost all mosques had flat roofs supported on mangrove rafters, which again provide the module and determine the widths of the aisles. Mosques on the Kenya coast tended to have two aisles separated by a row of square piers on the mihrab axis and thus obscuring it. Those further south, on the Tanzanian coast, were more likely to have two rows of octagonal columns and hence three aisles and a free view of the mihrab. These are, however, by no means general rules, nor is the significance of the difference yet apparent.

104
Carved coral bosses with
intricate interlaced ornament
that decorated the Great
Mosque and a smaller
fifteenth-century domed
mosque at Kilwa.

The local or ward mosques of the coastal towns were domestic in scale, with subdued light, low ceilings, and massive piers. They were cool, restful, and full of quiet corners. It was in their local mosque rather than their houses that men would have passed much of their day. The mosque was the meeting place of every ward, a business and social centre almost as much as a place of worship. Like so much of the coastal architecture, even the Friday Mosques were egalitarian. The only mosque on the coast to have a royal enclosure was the Great Mosque at Kilwa, where the Sultan of Husuni Kubwa, al Hasan ibn Suleiman, built himself a domed private chamber, expressing once more his unique status and overriding authority.

Mihrabs were monumental, reaching to the roof and covering about a third of the qibla wall. For over 400 years, starting in the thirteenth century, a slow continual evolution of mihrab design can be traced.[11] No mosques, save the thirteenth-century Friday Mosque in Mogadishu, had minarets. Only a few simple masonry minbars[12] survive. Courtyards, if they existed at all, were not designed for prayer or a large congregation of people. They were purely utilitarian places for ritual washing in plain basins rather than ornamental tanks.

Only two or three early inscriptions, carved in local coral in a decorative Kufic script, survive in mosques. The best known bears a date equivalent to 1107 and has been incorporated in a much later mihrab in a mosque at Kizimkazi on Zanzibar Island. They were very seldom used after this. A single inscription in a private room of Husuni Kubwa, is the only panel of decorative calligraphy.

In the late seventeenth and eighteenth centuries, when the flow of immigrants particularly from Oman began, there was a marked break in mihrab design, characterized by much more elaborate decoration of the mihrab in coarse plasterwork. The mihrab arch became first multilobed and then the projections of the lobes were given heavy foliated cusps. The interior of the mihrab niches was equally heavily decorated with fluting, panelling, and niches. Though the basic mihrab form survived, it was transformed with decoration that seems coarse and over-elaborate to an eye attuned to the reticence of the previous centuries.

Mosques in Mogadishu

The mosque of Fakhr ad Din, first sultan of Mogadishu, is dated to 1269 by an inscription on a glazed tile in the mihrab. It was built of the early squared, coursed coral blocks, and is a unified, articulated design planned around a single central axis [**105**]. Though the module remains the span of a mangrove pole, a system of main and subsidiary composite beams reduced the columns to two. This is a sophisticated, calculated plan: something that is not found further south.

All that survived—at least until recently—of the original Friday

105

Plan and section of the Mosque of Fakhr ad Din in Mogadishu, probably of the thirteenth century. The main doors lead to a courtyard and a portico with a central dome and then into the mosque with a single central dome. The portico dome is particularly tall, tent-shaped, and octagonal, with straight faces and decorated with cusped plasterwork both inside and out. The mosque dome is a true dome rising from a tall drum and entirely plain. On the exterior it was surmounted by a large Chinese celadon jar.

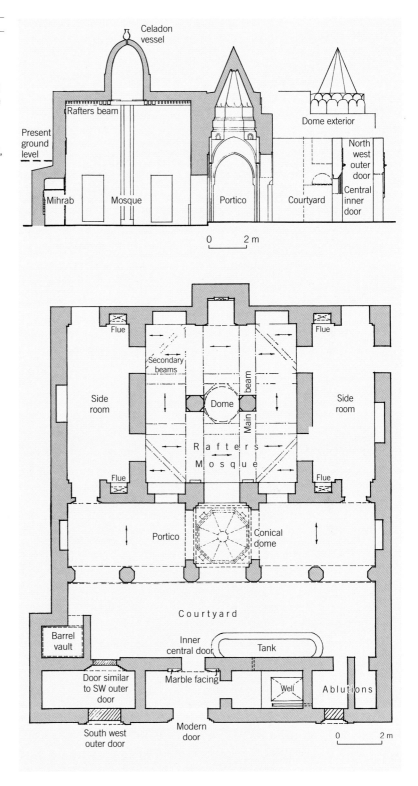

Mosque in Mogadishu is a massive round tower 13.5 m high and 4.25 m in diameter at its base. It was built in twelve stages, separated by string courses and each inset slightly from the one below. An inscription above the door dated it to 1238.

Kilwa and the Great Mosque

The unusual economic strength and architectural invention of Kilwa are demonstrated once more by the Friday Mosque or, as it is appropriately known, the Great Mosque. The original tenth- or eleventh-century mosque remains as a plain roofless shell of no great size, with the courses of squared coral blocks that were characteristic of the period. The flat roof was supported on nine massive polygonal wooden columns. In the early fourteenth century the builder of Husuni Kubwa, al Hasan ibn Suleiman, erected a cloister or arcade, with monolithic coral columns supporting a continuous barrel vault surrounding a large prayer court, the only example of this characteristic Islamic space on the coast. At the far corner of this court a 4 m square chamber was covered by a very large dome. It had its own entrance and tanks for the ritual washing. It is almost certainly the royal enclosure where Sultan al Hasan attended Friday prayers as ibn Battuta recounted, and whose collapse is remembered in the *Kilwa Chronicle*.

Sultan Suleiman ibn Muhammed, reigning from 1421 to 1442,

106

The interior of the fifteenth-century domed and vaulted prayer hall of the Great Mosque at Kilwa. Composite hexagonal columns, with coral blocks on alternate faces and filled with a concrete of coral rubble and with plain square capitals of a single coral block, formed 30 square arched bays. Around the perimeter and down the central aisle these supported concrete domes, resting on squared coral cornices and groined squinches—a new structural development since the building of Husuni Kubwa. The intervening bays bore barrel vaults.

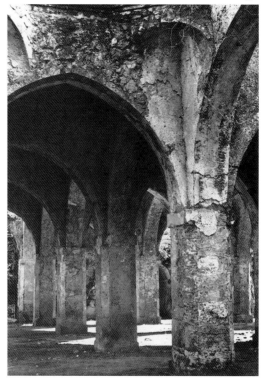

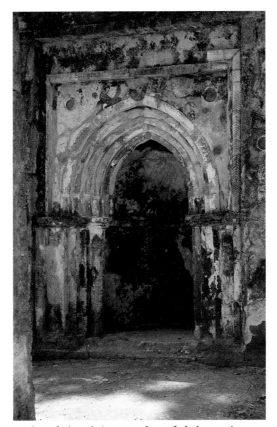

The mihrab of the early sixteenth-century Great Mosque at Gedi: the culmination of four centuries of indigenous evolution of mihrab design. As mihrab design gradually evolved and became more elaborate, panels were recessed within the outer frame, occasionally framed with a carved cable pattern. An increased number of arches and jambs were added. Rebates were cut into the projecting corners of arches and jambs. The arch shape became stilted and taller in relation to its width. Chinese porcelain bowls, carved coral bosses, or a small panel of glazed tiles, probably bearing an inscription, were recessed into the frame and spandrels.

replaced the cloister and roofed the entire prayer court with plain and fluted domes and barrel vaults to form the largest covered mosque on the coast [**106**]. The bays retain the same module and dimensions as any roofed in timber. The stability and strength of this structure have enabled it to survive over five centuries, with little attention for much of this time. It is innovative architecture but the bays are so small and high that the congregation could scarcely have been aware of the vaults. Despite the alternating forms, the interior space is read as undifferentiated and unarticulated, even monotonous, with no sense of centrality or direction.

The same system of roofing with alternating domes and vaults was used again in a small mosque in Kilwa contemporary with the Great Mosque, but only three bays wide and three long. Given its different scale, the spaces within it have greater impact. Occasional similar but much less skilled or successful domes and vaults roofed a few other mosques.

Building and houses

From at least the time of the building of Husuni Kubwa at the start of the fourteenth century, the characteristic forms and techniques of

Swahili domestic architecture were firmly established. They flourished until so recently that the ways the spaces were used and what they signified can be readily reconstructed and understood: a continuity that speaks volumes of the strength and self-confidence of the culture.[13]

The cores of houses generally consisted of two long rooms or galleries running the length of the house [**108**]. The front room, the *msana wa chini*, had wide double doors and large windows opening onto a platform running round three sides of a front courtyard. Most visitors probably never went further than this bench or platform round the courtyard. Doors leading into the further rooms are never aligned with the front doors so that no one could see further into the house than the front room. Two bedrooms, the *ndani*, and a carefully designed and compartmented latrine-washroom, the *choo*, reflecting the universal importance accorded to actual and symbolic purity, opened off the back of the rear long room, the *msana wa juu*.

Both long rooms were multifunctional: used for eating, sleeping, working, entertaining intimate friends and relatives, and storage. It is mistaken to assign specific functions to them. However, the rooms were also clearly graded from public to private in a steep and rigid 'intimacy gradient'. The rear rooms were certainly used only by the family and close female friends and relatives. Today the main bedroom, the *ndani*, belongs particularly to the owner's wife, the site of her marital bed, where as a bride she was displayed on her wedding day. It is where she will give birth, be purified after birth, will die and be laid out: the site of family rituals that punctuate its most significant moments.

From the seventeenth century, an increasing number of niches, *zidaka*, often with intricately arched openings and eventually in banks surrounded by diaper patterns in the plasterwork, were set in the walls of the long rooms, particularly in the *msana wa juu* and around the marital bed in the *ndani*. These niches were carefully designed with their sides and roofs splayed slightly outwards. Thus sides and roof were invisible from the right viewpoint—the entrance door—and the back floated as a dark unattached shadow, creating a sense of mysterious depth. Their main purpose was decorative, to give depth to the long galleries and to display imported glass and glazed ceramic plates and vases. These not only attested to the owners' aesthetic sensibilities and ability to satisfy them but eventually acquired the qualities of charms.

In the wealthier and more elaborate fifteenth-century houses, small private rooms, as ornate as any room, occasionally with vaults inlaid with lines of porcelain bowls and often with a washroom attached, open off one or both sides of the front room: the owner's study or bedroom. More frequently there is an equally decorated guest room, the *sabule*, with its own washroom in the far corner of the front courtyard and quite independent of the house, probably intended especially for visits by business and trading partners and the captains or officers of

overseas ships. The front reception courtyard has an entrance porch in another corner with benches along the side and wide double wooden doors, the only opening onto the outside world.

Behind the houses was a second spacious domestic courtyard, the women's, with a well and doubtless once a vegetable garden and orchard, the place for cooking, laundering, and other domestic tasks. Shared domestic courtyards and wells provided a meeting place for women, their communal social base.

Town planning and Songo Mnara

The largest towns probably never had more than 150 stone houses at most and many settlements had no more than two or three. The town on the island of Songo Mnara, separated from Kilwa by a shallow channel, was a typical prosperous town of the middle rank. It was contemporary with the second great building period at Kilwa in the fifteenth century and a satellite town to it, perhaps a place where the more prosperous citizens of Kilwa preferred to live at certain seasons, perhaps Kilwa's rural and agricultural base. There are several widely spaced clusters of stone houses [108].

The stone houses of Songo Mnara illustrate clearly how they were built in groups, usually with up to six houses, sharing party walls, wells, and domestic courtyards. Some were set back-to-back or even interlocking. In this case, a lobby led directly from one house into the other. This plan goes back in time at least as far as Husuni Kubwa. It is a certain indication that many coastal houses were built together by closely related families, and that houses and businesses were run as partnerships, as cooperative ventures, by members of clans or lineages.

A core of six apartments with another eight peripheral houses interconnecting with the core are called the 'palace' of Songo Mnara, with some justification. The structure of the vaulted cloister around the audience court was identical to that of Kilwa mosque vaults and was probably from the same hands. But this is the only sign of grandeur. Compared with the formality and dignity of Husuni Kubwa, this is not the palace of a sultan but the fourteen homes of the leading lineage. The six individual apartments in the palace are small with only one long room and a single bedroom.

Songo Mnara illustrates how clusters of houses in the early towns were quite widely spaced. Several mosques and cemeteries survive amongst them. Everywhere on the coast, the stone houses were probably partly surrounded by orchards and plantations: several visitors, from ibn Battuta to Vasco da Gama, noticed these with admiration. The stone houses were probably also interspersed with less permanent houses occupied by the poorer classes. There were few formal streets or alleys or sense of an urban environment. Though da Gama wrote of the

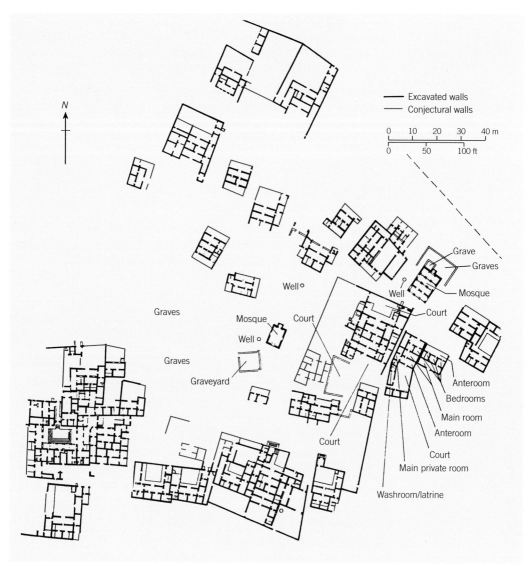

108

Plan of the stone dwellings and 'palace' at the core of the island town of Songo Mnara, near Kilwa. There are several widely spaced clusters of stone houses. A core of six apartments with another eight peripheral houses interconnecting with the core are called the 'Palace', with some justification (bottom left).

Within the plan are the following labels: Excavated walls, Conjectural walls, Grave, Graves, Mosque, Well, Court, Graves, Mosque, Court, Well, Graves, Graveyard, Anteroom, Bedrooms, Main room, Anteroom, Court, Court, Main private room, Washroom/latrine, N

narrow alleys and multistoreyed houses of the town, this is a considerable exaggeration. Only next to the Friday Mosque at Kilwa was there eventually sufficient pressure for house plans to be altered and compressed.

Stone houses are extremely important Swahili signifiers, defining class and wealth, establishing, expressing, and reinforcing the owners as citizens of substance, demonstrating their success, reliability, and creditworthiness. The people of the coastal settlements constituted a 'frontier society' and used their buildings and architecture, like their insignia and myths of origin, to define and maintain an ideology of difference and dominance. The rise of stone building marks the rise and differentiation of a distinct merchant class, politically wholly dominant but more concerned with economic success, rising and falling with

fluctuations in trade and trade routes. Each town or community was autonomous; territorial control was fragile; dynasties of merchants and city-states rose and decayed; there are few accounts in the various town chronicles of aggrandizing wars or heroic war leaders. A study of the stone architecture is the study of a single class within Swahili society, the Waungwana. We know nothing at present of the infrastructure of artisans, farmers or fishermen, domestic or plantation slaves. None of their timber and clay, palm leaf, matting, or grass buildings are visible on the surface and no excavations have focused on them.

Sources

One can find many elements in the architecture with parallels abroad, in many different parts of the Islamic world.[14] Building in coral and the mastery of all the various elements of this versatile material may have derived from towns along the southern Red Sea such as Dahlak Kabir and, in a much later manifestation, Suakin. The bastioned rectangle of Husuni Ndogo can be traced back to Roman *castra* and Umayyad building in Syria (*c.*650–750), but this form was long used for forts, barracks, caravanserais, and mosques in many parts of Islam. The overall axial planning and some of the carved decoration of Husuni Kubwa can be compared with ninth- and tenth-century Samarra on the Tigris, where there were also a mosque and barracks of similar forms to Husuni Ndogo. Conical domes are found on many Seljuk (*c.*1050–1250) tombs in Iran, Anatolia, and southern central Asia. The flat-faced or pyramidal false pendentive and the groined squinch [**102, 106**] are also found in Seljuk structures. The ornamental pool of Husuni Kubwa is a form used in Mamluk Egypt (*c.*1250–1550).

The plan of the coastal mosques, with small open courtyards for ablutions, longitudinal prayer halls with narrow aisles, and a central row of pillars, has close parallels in southern Arabia. On the other hand, the Swahili house plan has not been matched in Arabia nor India but has similarities with houses in the Gulf and Persia.

A surprising number of details point to Indian influences. As in Muslim India, all arches are actually corbelled structures, without voussoirs and with a nick at the apex and not a keystone. This 'ogee' arch is found in India, from the Great Mosque in Delhi, built in the twelfth century, to fifteenth-century Gujarat. The rectangular mihrab frame, rebated mihrab mouldings, and panelled mihrab lintels have been taken as features of the architecture of fifteenth-century Delhi.[15] The lamp niche and the banks of niches in domestic contexts, especially those intended to hold decorative ceramics, are found widely in houses and palaces of Muslim India. The vaulting of the Great Mosque and other Kilwa mosques has been compared with a mosque at Gulbarga (*c.*1367), a major monument of Bahmanid India, though

the similarities are only general and attract attention mainly because Gulbarga is one of the few other mosques that are entirely covered and vaulted.

Some of these similarities with works from around the Islamic world may be significant but no systematic comparative studies have been made. The architectural connections may be direct or indirect. None of them should seem surprising. After all, there is a very long and well-attested history of contact between the coast and almost every part of the Islamic world, a certain vehicle of architectural influence and even one that made easy the passage of craftsmen.

To visitors from the centres of Islam the coastal towns may have seemed provincial. There was no formal urban planning. There were no bazaars or public baths. Indeed only two public secular buildings of any consequence survive: the Husunis. There were no formal gardens, private or public. Some towns had defensive walls around them; but these were flimsy and unadorned and their gateways were without any pretensions. A sense of monumentality was only apparent in the mihrabs of mosques and some doorways in houses. Although most buildings were severely geometric, there was no overall system of proportions beyond the functional one of the mangrove module. Most of the buildings were almost monotonous in their simplicity and similarity. Most of the architecture was functional with very little sense of grandeur. This set the coast apart from the many dramatic expressions of civic pride, religious piety, or public duty manifest in the architecture of Islam elsewhere.

Few would claim that the coastal architecture made any important contribution to the development of Islamic architecture outside eastern Africa. The initial impetuses that stimulated the coastal architecture became incorporated in a single coherent, living and evolving, secure and established local architectural tradition. It is a close reflection and embodiment of coastal culture and its most enduring monument.

Swahili architecture and Great Zimbabwe

Finally, it is particularly noteworthy that there was an entire absence of any architectural influences from the coast passing to the other great centre of building at the time: the far interior, Great Zimbabwe and the scores of minor zimbabwes. Husuni Kubwa is the exact contemporary of the first major phase of building at Great Zimbabwe. Indeed a copper coin of al Hasan ibn Suleiman is the only coin found at Great Zimbabwe, though unfortunately it does not date a specific deposit there. Kilwa and Zimbabwe were in close contact throughout the fourteenth and fifteenth centuries, with Swahili traders resident and influential at the courts of Zimbabwe rulers in the sixteenth century.

Trade between the two centres played an important part in generating the wealth that stimulated and fuelled building in both regions. Perhaps Swahili carvers were commissioned to sculpt the soapstone of Great Zimbabwe; yet not a single architectural concept passed between them or was adopted by either partner.

This scarcely requires explanation. Both had strong, locally developed, indigenous architectural systems. These fully and accurately met the needs and reflected very different systems of belief, perception, custom, ritual, and the symbolic representation of these. Both are the products of sophisticated modes of representation operating at the deepest levels. They had nothing in common and saw nothing in the other to appeal to very different sensibilities.

Tombs

It is the stone-built tombs, isolated or in small cemeteries, that are the most innovative and individual feature of the coastal architecture. Their designs are unknown elsewhere in the Islamic world. From the fourteenth century, important tombs were surrounded by coral walls, their façades usually divided into panels, to form rectangular enclosures. At the head or qibla end of the enclosure, a tall masonry pillar was often erected: square, round, fluted, or polygonal in cross-section. Its shaft was frequently also inlaid with one or more decorative ceramic bowls—usually of Chinese blue-and-white porcelain. Very few if any inscriptions survive on the tombs to give us any idea of who was buried beneath them or precisely when [**109**].

The derivation of the pillar tombs remains a mystery. Because such tombs have no place in orthodox Islam, their derivation was probably African rather than external: suggested models range from the grave markers of southern Ethiopia, the stelae of Aksum, and the standing

109

Two monumental tombs at Ishikani on the northern Kenya coast. A fourteenth- to fifteenth-century celadon bowl was originally inset in the tall pillar. The wall panels have different bold and asymetric patterns: decoration that seems more African than Islamic.

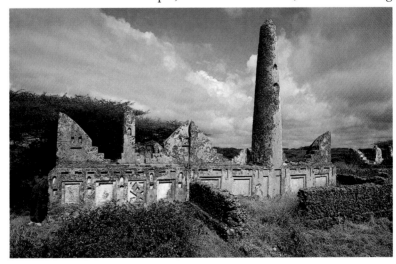

stones of the west African sahel. The stone tombs may reflect a widespread and non-Islamic African respect for and veneration of ancestors. This may still survive in Swahili traditions of visiting, praying, and sacrificing at such tombs. The pillar tomb, like so many other monuments of the coast, was a symbol of residence, a validation of citizenship, a commemoration of civic rectitude and piety, and a ratification of ancestry and of the principle of hereditary succession.

The decorative arts

Almost nothing of the decorative arts of the coast survives. Doors, door jambs, window surrounds, grilles in the windows, rafters, cornices, hanging rails, beds, and furniture were all made of wood and almost certainly carved and painted. Not a single fragment survives. Only lines of fixing holes attest to the hangings that once adorned the walls of Husuni Kubwa apartments. All we have to give us a taste of what has vanished are some carved coral discs with intricate interlaced patterns inset in a few mosque walls [104].

The only other intimation of the early decorative arts are descriptions of the 'thrones' of some 'sultans'—*kita cha ezi* or 'chairs of power'—made of ebony inlaid with silver. Some former royal wooden drums, with typical African forms and diapered and interlaced Islamic carving, survive but they are rare and little is known of them. More significant are the side-blown trumpets or *siwa*. Two magnificent examples survive, important even if they are slightly later than most of the monuments we have described.[16]

The *siwa* of Lamu, 1.80 m long and probably dating from about 1720, is a lost-wax casting in brass [110]. It is in three parts: the horn, a long, perforated, decorative cylinder, and a heavy, ornate finial. The two latter are hinged and were hung over the shoulder of the trumpeter, to act as a counterweight to the horn.

The *siwa* of Pate, even longer than the Lamu example at 2.15 m and dated to 1695 in the *Pate Chronicle*, is also in three parts and made of two or three elephant tusks. The horn is a single large tusk. The elaborate and delicate interlaced guilloche patterns carved along it are typical of fourteenth- to sixteenth-century carved stone decoration on the coast, so this *siwa* may be earlier than supposed or a copy of an earlier example. The inscriptions are in an Arabic so corrupt they cannot be read.

A few equally large but much simpler wooden *siwa* survive, like that of the small fishing village of Mbweni on the central Tanzanian coast. Once the *siwa* was one of the insignia of royalty, an embodiment of authority. This is true not only of the coast but of much of the rest of Africa in the seventeenth century. On the coast they became the symbols of a town's and people's identity, status, and citizenship. They

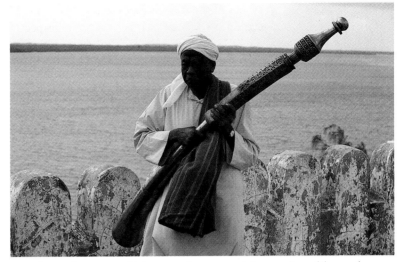

110
A clan elder holds the brass *siwa* of Lamu. The inscription on the cylinder is in a corrupt Mamluk script copied for its pattern rather than its sense. The finial is decorated with interlaced 'Solomon' or 'Yoruba' knots.

were brought out and blown only on special occasions like enthronements or weddings. The right to have the *siwa* blown was a jealously guarded privilege of senior Waungwana clans, an honour as well as often a source of rivalry and ill-feeling.

Notes

Chapter 1. Introduction

1. P. D. Curtin in J. Ki-Zerbo (ed.), *Methodology in African Prehistory: Unesco General History of Africa, Vol. I* (London, 1981), 58.

2. See G. S. P. Freeman-Grenville, *The East African Coast: Select Documents from the First to the Earlier Nineteenth Century* (Oxford, 1962).

3. The Portuguese documents relevant to southern Africa are collected in G. M. Theal, *Records of South-eastern Africa*, 9 vols (1898–1903) and, for the period 1497–1615, in (no names), *Documentos sobre os Portugueses em Moçambique e na Africa Central*, 9 vols with full English translations (Lisbon, 1962–89).

4. C. F. Beckingham and G. W. B. Huntingford (eds), *The Prester John of the Indies* (London, 1961).

5. J. C. Smuts, 'Climate and man in Africa', *South African Journal of Science*, 29 (1932), 128–31.

6. R. Fry, *Vision and Design* (Harmondsworth, 1920), 84 in the 1940 edition.

7. L. Frobenius, *Madsimu Dsangara* (Berlin, 1931).

8. H. Breuil, *The White Lady of the Brandberg* (London, 1955), 9, 12.

9. See P. Robertshaw (ed.), *A History of African Archaeology* (London, 1990).

10. A. J. Arkell, *Memorandum to the West African Higher Education Commission*, 1946.

11. See J. R. Ellison et al., 'The future of African archaeology', *African Archaeological Review*, 13, 1 (1996). The whole issue is devoted to this subject with numerous contributions from many different sources.

12. The ways politics may determine interpretation are dealt with in P. Garlake, 'Prehistory and ideology in Zimbabwe', *Africa*, 52, 3 (1982), 1–19; H. Kuklick, 'Contested monuments: the politics of archaeology in southern Africa', in G. W. Stocking (ed.), *Colonial Situations* (Madison, 1991), 135–69; and M. Hall, 'Great Zimbabwe and the Lost City: the cultural colonization of the South African past', in P. Ucko (ed.), *Theory in Archaeology: A World Perspective* (London, 1995), 28–45.

13. G. Caton-Thompson, *The Zimbabwe Culture: Ruins and Reactions* (Oxford, 1931), 103.

14. K. R. Robinson, R. Summers, and A. Whitty, 'Zimbabwe excavations 1958', *Occasional Papers of the National Museums of Southern Rhodesia*, 3, 23a (1961), 157–332.

15. H. Trevor-Roper, 'David Hume as a historian', *The Listener*, 66, 1709 (1961), 1103–4.

16. Examples are A. J. Bruwer, *Zimbabwe: Rhodesia's Ancient Greatness* (Johannesburg, 1965); R. Gayre of Gayre, *The Origins of the Zimbabwe Civilization* (Salisbury, 1972); or C. Hromnik, *Indo-Africa: Towards a New Understanding of the History of Sub-Saharan Africa* (Cape Town, 1981).

17. T. Huffman, 'Rise and fall of Zimbabwe', *Journal of African History*, 13, 3 (1972), 353–66.

18. The role of cattle and the political relationships between zimbabwes are discussed in P. Garlake, 'Pastoralism and zimbabwe', *Journal of African History*, 19, 4 (1978), 479–93. This is based on the exemplary analysis of cattle and site management developed in G. Barker, 'Economic models for the Manekweni zimbabwe, Mozambique', *Azania*, 13 (1978), 71–100.

19. T. Huffman has spent over twenty years publishing works interpreting the symbolic significance of the layouts and patterned stonework of zimbabwes, culminating in *Snakes and Crocodiles: Power and Symbolism in Ancient Zimbabwe* (Johannesburg, 1996). These works are all tendentious and fail to distinguish facts from opinions; most of the arguments used are illogical and circular. They have met with universal rejection from archaeologists, anthropologists, and historians; see 'Review feature', in the *South African Archaeological Bulletin*, 52 (1997), 125–43; and D. Beach, 'Cognitive archaeology and imaginary history at Great Zimbabwe',

Current Anthropology, 39, 1 (1998), 47–72, especially 'Comments', 61–8.

20. K. Mufuka, *Dzimbahwe: Life and Politics in the Golden Age, 1100–1500 A.D.* (Harare, 1983). See also P. Garlake, 'Ken Mufuka and Great Zimbabwe', *Antiquity*, 58 (1984), 121–3.

21. G. Pwiti, *Continuity and Change: An Archaeological Study of Farming Communities in Northern Zimbabwe, AD 500–1700* (Uppsala, 1996), 154–5, 166.

22. G. Pwiti and G. Mvenge, 'Archaeologists, tourists and rainmakers: problems in the management of rock art sites in Zimbabwe, a case study of Domboshava national monument', in G. Pwiti and R. Soper (eds), *Aspects of African Archaeology: Papers from the 10th Congress of the PanAfrican Association for Prehistory and Related Studies* (Harare, 1996), 817–23.

23. See C. M. Kusimba, 'Kenya's destruction of the Swahili cultural heritage', 201–24; T. H. Wilson and A. L. Omari, 'Preservation of cultural heritage on the East African coast', 225–49, in P. R. Schmidt and R. J. McIntosh (eds), *Plundering Africa's Past* (Bloomington, 1996); T. H. Wilson, 'The loss of cultural heritage in Mali: a perspective from Kenya', *African Arts*, 29, 1 (1996), 36–41.

24. See N. J. Koroma, 'The deterioration and destruction of archaeological and historic sites in Tanzania', 191–200, in Schmidt and McIntosh, 1996.

25. See Schmidt and McIntosh, 1996; T. Shaw, 'The contemporary plundering of Africa's past', *African Archaeological Review*, 14, 1 (1997), 1–17.

26. See M. Brent, 'The rape of Mali', *Archaeology*, 47, 3 (1994), 26–35; *Protecting Mali's Cultural Heritage*, special issue, *African Arts*, 28, 4 (1995); M. Brent, 'A view inside the illicit trade in African antiquities', 63–78; K. C. McDonald, 'Djenne: a thousand-year-old city in Mali', *African Archaeological Review*, 13, 2 (1996), 147–52; Schmidt and McIntosh, 1996.

27. See R. D. McIntosh 'Just say shame: excising the rot of cultural genocide', 45–62, in Schmidt and McIntosh (eds), 1996, which gives full details of the de Grunne transactions.

28. B. de Grunne, *The Birth of Art in Black Africa: Nok Statuary in Nigeria* (Luxembourg, 1998) illustrates over 50 Nok works that are 'recent discoveries on the art market [sic] in Europe and the United States'. The 14 pages of text suffer all the deficiencies experienced in de Grunne's other works.

29. T. Shaw and K. C. McDonald, 'Out of Africa and out of context', *Antiquity*, 69, 266 (1995), 1036–9.

30. E. Eyo, Paper presented to the Eleventh Triennial Symposium on African Art of the Arts Council of the African Studies Association, New Orleans, April 1998.

31. D. Jegede, 'Nigerian art as endangered species', in Schmidt and McIntosh, 1996, 125–42.

32. The legal implications of the Unesco convention and US ban are fully discussed in a series of papers in the special issue of *African Arts*, 28, 4 (1995).

33. See *The Art Newsletter*, 11, 104 (July 2000), 1, for an account of an arrangement between the presidents of France and Nigeria to legalize retrospectively the acquisition by the Louvre of two Nok sculptures.

Chapter 2. Rock Art of Southern Africa

1. L. G. A. Smits, 'Rock paintings in Lesotho: site characteristics', *South African Archaeological Bulletin*, 38 (1983), 62–76.

2. P. Vinnicombe, *People of the Eland* (Pietermaritzburg, 1976); H. Pager *Ndedema* (Graz, 1973).

3. H. Pager, *The Rock Paintings of the Upper Brandberg*, 3 vols so far (Cologne, 1989–95).

4. T. A. Dowson, *Rock Engravings of Southern Africa* (Johannesburg, 1992).

5. A. I. Thackeray, 'Dating the rock art of southern Africa', in J. D. Lewis-Williams (ed.), *New Approaches to Southern African Rock Art Studies: The South African Archaeological Society Goodwin Series*: 4 (Leeusig, 1983), 21–6; J. Kinahan, catalogue entries in T. Phillips (ed.), *Africa: Art of a Continent* (Munich and New York, 1995), 185–6.

6. P. Breunig, 'Archaeological investigations into the settlement history of the Brandberg', in Pager, 1989, 33–45.

7. N. J. Walker, 'Dating the rock art of Zimbabwe', *Rock Art Research*, 4, 2 (1987), 137–48; 'Painting and ceremonial activity in the Later Stone Age of the Matopos, Zimbabwe', in T. Dowson and J. D. Lewis-Williams (eds), *Contested Images: Diversity in Southern African Rock Art Research* (Johannesburg, 1994), 119–30.

8. A. D. Mazel, 'Dating the Collingham Shelter paintings', *Pictogram*, 6, 2 (1994), 33–5.

9. D. S. Whitley and H. J. Annegarn, 'Cation-ratio dating of rock engravings from Klipfontein, Northern Cape', in Dowson and Lewis-Williams (eds), 1994, 189–97.

10. See Chapter 1, note 6.

11. Extracts, all entitled 'Beliefs and customs of the Xam Bushmen', were published

posthumously by his daughter, Dorothea F. Bleek, in nine papers in *Bantu Studies*, 5–10 (1931–6).

12. J. M. Orpen, 'A glimpse into the mythology of the Maluti Bushmen', *Cape Monthly Magazine*, 9, 49 (1874), 1–10. The same volume contains W. H. I. Bleek, 'Remarks on J. M. Orpen's *Mythology of the Maluti Bushmen*', 10–13.

13. L. Frobenius , *Vol I: Die archaeologische Keilstile* (1931), 21, 24, 25.

14. J. D. Lewis-Williams, *Believing and Seeing: Symbolic Meanings in Southern San Rock Paintings* (London, 1981).

15. J. D. Lewis-Williams, 'Ideological continuities in prehistoric southern Africa: the evidence of rock art', in C. Schrire (ed.), *Past and Present in Hunter-Gatherer Studies* (New York, 1984), 225–52.

16. J. D. Lewis-Williams, 'Beyond style and portrait: a comparison of Tanzanian and southern African rock art', in R. Vossen and K. Keuthmann (eds), *Contemporary Studies on the Khoisan, Part 2; Quellen zur Khoisan Forschung*, 5.2 (Hamburg, 1986), 93–139.

17. E. N. Wilmsen, 'Of painting and painters in terms of Zhuhoasi interpretations', in Vossen and Keuthmann (eds), 1986, 347–72.

18. All the following quotes are taken from Lewis-Williams, 1998, 87–8.

19. The debates between Skotnes, Solomon, and Lewis-Williams can be followed in P. Skotnes, 'Rock art: is there life after trance?', *De Arte*, 44 (1991), 16–24; and 'The visual as a site of meaning', in Dowson and Lewis-Williams (eds), 1994. A. Solomon writes in *The South African Archaeological Bulletin*: 'The myth of ritual origins? Ethnography, mythology and interpretation of San rock art' (52, 1997, 3–13). Lewis-Williams responds in 'Quanto?: the issue of "many meanings" in southern African San rock art research' (53, 1998, 86–97). Solomon replies in 'Meanings, models and minds: a reply to Lewis-Williams' (54, 1999, 51–60).

20. This is particularly true of J. D. Lewis-Williams and T. Dowson, *Images of Power* (Johannesburg, 1989).

21. Schapiro quoted in Solomon, 1999, 55. See also Solomon in Dowson and Lewis-Williams (eds), 1994, 368.

22. See P. Garlake, *The Hunter's Vision* (London, 1995).

23. Similar—but by no means identical—associations and conflations of the elephant in the Western Cape demonstrate the wide dissemination of similar beliefs and their visual representations. See T. M. O'C. Maggs and J. Sealy, 'Elephants in boxes', in Lewis-Williams, 1983, 44–8.

Chapter 3. Nubia

1. This is discussed in J. Alexander, 'The Saharan divide in the Nile Valley: the evidence from Qasr Ibrim', *African Archaeological Review*, 6 (1988), 73–90.

2. B. G. Trigger, 'Paradigms in Sudan archaeology', *International Journal of African Historical Studies*, 27, 2 (1994), 323–45.

3. C. Bonnet, 'Excavations at the Nubian royal town of Kerma: 1975–91', *Antiquity*, 66 (1992), 611–25.

4. D. Dunham, *Excavations at Kerma, Part VI* (Boston, 1982).

5. D. O'Connor, in S. Wenig (ed.), *Africa in Antiquity: The Arts of Ancient Nubia and the Sudan*, 2 vols (Brooklyn, 1978).

6. T. Kendall, 'Kingdom of Kush', *National Geographic Magazine*, 178, 5 (1990), 96–125.

7. Nubian kingly succession appears to have passed from senior to selected junior brothers before the next generation succeeded: a common African mode of succession that frequently gave rise to prolonged disputes.

8. N. A. Pomerantseva, 'Some principles of architectural-sculptural composition observed at two temples in Musawwarat es Sufra', in S. Donadoni and S. Wenig (eds), *Proceedings of the Fifth International Conference on Meroitic Studies, Rome, 1984* (Berlin, 1989).

9. Pomerantseva, 1989.

10. L. Torok, 'Meroitic art', in Donadoni and Wenig, 1989.

11. P. Lenoble and N. D. M. Sharif, 'Barbarians at the gates: the royal mounds of el Hobagi and the end of Meroe', *Antiquity*, 66 (1992), 626–35.

12. This was originally known as the 'X Group'.

13. W. B. Emery, *Nubian Treasure: An Account of the Discoveries at Ballana and Qustul* (London, 1948).

14. P. M. Gartkiewicz, *An Introduction to the History of Nubian Church Architecture: Nubia Christiana* (no ed. named) (Warsaw, 1982); 'The central plan in Nubian church architecture', in K. Michalowski, *Nubie: récentes recherches* (Warsaw, 1975).

15. Fresco secco paintings are executed on plaster after it has dried. In true fresco work pigment is applied to the plaster while it is still damp. The pigments thus permeate the plaster and become part of it. They are thus more durable than fresco secco work.

16. K. Michalowski, *Faras: centre artistique de la Nubie chrétienne* (Leiden, 1966) and *Faras: die*

Kathedrale aus dem Westensand (Einselden, 1967); see also E. Dinkler (ed.), *Kunst und Geschichte Nubiens in Christlicher Zeit* (Recklinghausen, 1970).

17. Michalowski, 1966.

18. K. Weitzmann, 'Some remarks on the sources of the fresco paintings of the Cathedral of Faras', in Dinkler, 1970.

19. M. Marteus-Czarnecka, *Faras VII: Les éléments décoratifs sur les peintures de la Cathédrale de Faras* (Warsaw, 1982).

Chapter 4. Aksum

1. H. de Contenson, 'Les monuments d'art sud-arabes découverts sur le site de Haoulti (Ethiopie) en 1959', *Syria*, 39 (1962), 68–83; 'Les fouilles à Haoulti en 1959: rapport préliminaire' *Annales d'Ethiopie*, 5 (1963), 41–86. For a convincing interpretation of the iconography of throne and statuary see J. Pirenne, 'Haoulti et ses monuments: nouvelle interprétation', *Annales d'Ethiopie*, 7 (1967), 125–40.

2. J. Pirenne, unpublished conference paper.

3. See D. W. Phillipson, *The Monuments of Aksum* (Addis Ababa, 1997). This makes E. Littman et al., *Deutsche Aksum-Expedition* (Berlin, 1913) once more accessible.

4. See especially reports by F. Anfray and H. de Contenson in *Annales d'Ethiopie*.

5. F. Anfray, *Les Anciens Ethiopiens: siècles d'histoire* (Paris, 1990).

6. M. E. Heldman, 'Maryam Zion: Mary of Zion', in M. E. Heldman, *African Zion: The Sacred Art of Ethiopia* (New Haven, 1993).

7. D. H. Matthews and A. Mordini, 'The monastery of Debre Damo, Ethiopia', *Archaeologia*, 97 (1959), 1–58.

8. For an interpretation of the iconography see Heldman, 1993, 118.

9. A. Tarekegn, 'Aksumite burial practices: the "Gudit Stelae Field", Aksum', in Pwiti and Soper (eds), 1996, 611–19.

10. D. W. Phillipson, 'The significance and symbolism of Aksumite stelae', *Cambridge Archaeological Journal*, 4, 2 (1994), 189–210, takes a different approach.

11. S. Munro-Hay, *Excavations at Aksum* (London, 1989); D. W. Phillipson, *Ancient Ethiopia: Aksum: Its Antecedents and Successors* (London, 1998) is at present the best anticipation of a full report on the second campaign.

12. Illustration from Littman et al., 1913, reproduced in Phillipson, 1997, 30.

13. F. Anfray and G. Annequin, 'Matara: deuxième, troisième et quatrième campagnes de fouilles', *Annales d'Ethiopie*, 6 (1965), 49–92.

14. F. Anfray, 'Matara', *Annales d'Ethiopie*, 7 (1967), 33–88.

15. Phillipson, 1998, 116.

16. F. Bradley (ed.), *Rachel Whiteread: Shedding Life* (London, 1997). See also many reports on the unveiling of her Holocaust Memorial in Vienna in November 2000.

17. This section depends heavily on the work of M. F. Heldman, especially 'Frē Seyon: a fifteenth-century Ethiopian artist', *African Arts*, 31, 4 (1998), 48–55.

Chapter 5. The Niger River

1. S. K. and R. J. McIntosh, 'Field survey in the tumulus zone of Senegal', *African Archaeological Review*, 11 (1993), 73–107.

2. This term 'pottery sculpture' is preferable to 'terracotta'. Not only is it more accurate, for many west African sculptures are parts of pottery vessels, they all have identical fabrics and finishes to pottery. The fine art and gender connotations of 'terracotta' are also misleading. See M. L. Berns, 'Art, history and gender: women and clay in West Africa', *African Archaeological Review*, 11 (1993), 129–48.

3. See S. Vogel, 'African aesthetics and the art of ancient Mali', in (no ed. named) *The Menil Collection: a Selection from the Paleolithic to the Modern Era* (New York, 2nd edition, 1997), 124–7.

4. See R. J. and S. K. McIntosh, 'Dilettantism and plunder: dimensions of the illicit traffic in ancient Malian art', *Museum*, 49 (1986), 49–57 (an essay much wider in scope than its title suggests).

5. The physical and social contexts of the sculpture with critiques of the ethnographic approach are in: R. J. McIntosh, 'Middle Niger terracottas before the Symplegades gateway', *African Arts*, 22, 2 (1989), 74–83; and R. J. McIntosh, 'From traditional African art to the archaeology of form in the Middle Niger', in G. Pizzoli (ed.), *From Archaeology to Traditional African Art* (Milan, 1992), 145–51. Ethnographic analogy is the basis of B. de Grunne, 'An art historical approach to the terracotta figures of the Inland Niger Delta', *African Arts*, 28, 4 (1995), 70–9. The de Grunne Collection is discussed by R. J. McIntosh in Schmidt and McIntosh, 1996, and in M. Brent, 'The rape of Mali', *Archaeology*, 47, 3 (1994), 26–35.

6. J. Anquandah, 'L'art du Komaland: une découverte récente à Ghana septentrional', *Arts d'Afrique Noire*, 62 (1987), 11–18; J. Anquandah, 'The stone circle sites of Komaland: Northern Ghana, in West African archaeology', *African Archaeological Review*, 5 (1987).

7. G. Jansen and R. G. Gauthier, *Ancient Art of the Northern Cameroons* (Oosterhout, 1973); J. P. and A. Lebeuf, *Les Arts des Sao, Cameroun, Tchad, Nigeria* (Paris, 1977).

8. See B. Gado, '"Un village des morts" à Bura en Republique du Niger' in J. Devisse, *Les Vallées du Niger* (Paris, 1993), 365–74.

9. See 'Les expositions', in *Arts d'Afrique Noire* (Winter 1993) and P. Ravenhill, 'Beyond reaction and denunciation: appropriate action to the crisis of archaeological pillage', *African Arts*, 28, 4 (1995), 56.

10. A. J. Priddy, 'RS63/32: an Iron Age site near Yelwa, Sokoto Province: preliminary report', *West African Archaeological Newsletter*, 12 (1970), 20–32.

11. A. Bassing, 'Grave monuments of the Dakakari', *African Arts*, 6, 4 (1973), 36–9.

12. B. E. B. Fagg, 'Recent work in West Africa: new light on the Nok culture', *World Archaeology*, 1, 1 (1969), 41–50.

13. A. Fagg, 'A preliminary report on an occupation site in the Nok Valley, Nigeria: Samun Dukiya, AF/70/1', *West African Journal of Archaeology*, 2, (1972), 75–9.

14. These figures are illustrated in T. Phillips (ed.), *Africa: The Art of a Continent* (Munich, 1995), Fig. 6.52, p. 529.

15. Eyo, 1998; see note 29 of Chapter 1.

Chapter 6. West African Forests

1. T. Shaw, *Igbo-Ukwu*, 2 vols (London, 1970).

2. B. Lawal, 'Dating problems at Igbo-Ukwu', *Journal of African History*, 14, 1 (1973), 1–8; T. Shaw, 'Those Igbo-Ukwu radiocarbon dates: facts, fictions and probabilities', *Journal of African History*, 16, 4 (1975), 503–17.

3. V. E. Chikwendu and A. C. Umeji, 'Local sources of raw materials for the Nigerian bronze/brass industries with emphasis on Igbo-Ukwu', *West African Journal of Archaeology*, 9 (dated 1979 but actually 1983), 152–65; P. T. Craddock, 'Mediaeval copper alloy production and West African bronze analyses', Part I: *Archaeometry*, 27, 1 (1985), 17–41; Part II (with J. Picton): *Archaeometry*, 28, 1 (1986), 3–32; V. E. Chikwendu, P. T. Craddock, R. M. Farquar, T. Shaw, and A. C. Umeji, 'Nigerian sources of copper, lead and zinc for the Igbo-Ukwu bronzes', *Archaeometry*, 31, 1 (1989), 27–36; D. Williams, *Icon and Image* (London, 1974), 211.

4. L. Garenne-Marot, 'Organization of metalworking societies in "medieval" West Africa: the smith of Sintiou Bara (Senegal)', in Pwiti and Soper, 1996, 523–32.

5. See H. J. Drewel, J. Pemberton, and R. Abiodun, 'The Yoruba world', in A. Wardwell (ed.), *Yoruba: Nine Centuries of African Art and Thought* (New York, 1989), 12–42.

6. Only a modern copy survives. When and where the copy was made remain a mystery. It was substituted for the original soon after discovery. The original has never been located.

7. Two of the Wunmonijie brasses and eight pottery heads were stolen from the museum in Ife in April 1993. Brasses are still being discovered, smuggled out of Nigeria, and sold to dealers, unseen and unrecorded by any experts. One African arts journal shows a queen so closely similar to the brass of an Oni that it could be its pair.

8. F. Willett, describing the work of Blackmun, in 'Stylistic analysis and the identification of artists' workshops in ancient Ife', in R. Abiodun, H. J. Drewel, and J. Pemberton (eds), *The Yoruba Artist: New Theoretical Perspectives on African Arts* (Washington, 1994), 48–57. This takes formal or trait analysis to almost absurd extremes.

9. O. Werner and F. Willett, 'The composition of brasses from Ife and Benin', *Archaeometry*, 17, 2 (1975), 141–56.

10. F. Willett, 'On the funeral effigies of Owo and Benin and the interpretation of the lifesize bronze heads from Ife', *Man*, 1 (1966), 34–45.

11. See the many illustrations and references to the work in F. Willett, *Ife in the History of West African Sculpture* (London, 1967).

12. The only evidence for this may have been the presence of seven left feet. Only four more or less intact heads were recovered.

13. E. Eyo, 'Ode Ogbe Street and Lafogido: contrasting archaeological sites in Ile-Ife, Nigeria', *West African Journal of Archaeology*, 4 (1974), 99–110.

14. P. S. Garlake, 'Excavations at Obalara's Land, Ife: an interim report', *West African Journal of Archaeology*, 4 (1974), 111–48; and P. S. Garlake, 'Excavations on the Wove Asiri Family land in Ife, Western Nigeria', *West African Journal of Archaeology*, 7 (1977), 57–95.

15. F. Willett and S. J. Fleming, 'A catalogue of important Nigerian copper-alloy castings dated by thermoluminescence', *Archaeometry*, 18, 2 (1976), 135–46; see the revisions of these dates in F. Willett, 'L'archaeologie de l'art Nigérian', in F. Willett and E. Eyo and editorial committee, *Arts du Nigéria* (Paris, 1997), 23–43.

16. Charcoal associated with the Owo sculptures gave a date of between 1340 and 1525 CE: E. Eyo, 'Igbo Laja, Owo', *West African Journal of Archaeology*, 6 (1976), 38.

17. H. J. Drewel, 'Ife: origins of art and civilization', in A. Wardwell (ed.), 1989, 56–74.

18. R. Abiodun, 1989; R. Abiodun, 'An African(?) art history: promising theoretical approaches in Yoruba art studies', in Abiodun, Drewel, and Pemberton (eds), 1994. Abiodun's work can be followed further in 'Understanding Yoruba art and aesthetics: the concept of *ase*', *African Arts*, 28, 3 (1994), 68–78; and also in 'The future of African art studies: an African perspective', in (no ed. named), *African Art Studies: The State of the Discipline: Papers Presented at a Symposium Organised by the National Museum of African Art, Smithsonian Institute* (Washington, 1990), 63–89.

19. Drewel, 1989, 67, and see S. Vogel, 'Rapacious birds and severed heads: early bronze rings from Nigeria', The Art Institute of Chicago Centennial Lectures: *Museum Studies*, 10 (Chicago, 1983), 331–57.

20. But see R. Horton, 'Ancient Ife: a reassessment', *Journal of the Historical Society of Nigeria*, 9, 4 (1979), 69–149.

21. H. J. Drewel, personal communication.

22. Eyo, 1976, 37–58.

23. Willett, 1967, pl. 89.

Chapter 7. Great Zimbabwe and the Southern African Interior

1. J. Vansina, 'New linguistic evidence and "the Bantu expansion"', *Journal of African History*, 36, 2 (1995), 173–95.

2. See J. Denbow, 'The Toutswe tradition', in R. R. Hitchcock and M. R. Smith (eds), *Settlement in Botswana* (Johannesburg, 1982), 73–86; or 'Cows and kings: a spatial and economic analysis of a hierarchical Early Iron Age settlement system in eastern Botswana', in M. Hall et al. (eds), *Frontiers: Southern African Archaeology Today* (Oxford, 1984), 24–39.

3. The Limpopo valley sites have a disastrous history of bad excavation and misguided interpretation and then of belated and inadequate publication. The best substitute for the inaccessible E. Voigt (ed.), *Guide to Archaeological Sites in the Northern and Eastern Transvaal* (Pretoria, 1981) is M. Hall, *The Changing Past: Farmers, Kings and Traders in Southern Africa, 200–1860* (Cape Town, 1987). See also M. Leslie and T. Maggs (eds), *African Naissance: The Limpopo Valley 1000 Years Ago: The South African Archaeological Society Goodwin Series: 8* (Cape Town, 2000).

4. T. Maggs and P. Davison, 'The Lydenburg heads', *African Arts*, 14, 2 (1981), 28–33.

5. G. Whitelaw, 'Lydenburg revisited: another look at the Mpumalanga Early Iron Age sequence', *South African Archaeological Bulletin*, 51 (1996), 75–83.

6. E. J. Wayland et al., 'Archaeological discoveries at Luzira', *Man*, 33 (1933), 25; M. Posnansky, entry in Phillips (ed.), 1995, 140; Maggs and Davison, 1981.

7. P. J. Walker, 'The architectural development of Great Zimbabwe', *Azania*, 28 (1993), 87–102.

8. P. Garlake, 'Excavations at the Nhunguza and Ruanga Ruins in northern Mashonaland', *South African Archaeological Bulletin*, 27 (1973), 107–43.

9. D. Collett et al., 'The chronology of the Valley Enclosures: implications for the interpretation of Great Zimbabwe', *African Archaeological Review*, 10 (1992), 139–61.

10. K. Volans, quoted in B. Chatwin, *What am I doing here?* (London, 1989), 67.

11. Anthropological and historical works that show great insight into the relevant Shona beliefs and which have formed the basis of the architectural interpretations developed in this chapter are D. Lan, *Guns and Rain: Guerrillas and Spirit Mediums in Zimbabwe* (London, 1985) and T. Ranger, *Voices from the Past* (London, 1999).

12. F. de Sousa, *O Oriente Conquista* (Lisbon, 1710), 837, quoted in S. Mudenge, *A Political History of Munhumutapa* (Harare, 1988), 78.

13. See P. Garlake, 'Pastoralism and *zimbabwe*', *Journal of African History*, 19, 4 (1978), 479–93.

14. See P. Garlake, 'An investigation of Manekweni, Mozambique', *Azania*, 11 (1976), 25–47; and G. Barker, 'Economic models for the Manekweni Zimbabwe', *Azania*, 13 (1978), 71–100.

15. A varied assortment of animal figurines was found near a stone enclosure near Mutare (Umtali) said to be a zimbabwe but again they are unique and their actual context and date are quite unclear.

16. C. Tagart, 'Relics of a golden age', *Africa Calls*, 168, July, 1988, 13–15; C. E. Thornycroft, 'Report on an excavation at Castle Kopje, Wedza', *Zimbabwean Prehistory*, 20 (1988), 29–36; P. A. Robins and A. Whitty, 'Excavations at Harleigh Farm, near Rusape, Rhodesia, 1958–1962', *South African Archaeological Bulletin*, 21, 82 (1966), 61–80.

17. W. A. Oddy, 'Gold foil, strip and wire in the Iron Age of southern Africa', in D. A. Scott et al. (eds), *Ancient and Historic Metals* (Marina del Rey, 1994), 183–96.

18. P. Garlake, 'Excavations at the

seventeenth-century Portuguese site of Dambarare, Rhodesia', *Proceedings and Transactions of the Rhodesia Scientific Association*, 54, 1 (1969), 23–61.

19. K. R. Robinson, *Khami Ruins* (Cambridge, 1959).

Chapter 8. The East African Coast

1. A qibla is the wall of a mosque indicating the direction of Mecca and a mihrab is the decorative niche that is its focus.

2. Leading proponents of this view are J. de V. Allen and M. C. Horton. See the latter's 'Asiatic colonization of the East African coast: the Manda evidence', *Journal of the Royal Asiatic Society of Great Britain and Ireland* 2 (1986), 201–13. See also J. Middleton, *The World of the Swahili: An African Mercantile Civilization* (New Haven, 1992) and J. de V. Allen, *Swahili Origins* (London, 1993).

3. See Middleton, 1992.

4. F. Chami, 'A review of Swahili archaeology', *African Archaeological Review*, 15, 3 (1998), 199–218.

5. M. C. Horton, *Shanga: The Archaeology of a Muslim Trading Community on the Coast of East Africa* (London, 1996).

6. Horton, 1996.

7. H. N. Chittick, *Manda: Excavations at an Island Port on the Kenya Coast* (Nairobi, 1984).

8. M. C. Horton et al., 'The Mtambwe hoard', *Azania*, 21 (1986), 115–23.

9. M. C. Horton, 'The Swahili corridor', *Scientific American* (September 1987), 86–93.

10. See P. Garlake, *The Early Islamic Architecture of the East African Coast* (Nairobi, 1966), for an architectural analysis and H. N. Chittick, *Kilwa: An Islamic Trading City on the East African Coast*, 2 vols (Nairobi, 1974), for the full description of the excavations.

11. Garlake, 1966.

12. A minbar is the raised pulpit in a mosque from which preaching takes place: usually at the head of a narrow, straight small flight of steps.

13. J. de V. Allen, 'The Swahili house: cultural and ritual concepts underlying its plan and structure', in J. de V. Allen and T. H. Wilson, *Swahili Houses and Tombs on the Coast of Kenya* (London, 1979).

14. R. Lewcock, 'Architectural connections between Africa and parts of the Indian Ocean littoral', *Art and Archaeology Research Papers*, 9 (April 1976), 13–23.

15. Lewcock, 1976.

16. J. de V. Allen, 'The *siwas* of Pate and Lamu: two antique side-blown horns from the Swahili coast', *Art and Archaeology Research Papers*, 9 (April 1976), 38–47.

Further Reading

The paucity of studies of the early art of Africa forces us to rely unduly on archaeological reports, especially if we wish to place objects in context. Specialist journals carry current information. The *African Archaeological Review* contains many authoritative papers and covers all Africa. *Meroitica* (an occasional publication), *Annales d'Ethiopie*, *Bulletin de l'Institut Fondamental (Français) d'Afrique Noire* and the *West African Journal of Archaeology* cover northern and western Africa; sadly, these are now only intermittently published. *Azania* and the *South African Archaeological Bulletin* cover eastern and southern Africa. The well-illustrated art-historical *African Arts* and *Arts d'Afrique Noire* carry only occasional papers on early art.

The most useful introduction to the societies discussed in this book is **G. Connah**, *African Civilizations: Precolonial States and Cities in Tropical Africa: An Archaeological Perspective* (Cambridge, 1987; new edition 2001), even though its focus is very much as its subtitle suggests. A more general work is **J. Reader**, *Africa: Biography of a Continent* (London, 1997), although it pays little attention to the rich artistic traditions of the continent. It should be read together with a review of it: **K. A. Appiah**, *New York Review of Books*, 45, 20 (17 December 1998). Useful basic historical and anthropological studies are **R. Katz**, *Boiling Energy: Community Healing among the Kalahari Kung* (Cambridge, Mass., 1982); **D. Lan**, *Guns and Rain: Guerrillas and Spirit Mediums in Zimbabwe* (London, 1985); also on Zimbabwe: **T. Ranger**, *Voices from the Past* (London, 1999); and **J. Middleton**, *The World of the Swahili: An African Mercantile Civilization* (New Haven, 1992). See also **M. Horton and J. Middleton**, *The Swahili: the Social Landscape of a Mercantile Society* (Oxford, 2000).

Exhibition catalogues with their many excellent illustrations and diverse essays are a most useful source of information. **T. Phillips** (ed.), *Africa: Art of a Continent* (Munich and New York, 1995), is a fine introduction. For Nubia there are **S. Wenig** (ed.), *Africa in Antiquity: The Arts of Ancient Nubia and the Sudan*, 2 vols (Brooklyn, 1978); with this is **F. Hintze** (ed.), *Africa in Antiquity: The Arts of Ancient Nubia and the Sudan: Proceedings of the Symposium Held in Conjunction with the Exhibition, Brooklyn, 1978: Meroitica 5* (Berlin, 1979); see also **C. Bonnet** (ed.), *Kerma, Royaume de Nubie* (Geneva, 1990); **T. Kendall**, *Kerma and the Kingdom of Kush, 2500–1500 BC: The Archaeological Discovery of an Ancient Nubian Empire* (Washington, 1995); and **K. H. Priese**, *Gold of Meroe* (New York, 1998). For Ethiopia there is **M. E. Heldman**, *African Zion: The Sacred Art of Ethiopia* (New Haven, 1993). **J. Devisse**, *Les Vallées du Niger* (Paris, 1993), covers many aspects of the subject, beginning with ecology. **E. Eyo**, *Two Thousand Years of Nigerian Art* (Lagos, 1977) and **E. Eyo** and **F. Willett**, *Treasures of Ancient Nigeria* (Detroit, 1980 and London, 1982), are lavishly illustrated, but the essays on Nok and Ife are superficial and dated. The latter volume is reviewed critically by **D. Fraser** in *African Arts*, 14, 1 (1980). Much better on Ife is **A. Wardwell** (ed.), *Yoruba: Nine Centuries of African Art and Thought* (New York, 1989), written by **R. Abiodun, H. J. Drewel**, and **J. Pemberton**. The same three authors edit *The Yoruba Artist: New Theoretical Perspectives on African Arts* (Washington, 1994), essays from a symposium held in connection with the same exhibition.

2. Rock Art

P. Vinnicombe pioneered genuine rock art studies with *People of the Eland* (Pietermaritzburg, 1976). **J. D. Lewis-Williams**, *Believing and Seeing: Symbolic Meanings in Southern San Rock Paintings* (London, 1981), is his first and still his best major work. A short summary of his developed views is *Discovering Southern African Rock Art* (Cape Town, 1990). Lewis-Williams has edited two volumes of papers,

and taken together they chart the concerns and progress of southern African rock art studies: *New Approaches to Southern African Rock Art Studies: The South African Archaeological Society Goodwin Series:4* (Leeusig, 1983) and *Contested Images: Diversity in Southern African Rock Art Research* (with T. Dowson, Johannesburg, 1994). **C. Chippindale** and **P. S. C. Tacon** (eds), *The Archaeology of Rock-Art* (Cambridge, 1998), contains further papers on South African rock art by Dowson, Solomon, and others. **T. Dowson**, *Rock Engravings of Southern Africa* (Johannesburg, 1992) is too brief to be definitive but places the engravings within the mainstream of San art and shows their connections with shamanism. So does **P. Garlake**, *The Hunter's Vision* (London, 1995), interpreting the art of Zimbabwe.

3. Nubia
The best current introduction to the archaeology and material culture of Nubia is **D. A. Welsby**, *The Kingdom of Kush: The Napatan and Meroitic Empires* (London, 1996). **W. G. Davies** (ed.), *Egypt and Africa: Nubia from Prehistory to Islam* (London, 1991), is a basic text. Christian art is considered by the leading authority on the subject and leader of the Polish expeditions to Faras and Old Dongola, **K. Michalowski**, in *Faras: centre artistique de la Nubie chrétienne* (Leiden, 1966) and *Faras: die Kathedrale aus dem Westensand* (Einselden, 1967), and in **E. Dinkler** (ed.), *Kunst und Geschichte Nubiens in Christlicher Zeit* (Recklinghausen, 1970): the product of another exhibition and conference.

4. Aksum
The standard history of Aksum is **S. Munro-Hay**, *Aksum: An African Civilization of Late Antiquity* (Edinburgh, 1991).
D. W. Phillipson, *Ancient Ethiopia: Aksum: Its Antecedents and Successors* (London, 1998), is at present the best general account of the most recent excavations, the finds, and their contexts. **G. Gerster**, *Churches in Rock: Early Christian Art in Ethiopia* (London, 1970), is an excellent photographic record of several important churches, complemented by equally good architectural plans and sections.

5. The Niger River Valley
Summaries of the nature of the town and society of Jenne-Jeno are in **R. J. and S. K. McIntosh**, 'From *siècles obscurs* to revolutionary centuries on the Middle Niger', *World Archaeology*, 20, 1 (1988), 141–65; **R. J. McIntosh**, 'Cities without citadels:

understanding urban origins along the Middle Niger', in T. Shaw et al., *The Archaeology of Africa: Food, Metals and Towns* (London, 1993); or **R. J. McIntosh**, 'Clustered cities of the Middle Niger', in D. M. Anderson and R. Rathbone (eds), *Africa's Urban Origins* (Oxford, 2000). **B. Fagg**, *Nok Terracottas* (London, 1977), is a belated, somewhat obsolete work by the archaeologist who first recognized the importance of the tradition.

6. West African Forest
A concise general work on Igbo-Ukwu, Ife, Nok, and other topics is **T. Shaw**, *Nigeria: Its Archaeology and Early History* (London, 1978). **F. Willett**, *Ife in the History of West African Sculpture* (London, 1967), remains still the only real attempt at a monograph dealing with the history of an early African art outside north Africa and Nubia. It now seems unsatisfactory in its uses of archaeology, anthropology, and ethnographic analogy. It is reviewed critically by **D. Fraser** in *African Arts*, 14, 1 (1980).

7. Great Zimbabwe and the Southern African Interior
For a well-illustrated but dated synthesis of all work and opinion on Great Zimbabwe see **P. Garlake**, *Great Zimbabwe* (London, 1973). For summaries of later work see **I. Pikarayi**, *The Zimbabwe Culture: Origins and Decline of/in Southern Zambezian States* (Walnut Creek, 2001).

8. The East African Coast
The British Institute in Eastern Africa has published a superb set of monographs on coastal archaeology: **H. N. Chittick**'s *Kilwa: An Islamic Trading City on the East African Coast*, 2 vols (Nairobi, 1974), and *Manda: Excavations at an Island Port on the Kenya Coast* (Nairobi, 1984), and **M. C. Horton**'s *Shanga: The Archaeology of a Muslim Trading Community on the Coast of East Africa* (London, 1996). The great differences between these two authors' approaches have already been commented on. The first monograph of the British Institute, **P. Garlake**, *The Early Islamic Architecture of the East African Coast* (Nairobi, 1966), is an inexperienced student's work, its view of coastal history heavily influenced by Chittick and Kirkman; it is now only useful for its recording of buildings now destroyed and for its analysis of Husuni Kubwa. *Paideuma*, 28 (1982) is a collection of papers on the coast, many of them useful, published in honour of J. S. Kirkman.

Timeline
List of Illustrations
Index

Rock Art of Southern Africa	Nubia	Aksum	The Niger River

29000 BCE

26500 Earliest date for Namibian paintings

11000 Painted spalls in the Matopo Hills

8200 Dated engraving in the Northern Cape

8000–800 Cation dates for engravings at Klipfontein

7800–5600 Concentration of painted spalls in the Matopo Hills

2000

	1580 Thutmoses I invades Nubia. Decline of Kerma		
	1304–1257 Seti I and Rameses II establish Temple of Amun at Jebel Barkal		
	1086 Egyptians withdraw from Nubia. Kushite kingdom revives at Napata		
810 Dated spall in Brandberg that could be fitted to extant painting			
	748 Kushite (25th) dynasty rules Egypt		
	591 Psammetik occupies Kush. Rise of kingdom based at Meroe		

500

		500–300 Temple at Yeha	
			400–200 Dated Nok settlements
	270 All royal tombs now located at Meroe		
			250 Jenne-Jeno established
	235–218 Arnekhamani builds Temple of Apedemak at Musawwarat es Sufra		**200** Earliest dated stone circle
	24 Roman invasion reaches Meroe		

0

1 CE

200 BCE–500 CE Concentration of painted spalls in the Matopo Hills	**20** Natakamani builds Temple of Apademak at Naqa		
			100–700 Yelwa settlement with pottery sculpture
150 Dated painting at Collingham Shelter, Drakensberg			
		200 Alexandrian grave goods in Gudit stelae field	**200–300** Tumulus of Karauchi
			200–1000 Bura cemetery and sculpture
		200–300 Kushan coins buried at Debre Damo	

West African Forests	Great Zimbabwe and the Southern African Interior	East African Coast	A World View	
			29000 Dated paintings at Chauvet Cave, France	**29000 BCE**
			18000–10000 Accepted span of European cave paintings	
				2000
			500–350 Classical Greece	**500**
			30 BCE–14 CE Augustus transforms Imperial Rome	**0**
		100 Emporium of Rhapta described on East African coast		**1 CE**
			201 Christian church established in Armenia	

Rock Art of Southern Africa	Nubia	Aksum	The Niger River
		200–400 Stelae of Aksum	
	300–400 Earliest Christian churches at Faras	**300–500** 'Palaces' of Aksum	**300** Extensive trade at Jenne-Jeno
	300–600 Tumuli of el Hobagi. Cemeteries of Ballana and Qustul		
	350 Meroe declines. All pyramid building ceases	**350** Ezana converts to Christianity	
		500 Kaleb builds Cathedral of Mary of Zion at Aksum, occupies Yemen and builds Cathedral at Sana'a	
		500–600 'Palace' of Dungur	
		600–700 Jewellery hoard at Matara	
	641 Treaty (*baqt*) with Egypt		
		*c.***670** Aksum isolated and finally sacked	
			700–900 Calabar cemeteries and sculpture
	707 Cathedral of Faras built		
			800 Jenne-Jeno surrounded by wall. Integration of different groups and artisans
	850–870 'White' frescoes of Faras		
	900 'Orange-red' frescoes of Faras		
	1000 Faras Cathedral rebuilt. Enriched fresco colours	**1000–1100** Church at Debre Damo rebuilt	**1000** Start of decline of Jenne-Jeno
			1000 Intensive production of pottery sculpture at Jenne-Jeno
		1100–1400 Church at Debre Damo renovated	**1000–1400** Burials in tumuli widespread throughout region
		1137 Start of Zagwe dynasty at Roha	
	1169 Faras nave vaults collapse		
	1171 Start of disintegration of treaty with Egypt. Decline of Christian Nubia		

500

1000

West African Forests	Great Zimbabwe and the Southern African Interior	East African Coast	A World View
			313 Constantine declares Christianity Rome's official religion
	400 Presence of early farmers at site of Great Zimbabwe		
500 Earliest evidence of occupation at Ife			
			530 Hagia Sophia, Constantinople
			618–906 Tang dynasty, China
			632 Death of Muhammed
	700 Pastoralist societies in Botswana	**700** Indigenous settlements of Shanga established	
			750–950 Abbasid dynasty
800–1000 Igbo-Ukwu burials and metalwork	**800** Lydenburg pottery heads	**800** First evidence of Islam at Shanga	
800–1400 Evidence of occupation at Ita Yemoo			
	900 Female and cattle figurines in pottery		
	900 Hierarchical societies in Botswana and Limpopo River valley	**950** Coursed stonework first used at Shanga Mosque and elsewhere on coast	
1000–1200 Evidence of settlement at Lafogido		**1000** Foreign trade firmly established in coastal economy	**945–1171** Fatimid dynasty, Egypt
			1055–1300 Seljuk dynasty, Iran, Mesopotamia, and Anatolia
	1100 Start of continuous settlement at Great Zimbabwe		
		1189 Saladin sacks Jerusalem	

500

1000

Rock Art of Southern Africa	Nubia	Aksum	The Niger River
		1200 Lalibela king. Credited with creating the churches at Lalibela	
		1270 Zagwe dynasty overthrown. Start of Amharic Solomonic dynasty which lasts until 1974	
1300 Collapse of cave ceiling bearing 'later' paintings, Drakensberg			
			1400 Islam firmly established in region. Abandonment of Jenne-Jeno
		1450 Zara Ya'qob intensifies contacts with Europe, encourages new forms of painting	
		1527 Ahmed Gragn devastates Ethiopia	
		1543 Gragn defeated with Portuguese help	
		1632 Portuguese expelled from Ethiopia	
1830s Latest paintings in the Drakensberg, dated by subject			

1200

1500

West African Forests	Great Zimbabwe and the Southern African Interior	East African Coast	A World View	
1200–1400 Ita Yemoo pottery sculpture	**1200** First masonry work at Great Zimbabwe			**1200**
1200–1450 Obalara's Land occupied		**1238** Great Mosque, Mogadishu		
		1269 Mosque of Fakhr ad Din, Mogadishu		
1300–1550 Dated Ife brasses	**1300** Mastery of stonework at Great Zimbabwe			
		1320 al Hasan ibn Suleiman builds Husuni Kubwa and adds a private prayer hall to the Great Mosque, Kilwa	**1348** European gold price slumps. Black Death decimates its population. Economic recession	
			1368–1644 Ming dynasty, China	
			1400 Start of the European Renaissance	
	1450 Great Zimbabwe in considerable decline	**1420** Suleiman ibn Muhammed repairs and vaults Great Mosque, Kilwa		
	1450 Zimbabwes built on northern plateau. Mutapa state established	**1420** Town and 'palace' of Songo Mnara		
	1450 Khami zimbabwe capital of 'Torwa' state on south-western plateau		**1453** Constantinople falls to Ottoman Turks	
			1472 Portuguese establish Elmina Castle on coast of Ghana	
	1500 Danangombe zimbabwe capital of Changamire dynasty and Khami state	**1506** Kilwa sacked by Portuguese fleet	**1500** Vasco da Gama opens sea route from Portugal to India	**1500**
	1511 First Portuguese contacts with Mutapa			
	1644 Portuguese enter Torwa state briefly			
	1693 Changamire drives Portuguese from plateau			

List of Illustrations

The publisher would like to thank the following individuals and institutions who have kindly given permission to reproduce the illustrations listed below.

1. The Pyramid of Amenishakheto. Reproduced from F. Cailliaud, *Voyage à Meroe* (Paris, E. Jomard, 1823–7), by permission of the British Library, London.

2. The temple at Yeha, Eritrea. Reproduced from James Theodore Bent, *The Sacred City of the Ethiopians* (London, Longmans, Green and Co., 1893), by permission of the British Library, London.

3. Stelae at Aksum, Ethiopia, lithograph. Reproduced from Henry Salt, *Twenty Four Views in Saint Helena, the Cape, Ceylon, the Red Sea, Abyssinia and Egypt* (London, Miller, 1809), by permission of the British Library, London.

4. Stele at Aksum. Drawing from E. Littman et al., *Deutsche-Aksum Expedition* (Berlin, Reimer, 1913), Band II. Reproduced courtesy of David W. Phillipson.

5. The brasses of Wunmonijie Compound, Ife. Reproduced from L. Underwood, *The Bronzes of West Africa*, 1949, by permission of Alec Tiranti Ltd and the British Library, London.

6. Aerial view of the palace of Husuni Kubwa, Kilwa, 1961. Reproduced by kind permission of the British Institute in East Africa. © BIEA.

7. The Conical Tower, Great Zimbabwe. Reproduced from James Theodore Bent, *The Ruined Cities of Mashonaland* (London, Longmans, Green and Co., 1893), by permission of the British Library, London.

8. Rock painting, southern Drakensberg, East Griqualand. Reproduced courtesy of the Rock Art Research Unit, University of the Witwatersrand.

9. Rock engravings, Twyfelfontein, Namibia. Reproduced courtesy of the Rock Art Research Unit, University of the Witwatersrand.

10. The Drakensberg, Kwa-Zulu Natal, South Africa. Reproduced courtesy of the Rock Art Research Unit, University of the Witwatersrand.

11. Rock painting, Silozwane, Matopo Hills, Zimbabwe. Reproduced courtesy of Frobenius Institut, Frankfurt.

12. Rock painting, Ndanga. Photo: Peter Garlake, Harare.

13. Rock painting, Eendvogelvlei, Bethlehem District. Reproduced courtesy of the Rock Art Research Unit, University of the Witwatersrand.

14. Rock painting, Charewa, Mutoko. Photo: Peter Garlake, Harare.

15. Rock painting, Game Pass, Kamberg. Reproduced courtesy of the Rock Art Research Unit, University of the Witwatersrand.

16. Rock painting, Chiconyora, Guruve. Photo: Peter Garlake, Harare.

17. Rock painting, Inanke, Matopo Hills. Photo: Peter Garlake, Harare.

18. Rock painting, Brentnor, Marondera. Copy: Courtney Yilk and Peter Garlake, Harare.

19. Rock painting, Gambarimwe, Mutoko. Copy: Courtney Yilk and Peter Garlake, Harare.

20. Rock painting, The Falls, Makoni. Copy: Peter Garlake, Harare.

21. Rock painting, Waltondale, Marondera. Copy: Peter Garlake, Harare.

22. Engraved bowl, Karanog, Lower Nubia. Second–third century CE. Bronze. H. 17.5 cm. D. 26.6 cm. Reproduced courtesy of Nubia Museum, Aswan.

23. Figurine. *c.*3000 BCE. Unfired clay. H. 8.4 cm. Sudan National Museum, Khartoum.

24. Excavations at Kerma, Nubia. Photo: Charles Bonnet, Switzerland.

25. Shrine depicting the Jebel Barkal. Second century BCE – second century CE. Sandstone with traces of red ochre on gesso. H. 63 cm.

Harvard University Museum of Fine Arts. Reproduced courtesy of Museum of Fine Arts, Boston. © 2000 Museum of Fine Arts, Boston. All rights reserved.

26. Sphinx of King Taharqo. 690–664 BCE. Granite. H. 40 cm. © British Museum, London.

27. The temple of Apedemak at Naqa. Early first century CE. Photo: Tim Kendall, Boston.

28. The external rear wall of the temple of Apedemak at Naqa. Early first century CE. Photo: Tim Kendall, Boston.

29. An incised drawing of King Shorkaror smiting his enemies. Jebel Qeili, Butana. 20–30 CE. Reproduced from D. A. Welsby, *The Kingdom of Kush* (London, British Museum Press, 1996).

30. The Kiosk at Naqa. Early first century CE. Photo: Tim Kendall, Boston.

31. Ba statue from a grave at Karanog. Second–third century BCE. Painted wood. H. 70 cm. Reproduced courtesy of University of Pennsylvania Museum of Archaeology and Anthropology, Philadelphia.

32. Crown. Ballana. Fourth century CE. Silver with carnelians and a garnet. D. 23.5 cm. Photo courtesy of Nubia Museum, Aswan.

33. Plans of Nubian churches. Reproduced from K. Michalowski, ed., *Nubia: récentes récherches* (Warsaw, National Museum, 1975).

34. Fresco secco of the Nativity. End of the south aisle, Cathedral of Faras. Early eleventh century CE. Photo: Georg Gerster, Network Photographers, London.

35. Fresco secco of the Virgin protecting Martha, Cathedral of Faras. Early eleventh century CE. Photo: Georg Gerster, Network Photographers, London.

36. Church of Imraha Kristos. Photo: Georg Gerster, Network Photographers, London.

37. Throne. Limestone. H. 140 cm. Hawelti. National Museum, Addis Ababa. Reproduced from H. de Contenson, 'Les monuments d'art sud-arabes découverts sur le site Haoulti (Ethiopie) en 1959', *Syria*, 39 (1962) courtesy of School of Oriental and African Studies, London.

38. Seated figure. Local limestone. H. 140 cm. Hawelti. National Museum, Addis Ababa. Photo: Georg Gerster, Network Photographers, London.

39. Plan of the 'palace' at Dungur, Aksum. Reproduced from E. Littman et al., *Deutsche-Aksum Expedition* (Berlin, Reimer, 1913).

40. Reconstruction of Enda Mikael, Aksum. Reproduced from E. Littman et al., *Deutsche-Aksum Expedition* (Berlin, Reimer, 1913).

41. The Old Church at Debre Damo. Photo: Georg Gerster, Network Photographers, London.

42. The ceiling of the narthex of the Old Church at Debre Damo. Photo: Georg Gerster, Network Photographers, London.

43. The largest stele at Aksum. Photo: Peter Garlake, Harare.

44. Interior of the Tomb of the Brick Arches, Aksum. Photo: David W. Phillipson.

45. Carved ivory panels. Tomb of the Brick Arches, Aksum. Ivory. H. 49 cm. Drawing: David W. Phillipson.

46. Female figurine. Ivory. Tomb of the Brick Arches, Aksum. H. 6 cm. Photo: David W. Phillipson.

47. Interior of Imraha Kristos. Photo: Georg Gerster, Network Photographers, London.

48. Beta Madhane Alem, Lalibela. Photo: Georg Gerster, Network Photographers, London.

49. Interior of Enda Kidana Mehrat, Debra Zion. Photo: Georg Gerster, Network Photographers, London.

50. Wall painting of a priest, possibly Melchisedek, Enda Maryam, Qorqor. Undated. Photo: Georg Gerster, Network Photographers, London.

51. Virgin and Child, the archangels Michael and Gabriel and the Twelve Apostles. Attributed to Frē Seyon. Mid-fifteenth century CE. Tempera on gesso-covered wood. H. 168 cm. Monastery Church of the Redeemer, Rema Island, Lake Tana. Photo: F. Anfray.

52. Horse and rider. Mali. Pottery. Date unknown, probably ninth–twelfth century CE. H. 44 cm. Provenance unknown. Private collection. Photo: Heini Schneebeli, London.

53. Squatting figure. Mali. Pottery. Date unknown, probably ninth–twelfth century CE. H. 30 cm. Provenance unknown. The Menil Collection, Houston, Texas. Reproduced courtesy of Heini Schneebeli/Bridgeman Art Library.

54. Figure of a nursing woman from Mali. Pottery. Date unknown, probably ninth–twelfth century CE. Provenance unknown. Reproduced courtesy of The Menil Collection, Houston, Texas.

55. Bankoni pottery sculpture. Date possibly fourteenth–fifteenth century CE. Pottery. Horseman H. 70 cm; other figures H. 46 cm (max.). The Art Institute of Chicago, Ada Turnbull Hertle Endowment. Photo Alan Newman. © Art Institute of Chicago.

56. Bankoni sculpted pot. H. 54 cm. Date and provenance unknown. Private collection.

Reproduced courtesy of Bridgeman Art Library.

57. Pottery head from Sokoto, Nigeria. Date possibly second century BCE–second century CE. Private collection. Photo: Dirk Bakker, Michigan.

58. The Bura Cemetery, Niger. Reproduced from J. Devisse, *Les Vallées du Niger* (Paris, RMN, 1995) by permission of University de Niamey, Niger and School of Oriental and African Studies, London.

59. Pottery sculpture from the Bura Cemetery, Niger. Left: H. 20.2 cm. Right: H. 17.3 cm. Reproduced from J. Devisse, *Les Vallées du Niger* (Paris, RMN, 1995) by permission of University de Niamey, Niger and School of Oriental and African Studies, London.

60. Dinya pottery head, Nok tradition. After *c.*400 BCE. H. 36 cm. The National Commission for Museums and Monuments, Lagos. Photo: Dirk Bakker, Michigan.

61. Kneeling figure, Nok tradition. After 400 BCE. Fired pottery. H. 66 cm. Provenance unknown. Private collection. Photo: Dirk Bakker, Michigan.

62. Pottery vessel. H. 36 cm. *c.*seventh–eleventh century CE. From Orok Orok Lane, Calabar, Nigeria. National Commission for Museums and Monuments, Calabar. Photo: Ekpo Eyo.

63. Lifesize brass lost-wax casting. Wunmonijie compound, Ife. National Commission for Museums and Monuments, Lagos. Reproduced from A. Wardwell, ed., *Yoruba: Nine Centuries of African Art and Thought* (New York, 1989).

64. Reconstruction of the burial at Igbo-Ukwu. *c.*tenth century CE. Painting by Caroline Sassoon. Reproduced by permission of C. Thurstan Shaw. Photo: Chris Morris, UK.

65. Decorated bowl from Igbo-Ukwu. Ninth–tenth century CE. Bronze lost-wax casting. D. 26.4 cm. The National Commission for Museums and Monuments, Lagos. Photo: Dirk Bakker, Michigan.

66. Ornamental pendant from Igbo-Ukwu. Bronze lost-wax casting. H. 21.5 cm. The National Commission for Museums and Monuments, Lagos. Photo Dirk Bakker, Michigan.

67. Figure of an Oni of Ife from Ita Yemoo. *c.*fourteenth century CE. Brass lost-wax casting. H. 47 cm. The National Commission for Museums and Monuments, Lagos. Photo: Dirk Bakker, Michigan.

68. Brass lost-wax casting of a vessel in the shape of a stool with a figure wrapped around it, from Ita Yemoo, Ife. *c.*fourteenth century CE. H. 12.4 cm. The National Commission for Museums and Monuments, Lagos. Photo: Dirk Bakker, Michigan.

69. Reconstruction of a ceremonial stool froom Iwinrin Grove, Ife. Twelfth–fifteenth century. Pottery. H. 60 cm. The National Commission for Museums and Monuments, Ife, Nigeria. Reproduced from T. Phillips, ed., *Africa: the Art of a Continent* (Munich, Prestel, 1995).

70. Brass head from Wunmonijie Compound, Ife. The National Commission for Museums and Monuments, Lagos. Reproduced from Monica Blackmun Visona et al., *A History of Art in Africa* (New York, Harry N. Abrams, 2001).

71. Head of a bush-pig with royal headdress. Pottery. 14 cm. *c.*fifteenth century CE. Excavated by Ekpo Eyo in 1969 at Lafogido Street, Ile-Ife, Nigeria. The National Commission for Museums and Monuments, Lagos. Photo: Ekpo Eyo.

72. Head from Obalara's Land, Ife. *c.*fourteenth century CE. Pottery. H. 15 cm. University Art Museum, Obafemi Awolowo University, Ife. Courtesy of the Museum for African Art, New York. Photo: Jerry L. Thompson.

73. Head from Obalara's Land, Ife. *c.*fourteenth century CE. Pottery. H. 12.5 cm. University Art Museum, Obafemi Awolowo University, Ife. Photo: Frank Speed, London.

74. Head from Obalara's Land, Ife. *c.*fourteenth century CE. Pottery. H. 12.5 cm. University Art Museum, Obafemi Awolowo University, Ife. Photo: Frank Speed, London.

75. Excavations at Obalara's land, Ife. Photo: Peter Garlake, Harare.

76. Pot found embedded in a pavement at Obalara's Land, Ife. *c.*fourteenth century CE. Pottery. D. 22.5 cm. University Art Museum, Obafemi Awolowo University, Ife. Photo: Frank Speed, London.

77. Head from Obalara's Land, Ife. *c.*fourteenth century. Pottery. H. 22 cm. University Art Museum, Obafemi Awolowo University, Ife. Photo: Frank Speed, London.

78. Pottery vessel from Obalara's Land, Ife . University Art Museum, Obafemi Awolowo University, Ife. Photo: Frank Speed, London.

79. Ceremonial ring. Copper alloy. Fifteenth–nineteenth century CE. H. 6.4 × 19 cm. Provenance unknown. National Museum of African Art, Smithsonian Institution, Washington DC. Photo: Franko Khoury.

80. Leopard devouring a human leg. Pottery. H. 35 cm. *c.*fifteenth century. Igbo Laja, Owo,

Nigeria. The National Commission for Museums and Monuments, Lagos. Photo: Ekpo Eyo.

81. Drawings of ritual pots from Igbo Ukwu (left) and Obalara's Land (right). Ife. H. 46 cm. Department of Archaeology and Anthropology, University of Ibadan, and H. 57.7 cm. University Art Museum, Obafemi Awolowo University, Ife. Drawing (right): Peter Garlake, Harare.

82. Conical Tower, Great Zimbabwe. Photo: Peter Garlake, Harare.

83. Figurine. c.thirteenth century CE. Pottery. Khami, Zimbabwe. National Museums and Monuments of Zimbabwe, Museum of Human Sciences. Photo: Ian Murphy, Harare.

84. Head from Lydenburg, Eastern Transvaal. Sixth–tenth centuries CE. Pottery with traces of white pigment and specularite. H. 38 cm. University of Cape Town Collection, South African Museum, Cape Town. Photo: Herschel Mair.

85. Plan of the stone enclosures at Great Zimbabwe. After A. Whitty and Peter Garlake, Harare.

86. An early wall in the interior of the Western Enclosure of the Hill Ruin. Photo: Peter Garlake, Harare.

87. Original steps at the Northern Entrance, Great Enclosure. Photo: Peter Garlake, Harare.

88. The Conical Tower. Photo: Peter Garlake, Harare.

89. View of the Valley Ruins and the Great Enclosure from the Hill Ruin. Photo: Peter Garlake, Harare.

90. Eastern Enclosure, Hill Ruin, Great Zimbabwe. Photo: Peter Jackson, Harare.

91. Carved stone bird, Eastern Enclosure, Hill Ruin, Great Zimbabwe. H. of bird 32 cm. National Museums and Monuments of Zimbabwe, Great Zimbabwe Museum. Photo: Ian Murphy, Harare.

92. Carved stone bird, Eastern Enclosure, Hill Ruin, Great Zimbabwe. H. of bird 43 cm. National Museums and Monuments of Zimbabwe, Great Zimbabwe Museum. Photo: Ian Murphy, Harare.

93. Carved stone platter, Great Zimbabwe. H. 7 cm. Soapstone. South African Museum, Cape Town. Photo: Herschel Mair.

94. Carved stone platters from Great Zimbabwe. H. 4 cm, 7.5 cm, 7.5 cm. National Museums and Monuments of Zimbabwe, Great Zimbabwe Museum. Photo: Ian Murphy, Harare.

95. Carved stone figurine, Great Enclosure, Great Zimbabwe. H. 8.5 cm. National Museums and Monuments of Zimbabwe, Great Zimbabwe Museum. Photo: Ian Murphy, Harare.

96. The main approach passage, Khami. Photo: Peter Jackson, Harare.

97. The decorated outer wall of Naletale Ruin. Photo: Ian Murphy, Harare.

98. Two carved leopards. Ivory. H. 3.7 cm. National Museums and Monuments of Zimbabwe, Museum of Human Sciences. Photo: Ian Murphy, Harare.

99. Graffiti of some of the early trading ships of East Africa. Copies: Margaret and Peter Garlake, Harare.

100. A view of the palace at Husuni Kubwa. Computer-generated image: Peter Jackson, Harare, after Peter Garlake, Harare.

101. A reconstruction of the palace at Husuni Kubwa. Computer-generated image: Peter Jackson, Harare, after Peter Garlake, Harare.

102. Reconstructions of the various vault types at Husuni Kubwa. After Peter Garlake, Harare.

103. The audience court at Husuni Kubwa. Reproduced by kind permission of the British Institute in East Africa. © BIEA.

104. Carved coral bosses from the Great Mosque. Drawing: Peter Garlake, Harare.

105. Plan and section of the Mosque of Fakhr ad Din, Mogadishu. Plan: Peter Garlake, Harare, drawing: Roger Gorringe, London.

106. The interior of the fifteenth-century domed and vaulted prayer hall of the Great Mosque at Kilwa. Reproduced by kind permission of the British Institute in East Africa. © BIEA.

107. The mihrab of the Great Mosque at Gedi: Photo: Werner Forman Archive.

108. The stone dwellings on Songo Mnara, near Kilwa. Plan: Peter Garlake, Harare.

109. Two monumental tombs at Ishikani on the northern Kenya coast. Photo: Thomas H. Wilson.

110. A clan elder holds the brass *siwa* of Lamu. Photo: Thomas H. Wilson.

The publisher and author apologize for any errors or omissions in the above list. If contacted they will be pleased to rectify these at the earliest opportunity.

Index

Abiodun, Rowland, art historian 22, 135–6
Addi Gelamo 75
Adulis 86
African culture
 connections 13–15, 52
 continuity 12–13, 21–2
 diversity 11–12
 economics 15
 longevity 12–13
 society 11–12
Aksum
 Cathedral 77, 75, 86, 90, 93
 and Christianity 74–5
 coinage 64, 74
 palaces 77–9
 Roman and Byzantine influence 74–86
 society 11, 73, 79
 statuary 148
 stelae 8, 14, 15, 16, 17, 25, 81–2, 88
 symbolism 88
 'thrones' 84
 tombs 83–4
 topography 73
 trade 73–4
Ali ibn al Hasan, sultan 171
Allen, James de Vere, anthropologist 22
de Alvares, Francisco, priest 16, 93
Amanitore, candace 60
Amenishakheto, candace, pyramid of 13
Amun, temples to 54, 57, 58, 59
anthropology 21–2
Apedemak, god 59, 60, 61
Arabia, southern 73, 75–7, 86
archaeology, colonial 18–20
 interpretations of 23–5
 post-colonial 20–1
Armenia 71, 75
Arnekhamani, king 60
Atlantis 18
Augustus, emperor 54, 60, 63

ba statues 65
Ballana culture 65–6
Bankoni sculpture 106, *107*

Bantu languages 141–2, 169
ibn Battuta, Muhammed ibn Abdulla,
 geographer 16, 17, 172, 175, 178, 181
beads, glass *118*, 121, 135–6
Benin City 139
Bent, J. Theodore, antiquarian *14, 23*
Bleek, Wilhelm, linguist 38
Boccaleone, painter 92
Bonnet, Charles, archaeologist 55
Botswana 142
Brandberg 29, 31
brass and bronze casting 118–20, 122–6
 drawn wire 161–2, 163
 ores 118–19
Breuil, Henri, archaeologist 18
Bura, cemetery 108, 109
Butana 51, 53, 61, *71*
Byzantium 67, 71, 74–5, *81*, 86, 90, 92, 171

Calabar sculpture 113, *114*
 looting at 27
Castle Kopje zimbabwe 162
cation-ratio dating 33
Changamire, ruler 165
Chinese
 celadon 105
 porcelain 172, 185
 trade 167
Christianity 14, 66–7, 71, 74–5
 trade 167
coinage 64, 74, 86, 170–1, 184

Dakarikari sculpture 108
Dambarare 163
Danangombe zimbabwe 165
Dapper, Fondation 26
Debre Damo 80–1, *85, 89*
Deutsche Aksum-Expedition *15*, 76–7
Dinya sculpture *60*
Drakensberg 29, *31*, 32, 33, 39, 40

Early Iron Age 141–6, *161*
East African coast 167–8
Emery, William, archaeologist 55

Entebbe, Uganda 146
Ethiopia
 rock-cut churches 88–92
 painting 92–3
 topography 73
ethnographic analogy 99, 104–5
Eyo, Ekpo, archaeologist 27, 113, 127, 139
Ezana, negus 17, 64, 74, 79
Eze Nri, head of society 120

Faras 66, 67–71, 93
farming, development of 141
Fatimid dynasty 67, 71, 170–1
Ferlini, Giuseppe, antiquarian 13
figurines 23, 143–4, 161
forests, West Africa 117
Frobenius, Leo, ethnographer 18, 32, 38, 123
Fry, Roger, art historian 18, 33–4

da Gama, Vasco, navigator 16, 17, 181
Gragn, Ahmed, invader 93
Great Zimbabwe 146–54
 architecture 151, 184–5
 building techniques 148–9
 carved birds 158–61
 chikuva 153
 clay buildings 149–51
 Conical Tower 23, 140, 153
 dates 146
 decline 157
 Eastern Enclosure 155
 economy 158
 Great Enclosure 154
 interpretations 23–5
 metalwork 161–2
 Outer Wall 149, 151
 society 11–12
 stone carving 158–61, 185
 symbolism 24n19, 152–3
 trade 158, 184–5
de Grunne, Baudoin, collector 26
de Grunne, Bernard, collector 104
Gudit, queen 88
Gudit Stelae Field 81

Harleigh Farm zimbabwe 162
al Hasan ibn Suleiman, sultan 171, 175, 176, 178, 184
Hawelti 75, 76, 77
Herodotus, historian 16
el Hobagi 64
Holy Roman Empire 171
Horton, Mark, archaeologist 20
Huffman, Thomas, archaeologist 24 n19

Ife (Ile-Ife) 121
 buildings 121
 ceremonial stools 121, 124

crowns 136
 dates 134
 economy 137
 Ita Yemoo 122, 123, 124, 126, 134
 Lafogido 127–8
 Obalara's Land 128–35; thefts 27
 Oni 66, 67, 126, 128, 133
 paving 121–2, 127, 130–1
 pottery sculpture 126–35
 pottery vessels 128, 130–3, 138
 ritual sacrifice 127–8
 societies 132–3
 stelae 121
 trait analysis 125
 Wunmonijie brasses 19, 116, 123–5; looting and thefts of 27
Igbo society 120
Igbo-Ukwu 19, 117–20, 138
 dates 117
 grave 117
 thefts from 26–7
Imraha Kristos 72, 89
India, architecture 183–4
Inland Niger Delta 12, 97, 98
iron smelting 110, 141, 161
Islam 15, 71, 88, 93, 98, 108, 167, 169–70, 184
Italy 25, 92, 95
ivory 54, 67, 73, 85–6, 89, 143, 163, 165, 171

Jebel Barkal, Amun temple 54, 57, 58, 59
Jebel Qeili 61
Jenne-Jeno 97–9, 104, 115
 for sculpture see Mali
Jerusalem 14, 75, 79, 88

Kaleb, negus 79, 81, 86–7
Karanga people 148, 152, 162
 see also Shona
Karauchi tumulus 107
Kerma 54–7
 deffufas and temples 55–6
 Egyptian connections 56
 figurines 54, 55
 jewellery 56
 sub-Saharan connections 54, 55, 56
 tombs and tumuli 56
Khami zimbabwe 158, 163–5
Kilwa, Great Mosque 176, 178–9
 Husuni Kubwa, palace 19, 22, 171–5
 Husuni Ndogo, caravanserai 174
 Kilwa Chronicle 16, 169, 171, 178
Koma, sculpture 105
Kushan coins 81

Lalibela, negus 88
Lalibela 88
Lamu 167, 186
Lan, David, anthropologist 22

Later Stone Age 12, 31–2, 36, 40
Lewis-Williams, David, archaeologist 21–2,
 38–40, 41, 42
Liavala, Angola 146
Limpopo valley 143
Luzira, Uganda 146
Lydenburg, sculpture 144–6

McIntosh, Roderick and Susan,
 archaeologists 20, 97, 103
Makuria 67
Mali sculpture 99–105
 comparisons with Nok 111
 comparisons with Sokoto 107
 contextual analysis 103
 ethnographic analogies 104–5
 looting 26
Mamluk dynasty 183
Manda 19, 170
Manekweni zimbabwe 158
Mapungubwe 143, 162
Matopo Hills 31, 32, 44
Mbweni 186
Mecca, Ka'aba 75
Melazzo 75
Meroe 51, 59–64
 Aksumite contacts 17, 64
 Egyptian influences 60, 64
 Hellenistic influences 60, 61, 63, 71
 mortuary chapels 63
 Persian contacts 61, 63
 pyramids 13, 62–3
 script 15
Middle Stone Age 31
Middleton, John, anthropologist 22
migrations 141–2, 169
Mtambwe Mkuu 170–1
Musawwarat es Sufra 59–60
Mutapa, state and ruler 148, 150, 156–7,
 162–3
Mwari, god 156

Naletale zimbabwe 164
Namibia 29, 31
Napata 57–9
 pyramids 59
 sculptural style 58
Naqa 59–61
 'kiosk' 61
Natakamani, king 60
Nguni invasions 165
Nhunguza zimbabwe 150
Nile River 51
Nobadia 66
Nok sculpture 19, 109–12
 adornments 111, 112
 dates 110
 looting 26

settlements 110
Sokoto, similarities to 107
Nubia
 Christian links 67, 71
 churches 67–71
 connections with Rome 54
 cultural characteristics 53
 economy 53–4
 frescoes 69–71
 Muslim conquest 71
 relations with Egypt 53–4, 67, 71

Orpen, James, magistrate 38–9, 42
Owo 139

Pate Chronicle 186
Periplus of the Erythraean Sea 16, 17, 169
Persia 63, 67, 167, 169
Piye (Piankhi), pharaoh 54
Pliny, the Elder, historian 16
Portuguese invaders 9, 16, 93–5, 139, 148, 156,
 162, 164–5, 167, 169
 records 148, 156
Psammetik II, pharaoh 11, 54
Ptolemy, Claudius, geographer 16

Qing, interpreter 38–9, 42
Qustul cemetery 65

radiocarbon dates 31–3, 40, 97–8, 108, 110,
 117–18, 134, 144, 146
Rameses II, pharaoh 54, 62
Red Sea 64, 67, 171, 183
Reisner, George, archaeologist 56
Rhapta 17, 169
Rhodes, Cecil, imperialist 23
rock engravings 29, 30, 33
rock paintings
 animal symbolism 37, 39, 40
 archetypes 36–7
 dating 31–3, 40
 elephants in 45–7
 oval designs 43, 44, 45
 pigments 33
 potency 40, 47, 48
 principles of 35
 Saharan 10–11
 semi-human figures 39, 44, 46
 shamanism in 15, 40, 42, 47–8
 surfaces 34, 40
 trance in 39–40, 42, 45, 48
 Zimbabwean 43–8
Roha 88
van der Rohe, Mies 87
Rome 88

Saba 75–6
Saharan rock art 10–11

Salt, Henry, traveller *14*
Samarra 183
Samun Dukiya 110
San, people 17–18, 21–2, 30, 36, 40–3, 48–9
 see also rock paintings
Sana'a 86–7
Santos, Joao de, chronicler 16
Sao sculpture 105
Senegal 103, 108, 119
Seti I, pharaoh 54
Seyon, Frē, painter 93, *94*
shamanism 30, 47
 see also rock paintings
Shanga 20, 170
Shaw, Thurstan, archaeologist 117
Shona people 154–6, 157, 160
 see also Karanga
Shorkaror, pharaoh *61*
Sintiou Bara 119
Skotnes, Pippa, artist 40–1
Smuts, Jan Christiaan, statesman 17–18
Sokoto sculpture 107
Solomon, Anne, archaeologist 41
Songo Mnara 181–2
 destruction 26
South Africa, biomass 30–1
 topography 29–30
stone circles (burials) 103
Suleiman ibn Muhammed, sultan 178–9
Swahili 158, 161, 169
 coinage 170–1, 172, 184
 destruction of towns 25–6
 and Great Zimbabwe 161, 184–5
 houses 180–3
 insignia 186–7
 mosques 170, 175–6
 navigation 167–8
 origins of architecture 183–4
 ships *169*
 siwa (trumpets) 186–7

tombs 167, 185–6
 town planning 181
Syria *83*

Tada 137
Taharqo, pharaoh 54, *58*, 61, 62
Taruga 110, 141
Tegdaoust 119
thermoluminescence dates 134
Thutmoses I, pharaoh 54
tumuli 13, 56, 65, 98
 Karauchi 106, 107
 Yikpabongo 105
Twyfelfontein *29*, 30

Uganda 146
Unesco 27
United States of America 21, 27, 113

Waungwana, class or clan 169, 183, 187
Whiteread, Rachel, artist 88
Willett, Frank, archaeologist 127
women sculptors 99 n2, 113

Yeha temple *14*, 75
 Arabian connections 75–6
 sculpture 75
Yelwa 108
Yikpabongo, cemetery 105
Yoruba 120–1
 concepts 135–6
 neck rings 27, 136, *137*
 societies 132–3, 136

Zagwe dynasty 88
Zara Ya'qob, negus 92
Zimbabwe, topography 11, 29
zimbabwes 146–62
 destruction 26
 later zimbabwes 148, 150–1, 163–5